LEONARDO

MARTIN KEMP is University Professor of the History of Art at the University of Oxford. He is the leading authority on Leonardo's art and science, his research resulting in the major exhibition, *Leonardo da Vinci*, at the Hayward Gallery, London, in 1989. He is the originator of the *Universal Leonardo* project across Europe in 2006.

He has broadcast extensively in the media, including radio interviews with artists, appearances on *Today* and *Night Waves*, television programmes on Piero della Francesca and Leonardo, two videos for the National Gallery, Washington DC, and a Leonardo CD-ROM for Bill Gates.

LEONARDO

MARTIN KEMP

OXFORD
UNIVERSITY PRESS

OXFORD

UNIVERSITY PRESS

Great Clarendon Street, Oxford OX2 6DP

Oxford University Press is a department of the University of Oxford.
It furthers the University's objective of excellence in research, scholarship,
and education by publishing worldwide in

Oxford New York

Auckland Cape Town Dar es Salaam Hong Kong Karachi
Kuala Lumpur Madrid Melbourne Mexico City Nairobi
New Delhi Shanghai Taipei Toronto

With offices in

Argentina Austria Brazil Chile Czech Republic France Greece
Guatemala Hungary Italy Japan Poland Portugal Singapore
South Korea Switzerland Thailand Turkey Ukraine Vietnam

Oxford is a registered trade mark of Oxford University Press
in the UK and in certain other countries

Published in the United States
by Oxford University Press Inc., New York

British Library Cataloguing in Publication Data

Data available

Library of Congress Cataloging in Publication Data

Data available

Typeset by RefineCatch Limited, Bungay, Suffolk
Printed on acid-free paper by
Ashford Colour Press Ltd., Gosport, Hampshire

ISBN 0–19–280644–0 978–0–19–280644–4

3 5 7 9 10 8 6 4 2

Preface

How can we best understand Leonardo? What makes him unique? How can we explain the surviving legacy, above all what we find in the 'notebooks', which find no real parallel in any period. How did his mind work—was he just diverse and scattered, or is there a method in what often seems to be his madness? What were his enduring concerns and how did they find expression across the whole range of his activities? Was he basically an artist who also pursued science and technology? Was he a visionary, anticipating the modern era, or was he very much constrained by the parameters of his own age? Was he a man 'without book learning', as he claimed? How did he make a career when he was apparently unable to complete projects? How can we evaluate the achievements of a figure who is obscured by the dense veil of legend? What was and is his real legacy? And, in the final analysis, what is all the fuss about?

This book uses the opportunity of a relatively small format to concentrate on how we can grasp the essential nature of Leonardo da Vinci, both in himself and as a historical phenomenon.

I am writing on the high terrace of the Villa Vignamaggio in Tuscany, close to Greve in Chianti, through which runs the old and picturesque road between Florence and Siena. It was once the villa of the Gherardini family, whose most famous daughter was named Lisa, wife of Francesco del Giocondo and Leonardo's perpetually enigmatic sitter. It is a ravishing land of vines and olives, clinging to rounded hills close-packed and patchworked with teetering fields of insistent green and roasted golden brown. It is a land to make anyone smile. The villa is now set up to let rooms and suites of rooms to guests. Tonight I sleep in the grand bed in the suite designated the 'Monna Lisa' (spelt thus as the short version of Madonna); tomorrow I was to move into the 'Leonardo', but, since the 'Monna Lisa' is now available for the full duration of eleven days, it is possible to remain with her. It was her family house, after all. There is a lingering heaviness in the atmosphere. A sudden wind, warm yet fiercely buffeting, flaps the hinged screen on my computer as if an ancient spirit is agitated at having its secrets probed. Perhaps this Leonardo

business is becoming too much for this measured British academic, normally so committed to sober empiricism. It is starting to rain.

Ten days later, and the text is in draft. Thereza Crowe, one of the team working on a huge project we have in hand for 'The Universal Leonardo' in 2006, involving exhibitions, technical examination, other events, and media outputs across Europe to celebrate the life of Leonardo da Vinci, telephones to say that the *Madonna of the Yarnwinder* has been stolen from the Duke of Buccleuch's great palace-castle in the Scottish borders. Four men in a Volkswagen Golf GTI at 11.00 in the morning appear to be responsible—as yet the news is fragmentary. When I return to Britain the next morning there will be a media frenzy. I think of the Duke and his family. For him and for them the small Leonardo picture was more than another inherited possession; his enthusiasm to share his deep pleasure in it has always transcended proprietorial satisfaction. I fear for the fate of the 500-year-old panel, and long for its speedy restitution.

I also learn during this period of the unexpected death of John Shearman, latterly Professor at Harvard and who had taught me as a postgraduate at the Courtauld Institute of Art in London. This most scrupulous and penetrating scholar of Renaissance art

played an essential role in inculcating any historical skills that I might now have. He liked my first monograph on Leonardo, published in 1981 in the earliest phase of my career, and I hope he would have enjoyed this book too.

This book bears an obvious relationship to the earlier monograph, which was entitled *Leonardo da Vinci: The Marvellous Works of Nature and Man*. It is now out of print, awaiting my long-promised revisions. It presented an attempt to paint a unified picture of Leonardo's creative and intellectual life across his many fields of endeavour within a biographical framework. The central hypothesis of that book, to the effect that there was an underlying unity to Leonardo's diversity, is carried forward into the present treatment.

I hope that anyone who really wants to come to terms with Leonardo will be encouraged to turn to the widely available transcriptions, translations, and anthologies of his thousands of pages of notes.

Where I depart from my earlier framework is in the thematic discussion of what I believe to be the main motifs that run through Leonardo's thought, and in the abandonment of the narrative of biography as the organizational principle for the chapters. The 1981 book gave sustained attention to the development

of his thought, whereas the thematic discussions I am providing here tend to emphasize continuities. I am also conscious that, after thirty years of involvement with Leonardo, I am writing in a manner that reflects the sustained nature of my personal dialogue with his legacy. The tone has become more 'literary' and personal. I am also giving a more sympathetic outing for the 'myth' of Leonardo, which is an active and even creative agent in the power he exercises over everyone who encounters his life and works.

In the meantime, Leonardo literature pours forth unabated. Carlo Pedretti continues to publish the fruits of his wholly unrivalled knowledge of the manuscipts. Pietro Marani in Milan has done much to extend our knowledge of Leonardo in his Lombard context. Carmen Bambach, who generously allowed me to cannibalize her published chronology of Leonardo's life, has made important contributions to our understanding of his drawings. Paolo Galluzzi has enriched our comprehension of Leonardo as a Renaissance engineer. There are many others who might and should be mentioned.

The origins of this book lie in the invitation from Katharine Reeve of Oxford University Press to contribute a volume on Leonardo to the 'Very Short Introductions' series. She and Emily Jolliffe have

provided unfailingly enthusiastic support. Katharine's editorial contribution improved the text significantly and her vision of how the book should be presented has been consistently creative. Liz Powell has produced a beautiful and user-friendly design, and Stuart Brill has designed a striking cover.

The fact that this book was written at all, when week after week is all too readily consumed by the day-to-day business of working in Oxford and by ever-escalating outside demands on my time, is down to a period of eleven days spent at the Villa Vignamaggio, deep in Chianti country. Marina Wallace set up the sojourn, was my fellow resident in the former Gherardini property, and provided vital clarifications to the first draft. I did not want to let her down by not achieving my goal, and I hope the present text represents some kind of thanks. For her part, she has mapped out her own book, drawing on her experience in the 'art-science business', which I eagerly look forward to reading. The Nunziante family who own the villa—producing delicious wine and olive oil—lent gracious support and material sustenance.

During the period of writing, Nicola Henderson, administrative secretary in the Department of the History of Art at Oxford, has played a vital role in helping manage incoming demands. Her under-

standing, vitality, and sense of humour have been sources of continual strength for me. While she was on leave of absence, Laura Iliffe offered unstinting and charming support. Roya Akrami has helped vitally in assembling the bibliography and illustrations, while Matt Landrus has as ever been on hand to assist. Colleagues in my other main enterprise, the company Wallace Kemp/Artakt, which we have founded to take forward our art-science exhibitions and other professional engagements, have also acted with great tolerance to my 'switching off' from matters that need my attention. Over the years, custodians of Leonardo material, public and private, have willingly made material accessible. If I mention by name only Lady Jane Roberts at Windsor, with whom I was delighted to collaborate on the 1989 exhibition at the Hayward Gallery in London, this does not mean that others are forgotten. A single author's name appears on the spine of the book, but it is in a sense a collaborative effort, involving all those with whom I have engaged in dialogue about Leonardo over the years, not only scholars, but also enthusiastic members of the public, to whom this book is dedicated.

Contents

List of Plates and Figures

All works are by Leonardo unless otherwise noted.

Figures

The Gallery

Picture Acknowledgements (MS shelfmarks in brackets)

Alte Pinakothek, Munich/Bayerische Staatsgemäldesammlungen: p. 248 (top); **Biblioteca Ambrosiana, Milan**: figs. 7 (Codice atlantico, 235r), 17 (Codice atlantico, 767r), 18 (Codice atlantico, 149rb), 19 (Codice atlantico, 858), pp. 250 (centre), 251 (top); **Biblioteca Nacional, Madrid**: fig. 16 (Codex Madrid I, 26r); **Bill Gates Collection, Seattle**/Photo: © Corbis: fig. 22 (Codex Leicester, 35v); © **The British Museum, London**: plate 11; **Castello Sforzesco, Milan**: plate 2, p. 252 (bottom); **Collection**

of The Duke of Buccleuch and Queensberry, K.T.: p. 253 (top); **Galleria dell'Accademia, Venice**/Photo: ©Bettmann/ Corbis: fig. 6; © **National Gallery, London**: pp. 247 (top), 251 (centre); **Louvre, Paris**/Photo: © RMN/Arnaudet/J. Schormans: plate 5; © RMN/Michèle Bellot: plate 14; © RMN/C. Jean: plate 17; © RMN/Hervé Lewandowski/ LeMage/Gattelet: plate 18, p. 253 (bottom); © RMN/ Hervé Lewandowski: pp. 250 (top), 251 (bottom), 254 (top, middle); © RMN: p. 254 (bottom); **National Gallery of Art, Washington**, Ailsa Mellon Bruce Fund/Photo: © 2004 Board of Trustees, National Gallery of Art, Washington: p. 248 (centre); **Princes' Czartoryski Foundation at the National Museum, Kracow**: plate 16, p. 250 (bottom); **Private collection**: plate 4, pp. 252 (centre), 253 (centre); **Refectory of Sta Maria delle Grazie, Milan**, under licence from the Italian Ministry for Cultural Goods and Activities: plate 15, p. 252 (top); **Royal Library, Windsor**/The Royal Collection © 2004, Her Majesty Queen Elizabeth II: plates 1 (12726), 3 (12284), 6 (12660v), 7 (12532), 8 (12281), 9 (12680), 10 (12678), 12 (12552), figs. 1 (19057), 8 (12516), 10 (19149–52v), 12 (19009), 13 (19102), 23 (12378); **State Hermitage Museum, St. Petersburg**: pp. 248 (bottom), 249 (bottom); **Szépmüvészeti Museum, Budapest**: plate 13; **Uffizi Gallery, Florence**/Photo: © Alinari Archives, Florence: plate 20, fig. 24, pp. 247 (centre, bottom), 249 (top); **Vatican Museums**: p. 249 (centre); **Marina Wallace** and **Martin Kemp**: plate 19.

Introduction

Leonardo and the 'Abbreviators'

> The abbreviators of works do injury to
> knowledge and to love, for love of anything is
> the offspring of knowledge, love being more
> fervent as knowledge is more certain, and
> certainty springs from a thorough knowledge
> of all those parts which united compose the
> whole . . . truly it is impatience, mother of folly,
> which praises brevity.
>
> (Leonardo, *c*.1510)

THIS SCATHING CRITICISM is not encouraging for any author wishing to capture the totality of Leonardo and to do justice to the huge range of his activities within a brief compass. The student of Leonardo's writings is faced with a daunting body of material, in terms of quantity, range, and inherent difficulty. This is to say nothing of the

problems presented by his handwriting, which would be difficult enough to read were it not written from right to left in mirror script (a natural move, by the way, for a left-hander using his materials and working at his speed). A rough count of surviving pages amounts to over 6,000. If, as a comparison, we take a modern book as 300 pages, Leonardo's total would fill at least twenty volumes. If we also take into account that as much as a quarter to four-fifths of his total written production may have been lost, we are dealing with someone who wrote and drew enough to fill 80–100 volumes. (This estimate is based on the passages transcribed by an editor in the sixteenth century for the 'Treatise on Painting', of which the great majority come from manuscripts that are no longer traceable.)

The situation for the modern 'abbreviator' of Leonardo's life and works looks to be discouraging on all fronts. However, if we look more closely at what he is saying, perhaps things are not so bad after all.

His attack was directed at those who made summaries or epitomes of large texts, and specifically at those who describe the manifold wonders of the human body in a summary manner. The true student of the glories of nature must always respect the awesome ways in which diverse forms have been designed to serve particular functions, whether the

vast clockwork of the heavens or a tiny valve in the human heart. But Leonardo himself came to realize that not even he could investigate every aspect of nature (or even of the human body) at the level he demanded.

Let us try to express his approach in his own terms, albeit in a horribly condensed manner at this stage. A set of loaded words is involved.

He strove to subject observable 'effects' to rigorous scrutiny in such a way as to ascertain their basic 'causes', 'reasons', or 'principles'. This understanding was to be accomplished through the study of 'cases', which provided 'experience' or evidence. Once the cases were properly demonstrated in terms of the perfect matching of causes and effects, the investigator could claim to have achieved 'proof'.

Each proof illuminates how nature operates as a whole. With a mastery of causes, the investigator was potentially in the position to reconstruct existing or new effects from the bottom up. Leonardo's own works of art constitute exactly this kind of building— remaking new visual effects from basic causes, not least those of an optical nature. Each painting is, in a sense, a proof of Leonardo's understanding.

Bearing this very compressed summary in mind, my strategy is to look at how we may use specific

examples to illuminate the central core of his beliefs—
in such a way as to respect the complexities of 'the
works of nature and of human things'. I will be
seeking the ubiquitous structures that lie below the
surface of his diversity. The trick is to show how he
considered that a limited number of central causes,
static and dynamic, can result in an awesome variety of
natural effects. If this strategy of taking cases to reveal
the broader and deeper structure succeeds, the reader
will be provided with a framework with which to make
sense of the very many aspects of his work that are
necessarily excluded from the present discussion.

The overarching premise on which Leonardo
operated is that all the apparent diversities of nature
are symptoms of an inner unity, a unity dependent
on something like a 'unified field theory' that reaches
out to explain the functioning of everything in the
observable world. For Leonardo, this unified theory
relied upon the proportional (geometrical) action of
every power in the world and explained the design
of everything. This explains why he wrote on one
of his anatomical drawings, 'let no one who is not a
mathematician read my principles' (actually para-
phrasing Plato).

Proportional theory explains why things look
smaller as they become more distant; why the twigs of

a tree are narrower than the branches (and in what ratio); why shadow becomes weaker the further it is from the object casting it; how a spring loses power as it winds down; how far a missile will travel when thrown by one of his machines of war; why an arch made of separate stones will stand up; and why a stone falls ever faster towards the ground. The list could encompass almost every phenomenon that can be analysed by the sciences we now call statics and dynamics. The analogous behaviour of different phenomena provided one of his key methods of argument. Light behaved like sound, like rippling water, like heat from a flame, like a bouncing ball, like a hammer striking a surface ... Analogy was an age-old technique for explaining the behaviour of things. Leonardo gave it a visual cogency, not least through the persuasive power of his drawings, placing it on a new basis.

Every act of looking and drawing was, for Leonardo, an act of analysis, and it was on the basis of these analyses that the human creator can remake the world. Thus the flying machine and the *Mona Lisa* comparably remake the natural world on nature's own terms, fully obedient to natural causes and effects. One is an artificial 'bird'; the other is an artificial remaking of the visual experience of a person's physical presence.

In a sense, this book is about why the *Mona Lisa* and the flying machine were, for Leonardo, the same kind of thing.

Chapter 1, consciously measured in tone, will search out the 'real' Leonardo through the documents of his career. On the face of it this career looks very odd. The list of works of art executed entirely or largely by him runs to no more than twenty, and the early records do not suggest that more than a handful of autograph works are lost. Of what we think of as the central Leonardos, some five or six (including the *Mona Lisa*) appear never to have left his hands. To put it bluntly, this indicates that he did not make a living by delivering completed paintings. Legend has it that he was a technological dreamer, inventing things that could not be realized for his patrons. The documentation of his career is littered with impatient noises from those who employed him. Yet he lived in some style and ended his career with a massive salary. How can we make sense of the apparent contradictions?

The five central chapters draw out the principles underlying his investigations of the world, nature, and his vision of the artist-engineer as a 'second nature in the world'. The eye itself is the first subject of focus,

since he believed that it was sight that provided our most certain knowledge of how things work. Light behaves in a meticulously geometrical manner, and the eye is specifically designed to pass on its truths to the intellect. The supreme subject of visual scrutiny was the human body, as nature's supreme creation, and it provides the model for the human engineer. A deep understanding of the forms and functions of the body constituted the base on which the engineer could aspire to contrive inventions that nature herself had not made. The body also played a key role in the understanding of the greater framework of the 'body of the earth'. He adhered to the traditional doctrine that the organization of the macrocosm, the universe as a whole, was mirrored in all its parts, above all in the microcosm or 'lesser world' of the human body. His brilliance as an observer and visualizer endowed the old doctrine with fresh urgency and conviction. Armed with these kinds of understanding, Leonardo assembled what might be called a 'kit' for the imaginative reassembly of nature in his works of art. A painting of a historical or biblical subject like the *Last Supper* is obviously born in his imagination, or *fantasia*, but it is also true that his portraits are not simply direct transcriptions of what he sees. Eye is always allied to intellect.

The final chapter, which serves with the first to frame the thematic chapters on Leonardo's creativity, will look very selectively at the legendary transformations that have arisen as each generation remakes its own Leonardo. He was never without his share of fame, even if this fame was for a long time based upon little direct knowledge of what he had actually done. In the seventeenth century he was the centre of bitter disputes in the French Royal Academy of Fine Arts about the foundations of good art. In the seventeenth and eighteenth centuries more 'Leonardos' were inventoried in noble collections and passed through the salerooms than he could ever have painted even had he been prolific. In the nineteenth, some firmer outlines began to appear, and towards the end of the century the vast legacy of his notebooks on all kinds of subjects began to be published. The twentieth century's major achievement was to cut back to the bedrock of what can be firmly documented and to establish what has actually survived from Leonardo's own hand. He was typically characterized, not least in the popular imagination, as one of the first representatives of what was to become the modern era, as a man 'ahead of his time'. Yet this 'scientifically' assembled, modern Leonardo is very much of its own time.

In the face of a vast and continuing barrage of

scholarship and popular manifestations, Leonardo remains an elusive, even enigmatic target, continually moving as we ask different questions of his legacy and look at him from different perspectives. The best for which I can hope is that Leonardo himself would have recognized something in the perspective I have adopted here.

A STRANGE CAREER

SATURDAY, 15 APRIL 1452. At around 3 a.m. Renaissance time in the Tuscan hill town of Vinci, Leonardo was born out of wedlock. As his grandfather recorded, he was the illegitimate son of the otherwise unknown Caterina and Ser Piero da Vinci, who was to become a prominent lawyer in Florence. In 1469 Ser Piero received an official government appointment as notary to the chief law-enforcement officer. Leonardo may have moved to Florence and entered the studio of the sculptor and all-round artist, Andrea Verrocchio, at that time or perhaps a little earlier. We tend to think of Leonardo as a predominantly Florentine artist, growing to maturity in a busy and versatile studio in a city that was a hard-nosed and vibrant republic, its wealth

founded on banking and cloth. As it transpired, most of his subsequent career was passed in the very different environment of aristocratic courts outside Florence. Of the forty-six years of his documented career, no more than sixteen were spent in Florence: nine years between 1473 and 1482; and six or seven fragmented years after 1500. For at least thirty years, Leonardo depended on courtly employment, with spells of approximately eighteen and six in Milan, and two periods of three each in Rome and France. He ended his career in French royal service, with a very impressive salary and residing in a grand manor house. As we will see, courts potentially provided the kind of occupations and remuneration that suited Leonardo's richly diverse talents.

If we study Leonardo's life as revealed in the documents, he seems to have pursued a very odd career as an artist who sold almost no pictures and completed no major sculptures. A number of the most famous paintings appear never to have been passed on to those who commissioned them. A central group of Leonardo paintings seem to have remained with him until his death, when they passed into the hands of Gian Giacomo Caprotti, known as Salaì. Entering Leonardo's studio in 1490 as a beguiling rascal, who stole anything not tied down, Salaì became

an important member of Leonardo's entourage, and appears to have become something of a 'front man'. When he died from an arrow wound in 1424, the inventory of his property for division between his two sisters contained the *Leda and the Swan* (now lost), the *Madonna, Child, St Anne, and a Lamb*, the *Mona Lisa*, another portrait of a woman, the *St John the Baptist*, and the *St Jerome*, together with five or six smaller works, including 'One Madonna with a son in her arms', which may be one of the two variants of the *Madonna of the Yarnwinder*.

If we add that the *Adoration of the Magi* was left unfinished, that he never completed a 1478 commission for an altarpiece in the government palace in Florence, that the *Virgin of the Rocks* commission took twenty-five years before final payment was handed over, that the *Last Supper* proceeded slowly, that the *Battle of Anghiari* for the Florentine Council Hall was never completed, and that neither of his planned equestrian monuments was brought to completion, we seem to be witnessing a sorry story.

How can we make sense of this? Why did patrons support him at all? How did he get away with not delivering? Or did he deliver in other areas? The relatively extensive documentation of his career, examined afresh, does confirm something of the

oddness, but it also paints a picture of someone who was richly engaged in various of the activities that his paymasters expected him to undertake. There is plentiful evidence to give us a good impression of his real life. Part of the explanation is that he was, for most of his career, a creature of the court, not a jobbing artist surviving from commission to commission.

The way I am going to look at Leonardo's documented life in this chapter is to group a series of episodes into five thematic sections: the first concerns the nature of the commissions he received, and the difficulties that emerged; secondly, we will look at the evidence of what moneys he attracted, and from whom; then we will characterize the nature of his duties in the courts he served; the fourth section examines his household and studio as a functioning unit; and finally we will quote some personal testimonies about Leonardo's character.

Working, or not Working, to Order

If we look at the conduct of the two major known commissions of the first phase of Leonardo's career, we can gain some idea of why court employment appealed to him. On 10 January 1478, aged 25, he

received the very prestigious commission for the altarpiece of the Chapel of S. Bernardo in the Palazzo della Signoria, the government palace now known as the Palazzo Vecchio. He received his first payment of 25 florins on 16 March. No finished painting resulted, and another painter, Filippino Lippi, eventually supplied the altarpiece some seven years later. Leonardo's obtaining this important commission may be explained in part by the position of his father, Ser Piero, as a procurator in government service. His father was also the notary for the monks of S. Donato a Scopeto, from whom he obtained his other large-scale commission at this time.

This second commission, which appears to have resulted in the unfinished *Adoration of the Magi*, is recorded in a memorandum of July 1481. It speaks either of the initiation of the project or, more probably, presents an interim summary of earlier agreements. The terms are surprising. Leonardo was to complete the work in twenty-four or at most thirty months, and was to receive one-third of a property that had been left to the monks by 'Simone father of brother Francesco'. The monks retained an option to buy back the property after three years. In addition Leonardo was to see that a dowry of 150 florins was provided for 'the daughter of Salvestro di Giovanni'.

Apparently, Leonardo could not raise the ready cash, and the monks themselves paid 28 florins into the Florentine Dowry Bank so that interest would accrue. The memorandum notes that 'time was elapsing and it was prejudicial to us'. The value of the contract to Leonardo was 300 florins, a considerable sum for even a large altarpiece. Something around 100 would have been more normal. The generous terms were presumably designed to compensate him for the unusual nature of the agreement, which seems to have provided no liquid cash. There are records of subsequent payments for pigments, the provision of corn and wine, and of kindling and logs for having painted the clock in the monastery. After September 1481 the record goes silent. In the event, it was Filippino Lippi, again, who supplied the finished work.

Why was Leonardo allowed to leave Florence with such important items of unfinished business? One possibility is that the demands of the commissioners were overridden by a higher authority. An early source tells how the 30-year-old Leonardo was sent to Milan by Lorenzo de' Medici, il Magnifico, who was effectively ruler of Florence. The story tells that he was dispatched with the musician, Atalante Migliorotti, bearing a remarkable lyre in the shape of a horse's skull. The artist and the lyre would have been

intended to serve as diplomatic gifts for Ludovico Sforza, il Moro, ruler of Milan. We know that Lorenzo used this novel form of diplomatic lubrication, and the story makes sense.

Our first record of Leonardo in Milan does not directly involve the court, but consists of the contract for an altarpiece for the chapel of the Confraternity of the Immaculate Conception in S. Francesco il Grande. To the highly formal legal contract in Latin of 25 April 1483 is appended an extensive list of obligations in Italian. The artist and his partners, the brothers Evangelista and Giovan Ambrogio da Predis, are required to provide paintings for the altar and to undertake the extensive gilding and polychroming of the elaborately carved structure supplied earlier by Giacomo da Maiano. By the early 1490s we see the first signs of the all too familiar trouble. A petition from Leonardo and Ambrogio urges their 'Most Illustrious and Excellent Lord' to intervene in a dispute over the artists' level of recompense. 'The blind cannot judge colours', the partners declare, little impressed by the rewards they were receiving for their labours. The 'Lord' is, presumably, Ludovico. The dispute dragged on, through various legal proceedings, including a substantial act of arbitration in 1506, when Leonardo had long since left Milan. Only when he returned

to the city in French employ after 1507 could the Confraternity exercise renewed leverage on the artist. Finally, in 1508, they received their painting. Leonardo and Ambrogio, for their part, were then given permission to make a copy of the picture. How this tangled documentation relates to the two major versions of the picture, in Paris and London, is notably problematic.

The documentation of his role in the Milanese court of his 'Illustrious Lord' is less rich than we might like, but the indications are clear. Our only documented reference for the painting of the *Last Supper* in the refectory of Sta Maria delle Grazie, which appears to have been a ducal commission, comprises an item in a list of instructions sent by Ludovico to one of his functionaries, Marchesino Stanga. It lists twelve tasks that require the Marchesino's attention. One of these instructs him, with a tone of impatience,

> to urge Leonardo the Florentine to finish the work on the Refectory of the Grazie, which he has begun, in order to attend afterwards to the other wall of the Refectory of the Grazie; and that agreements to which he has subscribed by his hand be fulfilled, which shall oblige him to finish the work within the time that shall be agreed upon with him.

The same official later appears in one of Leonardo's notes as his paymaster: 'on 28 April [1489?] I received from the Marchesino 103 *lire* and 12 *soldi*.'

The other records of Leonardo's involvement with murals in Milan paint a similar picture of the Duke instructing his officials to urge Leonardo to work more expeditiously. Leonardo was one of those engaged on the decoration of a suite of rooms in the castle, including the new apartments that Ludovico had constructed on a bridge above the moat. On 20 April 1498 a memorandum from another official stresses that 'time is not to be lost' in completing the decorations in the room known as the *saletta nigra* (small black room). A day later, it is repeated that 'in the *saletta nigra* time is not to be lost'. Nothing remains of whatever work might have been completed. The other note in the memorandum of 21 April refers to a work that has in part survived, namely the *Sala delle Asse* (**Plate 2**), with its intricate decoration of intertwined trees: 'On Monday the *camera grande delle asse*, that is in the tower, will be cleared out. Maestro Leonardo promises to finish it all by September, and with all this going on it will still be possible to avail oneself of it, because the scaffolding he will make will leave room underneath for everything.'

Leonardo, like Michelangelo, was skilled at

inventing scaffolding to meet particular needs. Two days later, the official noted that 'the *camera grande* is evacuated, and in the small room time is not to be lost'. Some idea of how Leonardo priced such work is provided by estimates in one of his manuscripts for decorations that involved '24 Roman stories', '4 philosophers', various pilasters in blue and gold, vaults, and windows. The 'stories' were very modestly priced at '14 *lire* for one', and were probably small pieces within a decorative framework, while the blue and gold materials were to cost '3½ *lire*'. They were probably to be farmed out to his assistants.

A tone of impatience is constant where Leonardo was concerned. The erratic pattern of work reported by Matteo Bandello, the writer of *novelle*, is unlikely to have elicited much sympathy from patrons. Matteo tells us that days of intense work on the *Last Supper* were punctuated by '2, 3 or 4 days, without touching it; and yet he always stayed there, sometimes for 1 or 2 hours, and he only contemplated, considered and criticized, as he debated with himself, the figures he had made'. This is to say nothing of days when he was distracted by other matters, scientific and technical.

There is also a record of what may be an even more serious problem than slowness. On 8 June 1496,

a secretary writes on Ludovico's behalf to the Archbishop of Milan, informing him that 'the painter who was painting our *camerino* today has made a certain scandal, on account of which he has absented himself'. The Archbishop is asked to use his good offices to enquire if Perugino, a fellow pupil of Verrocchio, might be available to travel from Florence. There is no definite evidence to identify Leonardo as the perpetrator of the 'scandal', but the painter was clearly of some status if the renowned Perugino was to be sought as a replacement. In the event, Perugino's services were not obtained.

Evidence in Leonardo's notebooks confirms that he communicated with his patron through written petitions where business arrangements were concerned, and that matters did not always flow smoothly. Most revealing is a draft of an appeal to Ludovico which survives in fragmentary form on a torn sheet:

> My Lord, knowing your Excellency's mind to be occupied . . .
> to remind your Lordship of my small matters and I should have maintained silence . . .
> that my silence should have been the cause of making your Lordship angry . . .
> my life in your service. I hold myself ever in readiness to obey . . .

of the horse [the bronze equestrian memorial to the Duke's father] I shall say nothing because I know the times . . .

to your Lordship how I was still two years salary in arrears from . . .

with two masters who were continuously maintained at my expense . . .

that in the end I found myself fifteen *lire* out of pocket over the said work . . .

works of renown by which I could show those to come that I have been . . .

does for everything. But I do not know where I could expend my labours . . .

my having expected to earn my living . . .

through not being informed as to what condition I find myself in . . .

remember the commission to paint the small rooms . . .

I brought to your Lordship, only requesting from you . . .

Another draft, less fragmentary but still incomplete, tells the same story:

I very much regret that the need to earn my living has forced me to break off from pursuing the work which Your Lordship has entrusted to me. But I hope in a short time to have earned enough to be able with renewed heart to satisfy Your Excellency, to whom I commend myself. If your Lordship believed that I had money, then Your Lordship was deceived, because I have had six mouths to

feed for 36 months, and have had 50 ducats. . . . Perhaps Your Excellency did not entrust anything further to messer Gualtieri, thinking that I had enough money . . .

Gualtieri Bascapè was the member of the Ludovico administrative team who had been entrusted with overseeing the decorations in the castle.

Although the drafts fall short of telling us everything we would like to know, they are both informative and unsurprising. Payments at court were often unreliable, particularly when, as towards the beleaguered end of Ludovico's reign, external threats were diverting court finances into armaments and defence. The written mode of communication with the Duke, when dealings with officials were proving unsatisfactory, is standard. It is worth noting that even Michelangelo was unable to get past papal officials in 1506 to discuss the Pope's tomb directly with Julius II, a snub that precipitated the sculptor's flight to Bologna, and his subsequent disciplining. The whining tone of Leonardo's appeal, with ritual declarations of financial hardship, is also familiar from other artists' correspondence. Although we now regard great artists as the cultural gods of the period, even those who were most highly regarded were functionaries who worked to order and were not generally high in the pecking

order of either courts or republics. Leonardo, in France at the end of his life, Raphael in Rome after 1515, and Michelangelo in middle and old age were exceptional in achieving a status beyond that accorded to most leading practitioners of their calling.

Leonardo's famous initial 'letter of recommendation' to Ludovico makes sense in the context of written communication with rulers. Leonardo's promise to demonstrate items from his extensive inventory of weapons and military devices 'in your park or whatsoever place shall please Your Excellency' implies that he is already in Milan and knows that the park adjoining the castle was the place for such demonstrations. If the letter was written after his arrival in Milan (probably in 1482), this does not indicate that he had yet to enter il Moro's service, on either a regular or a less formal basis, since we have seen that he was still communicating important matters by letter when he was undoubtedly a formal employee of the ducal court. We may reasonably assume that it dates from early in their relationship, but the precise timing and circumstances of Leonardo entering the Duke's service on a salaried basis cannot be deduced from any of the available evidence.

Cash Flow

His fragmentary petitions from the late 1490s suggest that Leonardo was due to receive a regular stipend from the Duke, as he had presumably done in the past. Direct payment was not the only kind of reward an artist might receive. He had already received kindling and logs in return for the painting of a clock at S. Donato. Payments in commodities, in whole or in part, was not uncommon. Rulers sometimes found it convenient to reward their 'familiars' with properties or income-bearing sinecures, which circumvented problems of lack of liquidity in court finances. Ludovico gave Leonardo a property just outside the walls of Milan, the income of which came from its vineyard. It is described as his *giardino* in his will of April 1519:

> The ... Testator gives and bequeaths in perpetuity to Battista de Vilanis, his servant, the half, that is, the moiety of the garden which he has outside the city of Milan, and the other half of his garden he gives to Salaì, his servant, in which garden the aforesaid Salaì has built and constructed a house, which shall be and shall remain similarly in perpetuity the property of the said Salaì, and of his heirs and successors, and this is in remuneration of the good and kind services which the said de Vilanis and Salaì, his servants, have done to this time.

It is clear that artists welcomed gifts of income-generating property, and invested in such properties when they were financially able. Not least, the holdings possessed heritable value. Leonardo's will also records his possession of a smallholding in Fiesole, which he had inherited and which his legitimate brothers had unsuccessfully claimed as their due.

We further learn from the will that Leonardo had received another income-generating gift, this time from the French king, Louis XII, whom he served in Milan between 1507 and 1512. 'M. Leonardo da Vinci has given and bequeathed . . . to the said M. Baptista de Vilanis . . . the rights that King Louis XII of pious memory lately deceased has elsewhere given to the same da Vinci of the water in the canal of S. Cristoforo in the Duchy of Milan for his enjoyment.'

The gift was a water concession, which granted Leonardo the right to draw off a measured amount of water, presumably for resale to others, most notably farmers. We know from a draft letter to Charles d'Amboise, governor of Milan, on behalf of the French king that he had to insist that the promise of the water concession was made good:

I should dearly like to know where upon my return to you [from Florence] I might have lodgings. . . . Also whether,

having worked for the most Christian King, my salary is to continue or not. I am writing to the President concerning that portion of water that was granted to me by the King and of which I was not put in possession because at the time the level was low in the canal by reason of the great droughts and because its sluice gates were not regulated. . . . I therefore beseech Your Lordship . . . to remind the President of my suit, that is, to give me possession of this water, for on my arrival I hope to set up my mechanical devices and things which will most greatly please Our Most Christian King.

Faced with the difficulty of obtaining his concession, Leonardo characteristically busied himself with the inventing of new devices for the regulation and measurement of the water.

The best records of Leonardo's level of regular salary in Milan come from when he was serving King Louis, as 'our dear and good friend Leonardo da Vinci, our painter and engineer in ordinary'. We need to take such effusive wording with a pinch of salt, since court 'familiars' were characteristically described in such terms.

When we look at the sums Leonardo received, it is difficult to arrive at clear modern equivalents, but we can bear in mind that 150 gold florins in Florence (or 150 of the corresponding gold coins elsewhere,

such as Milanese ducats), provided a comfortable annual income, equivalent to that of a senior civil servant or employee in the upper echelons of government service. Leonardo himself writes a 'record of the money I have had from the King of my salary from July 1508 until August next, 1509: first of all 100 *scudi*, followed by another 100, then 70, then 50, then 20, then 200 francs at 48 *soldi* to the franc [= approximately 80 *scudi*]'. The total is 420 *scudi* for nine months, or the equivalent of an annual income of 560 *scudi* a year. It is therefore clear that Leonardo was handsomely rewarded by the French in Milan. Later, when he entered the service of Francis I, he was awarded the grand sum of 2,000 *écus d'or* for 2 years 'pension'. Francesco Melzi, 'Italian gentleman' and Leonardo's amanuensis, was to receive 800, while Salaì as *serviteur* was accorded the far from trivial amount of 100. Francis installed Leonardo in the manor house of Cloux (Clos Lucé) near the royal chateau of Amboise, a house of which a member of the nobility would not have felt ashamed.

We have at least some indication that Leonardo deposited some of his income in bank accounts. On 14 December 1500 the substantial sum of 600 florins was transferred from Milan into his Florentine account at the Ospedale di Sta Maria Nuova. He also

notes on one occasion that he had withdrawn 50 ducats from an account that was now worth 450. Of the 50, 'I gave 5 the same day to Salaì, who had lent them to me'. The rascally boy became a man of some financial substance, and at his death in 1524 was owed money by some prominent Milanese citizens. How he came by his money is unclear. Leonardo himself lent money. A memorandum tells 'how on 8 April, I, Leonardo da Vinci, sent to Vante [Attavante?] the miniaturist 4 ducats in gold coins. Salaì carried them and gave them to him with his own hand: he has said he will give them back within the space of 40 days.' In his will Leonardo left to his half-brothers in Florence 400 *scudi* held at an interest rate of 5 per cent for almost six years in Sta Maria Nuova in the form of what we would call certificated bonds. The bank holdings do not suggest that Leonardo became wealthy— Michelangelo, by comparison, was able to bank 2,000 ducats after he had completed the Sistine ceiling— but he seems to have lived very comfortably for much of his life.

Courting Favour in War and Peace

The patrons who paid Leonardo's salary obviously expected something tangible in return. It seems

obvious to say that he was expected to produce paintings and other visual works. But matters were a good deal more complicated, not only because his production of paintings was far from expeditious but also because the duties he was requested to undertake were varied and often difficult to forecast.

The only official record of his appointment in Ludovico's court, which is undated, lists him amongst the four main ducal engineers as 'Leonardo da Vinci engineer and painter'. The great Donato Bramante heads the list. The most concrete record of Leonardo's activities as an engineer, primarily in a military capacity, is the letter of authority issued by Cesare Borgia on 18 August 1502. Leonardo had entered the service of Cesare, who was attempting to subjugate the territories in central Italy over which the Pope, his 'uncle', claimed dominion. The letter declares:

> We herewith charge and command them everywhere and in every place to give free entrance to our highly esteemed court architect Leonardo da Vinci, the bearer of this, who has been commissioned by us to inspect the fortresses and strongholds of our states, and to make such alterations and improvements as he may think needful. Both he and his entourage are to be received with hospitality, and every facility offered to him for personal inspection, for measurement and evaluation, just as he

may wish. For that purpose a band of men is to be placed at his disposal, which is to give him all the help that he might require. With reference to the state works already in course of completion, we desire that every engineer be prepared to further any undertaking that he may find necessary.

We could describe Leonardo as an executive consultant to Cesare on all matters relating to fortification. Some idea of the kind of 'personal inspection, measurement and evaluation' he was expected to conduct can be gained from the *Map of Imola* (**Plate** 3), produced on the basis of earlier maps and from direct measurements taken by Leonardo and his team. They paced out distances in the streets and he coordinated the results with a radial survey from a central vantage point. Immediately after serving Cesare, Leonardo was dispatched by the Florentines in a similar capacity to the coastal town and fortress of Piombino, where he devised ways of shaving the crests of hillocks to improve fire lines and planned tunnels for rapid and safe movement underground, schemes that are documented in his drawings and notes. The use of Leonardo as a visiting adviser was not new. While working in Milan in 1498 he had made notes on a ruined quay in the harbour at Genoa, presumably because his opinions had been sought.

His many sheets of studies for military devices testify to the intensity with which he engaged with the science of war, but we need to recognize that a good number of the surviving drawings are what might be called 'treatise engineering'—that is to say, intended to provide ideal demonstrations of his ideas for patrons rather than acting as working drawings in response to actual tasks. This point is, I believe, true for his drawings of both military and civil devices (**Fig. 17**), and can be applied with equal validity to his architectural projects. The nature of the surviving drawings does not, of course, prove that he undertook few practical tasks for his employers. It simply means that we have to recognize that the drawn record does not relate to practical operations in a straightforward manner. It is difficult to know what Leonardo actually accomplished in architecture and engineering in the civil and military spheres. The dominant impression is that he was active and effective as a consultant and sometimes as director of operations, particularly with respect to larger-scale projects, military and civil, advising others on how they might go about things. He seems to have built little or nothing as an architect on his own account—that is to say, devising a building and taking charge of all the processes leading to its completion. Later we will see evidence of his taking

technicians into his workshop to make specific devices of a utilitarian kind.

In the more obvious spheres of painting and sculpture for the courts his activities are apparent if frustratingly sparse. It is surprising that there is no record of his having portrayed Ludovico or his wife Beatrice d'Este, though he completed much-admired portraits of two of the Duke's mistresses, Cecilia Gallerani and Lucrezia Crivelli, both of which were celebrated by court poets. His relationships with the poets and with musicians involved both competition and collaboration. The competition can often be sensed behind his *paragone* (comparison) of painting with the other courtly arts. He consistently denigrated the products of his literary and musical rivals, none of whom could rival the arts of the eye. The collaboration involved various kinds of court spectaculars. The 1490s saw a series of grand *feste* (festivals or celebratory spectacles) involving Leonardo's inventive skills.

The *feste* include the set designed for Bernardo Bellincioni's *Paradiso* in 1490, in the form of a vision of the mobile heavens complete with luminous stars, to celebrate the wedding of Gian Galeazzo Sforza, the nominal Duke of Milan, to Isabella of Aragon. Bellincioni, the poet, was another of the Duke Ludovico's artistic recruits from Tuscany. A year later

Leonardo was involved with the staging of double celebrations for the weddings of Ludovico to Beatrice and Anna Sforza to Ludovico d'Este. In 1496 he designed performances of Baldassare Taccone's *Danäe* and of Bellincioni's *Timone*, including one produced in Pavia for Isabella d'Este, Marchioness of Mantua. His notebooks provide occasional glimpses of the kinds of designs he provided for such court spectacles, including rotating stages and very complex allegories of his patron's virtues. We also possess one nice memorandum that gives an insight into the kind of things that actually happened:

> On 26 January [1491] . . . I was in the house of Messer Galeazzo da Sanseverino [Ludovico's son-in-law and military commander] to organize the festivities for the tournament, and, while some footmen were undressing to try on some costumes of savages that were called for in the performance, Giacomo [Salai] went up to the purse of one of them, which was on the bed along with some other clothes, and removed as much money as he found inside it.

The sum of 2 *lire* 4 *soldi* was added to the debit side of Salai's youthful account.

Such ephemeral activities were time consuming, and there are signs of Leonardo's impatience that they

prevented him from achieving the enduring master-
pieces that would bring him lasting fame. But his
mastery of theatrical genres did help persuade patrons
that Leonardo was worth keeping on board.

Leonardo would have seen himself as gaining his
most enduring renown from the design and casting of
the massive bronze equestrian memorial that Ludovico
was planning in honour of Francesco Sforza, his
father and the founder of the dynasty. Ludovico had
already explored the possibility of importing a
Florentine sculptor to take on the project, but, when
Leonardo arrived, bringing experience of large-scale
casting from Verrocchio's workshop, the right man
seemed to be to hand. We learn in a letter of 1489
from the Florentine ambassador in Milan that
Leonardo was engaged on the project, but also that
Ludovico was soliciting the help of Lorenzo il
Magnifico in finding 'a master or two capable of
doing such work'. The most favourable interpre-
tation is that technical help is being sought; the least
favourable is that Leonardo was to lose the commis-
sion. In any event, on 23 April 1490 Leonardo notes
that he had himself resumed work on the horse.
He subsequently built a huge clay model and under-
took intensive studies of ways that the colossus
might be cast. The intended dimensions as recorded

by Luca Pacioli, his mathematician colleague in Milan, indicated that it was to measure almost 24 feet from the nape of the neck to the ground. Not only would it have surpassed the famed bronze equestrian monuments by Donatello and Verrocchio, but it would have overtly rivalled any of the wonders of the ancient world. The vast and expensive quantity of bronze was set aside, but, when the French king Charles VIII invaded Italy, Ludovico sent it to Ercole d'Este in Ferrara to make into cannon. The French were not good news for Leonardo's horse. Five years later, the clay model was to serve fatally as a target for Gascon bowmen who accompanied the invading Louis XII, successor to Charles as French king.

The court did not necessarily assume a monopoly of his services. We have already seen his complaint that the non-payment of his stipend had resulted in his taking outside work, and he seems to have made bids for commissions that were not under Ludovico's direct purview, including the crossing dome of the cathedral in Milan, for which he made a model, and the project for bronze doors at Piacenza cathedral. The latter quest resulted in a spirited draft petition to the building commissioners disparaging those who were jostling for the job:

one is a potter, another an armourer, another a bell-ringer, one is a maker of bells for harnesses, and there is a bombarbier [artillery specialist]. Also among them is one of the Duke's household, who boasts among other things that he is a familiar of messer Ambrogio Ferere, who is a man of some influence. . . . He would go on horseback to the Duke and entreat from him such letters that you would never be able to refuse him work of this calibre. . . . There is no capable man, and you may believe me, except Leonardo the Florentine, who has no need to promote himself, because he has work for his life time, and I doubt that, being so much work, he will ever finish it.

Nothing seems to have come of Leonardo's efforts at oblique self-promotion.

A court position offered real advantages for someone of Leonardo's proclivities, but it also placed him in a world of incestuous intrigue, social manœuvring, and bureaucratic officialdom. It also offers, for the historian, a source of frustration, since the surviving visual record of his extensive work on courtly spectacles is very thin, as it is for all such work at this time.

The Painter's Household and Workshop

Salaì, the thief of the Galeazzo pageant, elicited a succession of exasperated memoranda from Leonardo. 'Thief, liar, obstinate, glutton', one of them runs. But he remained with Leonardo until his master's death. In the will he is termed a *servitore*, but he seems to have been active as a painter, attempting to peddle his own services to Isabella d'Este. Together with the young Lombard nobleman, Giovanni Francesco Melzi, he seems to have become essential to the public operation of Leonardo's workshop. When Salaì's life was cut short by an arrow in 1524, the resulting inventory in 1525 of his possessions not only records far from modest possessions and moneys owed to him by some leading citizens, but also, as we have noted, lists the small group of paintings that stood at the centre of his master's achievements. We can only speculate about the means of Salaì's rise to substance, but we may guess he was what would now be called a sharp operator, with an eye for the main chance. There is some evidence to suggest that he became an international dealer in works of art, before such a profession really existed. Melzi, who also seems to have undertaken a modest number of paintings, was a very different character. He was the best educated

and cultivated member of the household, and was entrusted with the master's literary and drawn legacy after Leonardo's death.

From his time in Milan, Leonardo maintained a household of domestic staff, some of whom are known by name—Battista de Villanis, Luca, Maturina, and Caterina—and he was accompanied by an inner group of pupils, assistants, and workers, of whom Salaì and Melzi are the most conspicuous and constant. Other collaborators or associates came and went on various regular and irregular bases. We know that a certain Marco (probably Marco d'Oggiono) was working on Leonardo's premises in 1490, from a record that also tells how Salaì had characteristically stolen a silverpoint drawing 'pencil' from Boltraffio's room. Boltraffio was a gentleman painter who worked closely on polished paintings compiled from Leonardo's motifs and compositions, including the *Madonna Litta* in St Petersburg. Leonardo's notebooks contain fragmentary records of other workers about whom we know little or nothing. However, these accounts do give an important sense of the kinds of business Leonardo was conducting and indicate clearly that at least some of his designs were realized by technicians in his employ.

This documentation stands in marked contradiction to the popular perception of Leonardo as

perpetually unproductive. In 1493 Leonardo records that a certain 'Maestro Tommaso came back and worked on his own account'. Giulio Tedesco (presumably a German technician) had four months' pay, while nine months' pay was recorded for Tommaso, who 'made 6 candlesticks which took 10 days'. 'Giulio made some tongs', which occupied fifteen days. Giulio is also recorded as working 'on his own account', as well as 'making a wooden jack for me . . . and again for me on 2 locks'. A much later memorandum, written after 1513 when he was working in Rome, reminds himself to 'have the German make the lathe for ovals'. We know that this particular device was indeed made, since Lomazzo, the Milanese art theorist of the later sixteenth century, knew it and testified to its renown.

We also have accounts of payments of rent and apprenticeship fees to Leonardo. An otherwise unknown pupil called 'Galeazzo came to live with me', and was to pay 5 *lire* a month. Galeazzo's father gave the master 2 Rhenish florins, which suggests that 'Galeazzo' was a northerner. Jacopo Tedesco, another German, was accommodated at one *carlino* a day. When Leonardo was later working at the Vatican in Rome in the premises assigned to him by Giuliano de' Medici in the Belvedere, he housed a German

toolmaker who gave him nothing but trouble—working erratically, furthering only his own interests, going on shooting trips in the ruins with Swiss Guards, refusing to learn Italian, and obstructing Leonardo at every turn. Leonardo wrote to Giuliano, also known as il Magnifico, asking for the troublesome German to be put on a piecework rate rather than a regular salary—a precious record of Leonardo as a kind of business manager.

Such fragments paint at least part of the picture of a small household of loyal companions and a busy *bottega*, peopled by apprentices, assistants, and contracted workers who were engaged on a variety of technical and artistic tasks. This is very different from the standard picture of Leonardo as an unprofessional dreamer. The visual evidence in the field of painting suggests something of the kinds of collaborative activity that occurred in the workshop. A drawing of the *Madonna and Child* by Boltraffio is compiled precisely from separate drawings by the master of the heads of the Virgin and Child for the *Virgin of the Rocks*, perhaps directly from their cartoons. One of the versions of the *Virgin of the Rocks* was itself copied in 1508, when Ambrogio da Predis obtained permission on Leonardo's behalf to remove the panel from its altar in S. Francesco Grande for this purpose.

A highly informative letter of 3 April 1501 from Fra Pietro da Novellara in Florence to Isabella d'Este in Mantua contains an eyewitness account of studio participation. The head of the Florentine Carmelites reports that 'two of his apprentices are making copies, and he puts his hand to one of them from time to time. He is hard at work on geometry and has no time for the brush.' One of the pictures on which Fra Pietro reported, in a second letter of 14 April, concerned the commission for the *Madonna of the Yarn-winder* for Florimond de Robertet, who had accompanied Louis XII when the French invaded Milan in 1499. The subject of many copies and variants, this composition is best known in two prime versions, one of which, the 'Lansdowne Madonna' (**Plate 4**), is in an anonymous private collection, while the other (now stolen) was in the collection of the Duke of Buccleuch in Scotland. Infra-red examination of the two pictures has surprisingly revealed that the underdrawings of both originally included a group on the left of Joseph making a baby-walker for Christ—a motif known from other versions of lesser quality—and disclosed a series of other adjustments. This suggests very strongly that the two little pictures developed along-side each other in the studio, and involved much more than the limited participation that Fra Pietro records.

In such circumstances, the search for a lost 'original' is misplaced, since such small devotional works may well have been specifically designed to be produced in more than one version. They were of a quality to be viewed as 'Leonardos', but not necessarily what we would anachronistically call 'wholly autograph'. We know that 'off-the-peg' or speculatively produced pictures could be offered to patrons of the highest status, as Leonardo wrote in 1508 from Florence to Charles d'Amboise in Milan, 'I am sending Salaì to you to explain to your Lordship that I am almost at an end of my litigation with my brothers, and that I expect to find myself with you this Easter, and bring 2 pictures of . . . Our lady of different sizes . . . for our most Christian King or for whomsoever your Lordship pleases.'

This may well explain the making of two parallel versions of the small-scale *Madonna of the Yarnwinder*. The *Madonna, Child, St Anne, and a Lamb* in the Louvre is an example of a Madonna in a larger format, but we know that this particular version never left Leonardo's hands and was amongst the select group of Leonardo's paintings apparently owned by Salaì.

It looks increasingly as if the small-scale paintings of devotional subjects produced with appropriate

studio participation comprised the regular output of 'Leonardos'—in as much as there was any 'regular' production at all. However, it is clear that he did not sustain himself and his household primarily through the delivery of paintings. In this context, his general courtly duties as impresario of visual events, as consulting engineer and architect, and as a producer of utilitarian and decorative items become very important. Eventually, in his last years he seems to have been supported by Francis I at Amboise as an ornament of the court, as a kind of seer or *magus*, as a purveyor of ideas and knowledge, and as a wonder to be paraded before prestigious visitors, rather than as a productive worker of a more menial kind.

In Person

The impression that emerges from the early records is of a gracious and attractive person who retained for all but a few close companions the air of remoteness that accompanies a closely guarded inner self. There are clear signs in his disparagement of the messy business of carving that he tried to maintain a fastidious appearance, and his accounts of bodily functions, including sexual activity, hint at a barely suppressed distaste for the messier aspects of how our bodies

operate. According to an anonymous early source, called the Anonimo Gaddiano, his appearance was striking. 'He was of a fine person, well proportioned, full of grace and of a beautiful aspect. He wore a rose coloured tunic, short to the knee, although long garments were then in fashion. He had, reaching down to the middle of his breast, a fine beard, curled and well kept.'

This is the Leonardo we encounter in the profile drawing at Windsor, of very high quality and probably by Francesco Melzi (**Plate 1**). The bone structure in the portrait exhibits a fineness in sharp contrast to the lumpier features of the image in Turin, which is generally but incorrectly taken to be a self-portrait. Members of his entourage appear to have been encouraged to maintain high sartorial standards, as reflected in his notes recording purchases of fine clothes for them.

It is difficult to imagine Leonardo neglecting his person in the way that Michelangelo appears to have done when painting the Sistine ceiling. He does not seem to have shared Michelangelo's reclusive habits. I suspect that he was an ever-enquiring presence and lively discussant with the kinds of people he lists as sources of information. He is reputed to have played the *lira da braccia* (a relative of the violin) with skill,

and some of his jests and fables may have been presented in verbal displays at court. We know that he took part in at least one set piece debate on the arts at the Sforza court. He clearly cut an impressive and cultivated figure.

Given the obvious frustrations that Leonardo caused many of his patrons, it is nice to find moving confirmations of what Leonardo had to offer as a man. The two most effective records of the impact he made both date from the last years of his life.

When the sculptor Benvenuto Cellini was in France he reported that:

> King Francis, being enamoured to such an extraordinary degree of Leonardo's great talents, took such pleasure in hearing him talk that he would only on a few days deprive himself of his company. . . . I cannot resist repeating the words I heard the King say about him, in the presence of the Cardinal of Lorraine and the King of Navarre; he said that he did not believe that a man had ever been born who knew as much as Leonardo, not only in the spheres of painting, sculpture, and architecture, but in that he was a very great philosopher.

An 'inside' account comes from Francesco Melzi's moving letter to Leonardo's half-brothers on his master's death in 1519:

To the honourable Ser Giuliano and his brothers.

I understand that you have been informed of the death of Master Leonardo, your brother, who was like an excellent father to me. It is impossible to express the grief I feel at his death, and as long as my limbs sustain me I will feel perpetual unhappiness, which is justified by the consuming and passionate love he bore daily towards me. Everyone is grieved by the loss of such a man whose like Nature no longer has it in her power to produce. And now Almighty God grants him eternal rest.

LOOKING

THE PICTURE PAINTED in the first chapter is focused on the material circumstances of Leonardo's career, designed not least as a sober counterweight to the accumulation of legend. It is a career that is not so very different in its circumstances and in its range of activities from that of other leading artist-architect-engineers in the Renaissance— even if his production of identifiable works does not seem to have rivalled that of his peers. The documentary records barely hint at the great intellectual and visual edifice he erected in his private notebooks and papers. The extent of his manuscript legacy became progressively obscured during the sixteenth century and began to be fully apparent only from the 1880s onwards. Francesco Melzi treasured the piles of

bound and unbound papers he inherited, proudly showing them to visitors, and edited some of the disorderly writings on painting into what is known as the *Trattato dell'arte*. After his death, his pious stewardship was ill rewarded by the piecemeal dispersal of the notebooks and drawings. They suffered various fates, with probably more than four-fifths of them disappearing without trace. Those that remain today have passed through various collections across Europe, for long valued more as curious and barely legible memorials of a legend than for their real content.

Following major campaigns of publication and translation from the 1880s onwards, Leonardo's manuscripts have become increasingly familiar in the scholarly and public domains, to such an extent that we have come to take them for granted—as just the kind of thing he did. But they are utterly exceptional. Not one of his predecessors or contemporaries produced anything comparable in range, speculative brilliance, and visual intensity. And we know of nothing really comparable over succeeding centuries. Many of his 'drawings' are accompanied by words, just as his lengthy written texts are rarely unillustrated. He wrote in an effectively idiosyncratic manner, but the intelligence behind the texts is dominantly visual in nature. He was a supreme visualizer, a master manipulator of

mental 'sculpture', and almost everything he wrote was ultimately based on acts of observation and cerebral picturing. It is symptomatic of his visual imagination that he could undertake three-dimensional geometry through a form of spatial and sculptural modelling in his mind. On the other hand, his arithmetic was erratic verging on poor and he had no grasp of the symbolic language of algebra. If he could not 'see' it, he could not do it—or, rather, did not consider it worth doing.

He had no taste for the abstractions of pure philosophy, which he scathingly characterized as a kind of pseudo-knowledge 'that begins and ends in the mind'. He showed little patience with theology and religious dogma or with mystical bodies of knowledge such as astrology. He accepted that there was a supreme, ineffable power behind the design of nature, identifiable as God, but he was convinced that concrete knowledge could not reveal the nature of divinity itself. Rather, the role of human understanding was devoted to the revelations of the glories of natural design, which spoke more eloquently of divine creation than any theological book could speak of God himself. No knowledge was valid if it could not be derived from 'experience'. He placed great value on experiment—though not in the systematic manner

of modern 'experimental science'. He was as happy with 'proofs' derived from observation of phenomena in their natural state, and with the results of thought experiments, as he was with controlled tests conducted using specifically designed set-ups. Sometimes, when he had actually conducted a staged test, he wrote 'sperimentata' beside the relelvant drawing—indicating that the observed results were conclusive.

There is something very literal and apparently constraining in his insistent limiting of himself to the tangible facts of the physical universe as perceived through the senses. Yet such was the fertility of his imagination—what he called *fantasia*—that this ground-based enterprise took flight in a way that few creative artists and thinkers have ever emulated.

My way of entering the great legacy of manuscripts is to devote this chapter to the principles that underlie his thought—what he called *ragioni* (reasons or causes). This will necessarily involve a degree of abstraction. These principles will find realization in the chapters subsequently devoted to the concrete endeavours of his engineering, anatomy, geology, and art.

Common Sense, Imagination, and Intellect

The only fully valid source of knowledge, for Leonardo, was looking at real things and phenomena. And no one ever looked at them more intensively and represented them with more originality. Yet he did not rely at all upon simple seeing, as if the eye is a photographic apparatus. Leonardo's notion of what it is 'to see' embraced the double sense of the verb (in both Italian and English)—that is to say, 'to look at' and 'to understand'. The latter use applies, for instance, in the statement, 'I can see the logic of what you are saying'. Leonardo's particular goal of seeing as understanding could be realized only through the analysis of vision itself and, more broadly, of the workings of the mind. The eye was the instrument of the greatest of the five senses—a traditional view that had been influentially advocated by both Plato and Aristotle. Sound, touch, taste, and smell ranked far below sight. The eye was the analytical master of all visual pursuits:

> The eye, which is said to be the window of the soul, is the primary means by which the *sensus communis* [the co-ordinating centre for sensory impressions] of the brain may most fully and magnificently contemplate the infinite works of nature, and the ear is the second, acquiring nobility through the recounting of that which the eye

has seen . . . Now, do you not see that the eye embraces the beauty of the world? The eye is commander of astronomy; it makes cosmography; it guides and rectifies all the human arts; it conducts man to various regions of the world; it is the prince of mathematics; its sciences are most certain; it has measured the height and size of the stars; it has disclosed the elements and their distributions; its has made predictions of future events by means of the course of the stars; it has generated architecture, perspective, and divine painting. Oh excellent above all other things created by God . . . And it triumphs over nature, in that the constituent parts of nature are finite, but the works that the eye commands of the hands are infinite, as is demonstrated by the painter in his rendering of numberless forms of animals, grasses, trees, and places.

An essential ingredient in his view of seeing as analysis and of representation as infinitely varied was the legacy of his training in the Florentine artistic tradition. In the wake of Filippo Brunelleschi's devising of the system of linear perspective in the early fifteenth century, Florentine art had been based on the principle that the painter used rules extracted from the 'roots in nature' to invent new scenes according to orderly and rational principles. The phrase 'roots in nature' comes from the seminal little book *On Painting* by the author and architect, Leona Battista Alberti, written in Latin in 1435 and translated into

Italian one year later, with a dedication to Brunel-leschi. The first of the three parts of Alberti's treatise explains how to use geometrical perspective to construct an *a priori* space that could then be filled with precisely scaled objects and figures, all portrayed systematically according to the rules of light and shade. The figures, the chief means for the telling of great stories, should be depicted with a mastery of anatomy and of the visible signs of character and the emotions. This method of allying rational procedures with the imaginative devising of a new scene placed *invenzione* in intimate union with *scienza*. *Invenzione* was defined as the creation of something new that was true or plausible (to paraphrase the great Roman orator Cicero), while *scienza* was a body of knowledge based on rational and verifiable principles. At a deeper level, it represented the alliance of *fantasia* (imagination) with *intelletto* (the rational power of the mind). In all this it is important to bear in mind that the terms used by Leonardo in his original Italian often carry different connotations than they do today. I retain his orginal term when it seems vital to denote this difference.

Leonardo's studies of the brain and its sensory system concentrated from the first on how these mental attributes might be located and how they could

be nourished by the all-important senses. His earliest surviving set of sustained anatomical explorations, dating from 1489, were devoted to the skull and its contents. Within the cranium, represented both whole and sectioned in a series of wonderfully meticulous drawings (**Fig. 1**), he speculatively located the various mental faculties in a way that corresponded to how he believed them to operate. The basis for his arrangement was the medieval system of faculty psychology, which viewed the ventricles (cavities) within the brain as the sites of mental activity—not unreasonably given that our 'grey matter' looks very unpromising to the naked eye. Thus he depicted the ventricles as a series of receptacles (**Fig. 2**) arranged in terms of processing. The first move was that the sensory impressions arrive in the *imprensiva* (a receptor, which we may imagine registers an impression like warm wax receiving the indent of a seal). The *imprensiva* seems to have been Leonardo's own addition to the old system, and performed the registration function that was previously assigned to the *sensus communis*, where the data from the five senses came together to be systematically co-ordinated. The 'common sense' in Leonardo's arrangement was relocated in the second chamber, where it performed its function of measured comparison, together with *fantasia*, *intelletto*, and *volontà*

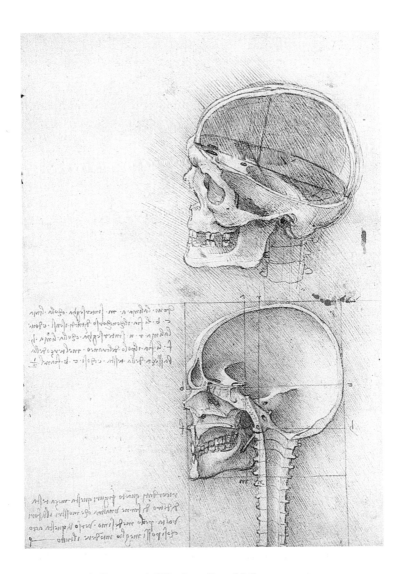

1. *Human Skull, sectioned,* Windsor, Royal Library, 19057

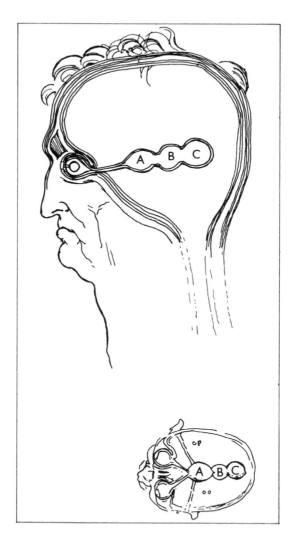

2. Based on Leonardo, *The Human Brain and Eyes, Sectioned Vertically and Horizontally*, Windsor, Royal Library, 112603

(voluntary motion). The soul, about which Leonardo was not otherwise much concerned, also stood in this central place. Finally, *memoria* resides in the 'flask' at the end of the sequence. Even when he later injected wax into the ventricles of an ox brain and realized that the three-vessel arrangement was much too simple, he continued to adhere to the basic tenets of medieval faculty psychology.

The advantage of the system for Leonardo was that it provided physiological confirmation of the routing of information from nature into the brain, with the optic nerves placed in the privileged position of communicating in the shortest and most direct way with the rational and imaginative faculties. It also provided a mechanism through which the data that had been extracted in the intellect from the senses could be recombined in the *fantasia* and sent out in the other direction. What is 'first in the imagination' is then 'in the hands'. The *volontà* is able to translate mental inventions into tangible form, initially in drawings and subsequently in paintings, sculpture, and buildings— and in sundry mechanical devices. The whole system operated with the ebb and flow of 'animal spirits' along the central core, or *medulla*, of the nerves, involving a dynamic interchange of sensory input and muscular output. When the disciples in the *Last Supper* start with

consternation at Christ's announcement of his impending betrayal by one of their number, the input of words and output of action could not be more dramatically realized.

The Eye

What of the 'window of the soul' itself? How was this most excellent of nature's inventions designed to perform its divine function?

Throughout his changing views of the internal structure of the eye, Leonardo worked on the non-negotiable principle that it must be an instrument constructed with a geometrical precision in keeping with the optical geometry of light itself. In a way, the simpler the better. His earliest concept of the eye's optical engineering was that the spherical crystalline or vitreous humour (the lens in our terminology) rested concentrically within the aqueous humour and the containing coats of the eye. Through its pupil, which controlled the angle of vision, it received the 'visual pyramid'—that is to say, the bundle of rays from an object or surface that converged on a point. This was the view that Alberti had maintained. The eye was designed to extract the pyramid from the welter of rays that sped from the object to every part

of the air. The further the same object was from the eye, the narrower the angle that its pyramid subtended in the eye, and the smaller it would appear to be (**Fig. 3**). If we consider light to be emanating from an object in the manner of a series of concentric ripples, the pyramid would become progressively narrower at each successive ripple away from the object. The difference in size, as painters' perspective taught him, would be proportional to its distance from the eye. He also explained that the power of the emanations from the object—he called them 'species', in line with the medieval tradition of optical science—diminished proportionately the further they are detached from the object. This optical theory accounts not only for the systematic diminution of things according to the rules of linear perspective but also for the loss of distinctness and colour of things at greatest distances. Together with the veiling qualities of moist air, the loss of definition and colour lies behind the magical effects of 'aerial perspective' in his drawn and painted landscapes (**Plate 5**).

From this view of the eye and its pyramid, to which Leonardo adhered in the 1490s, he progressed around 1508 to a more complex and nuanced inter-pretation of the eye's form and function. Not least, he became convinced that the pyramid could not literally

3. Based on Leonardo, *Radiant Pyramids emanating from a circular object*,
Paris, Institut de France, Ms Ashburham II, 6v

terminate in a point in the eye, since the point technically has no dimension and could result only in the loss of the separation between 'species' in the optical array. He thus resorted to the notion of a receptive surface (variously located and not to be confused with our idea of the retina). He considered that the eye and its pupil operated like a camera obscura (a darkened chamber with a pinhole, like the earliest photographic cameras). He knew that the image in a camera was formed upside down, and he speculatively devised a series of optical procedures designed to reinvert the image (**Fig. 4**). The more complex passage of the rays within the eye, in part based upon medieval texts of optics, explained such phenomena as the failure of a thin object to conceal more distant forms as it moves closer to the eye and our ability to see through a cloth with an open weave.

His increasing knowledge of the very impressive medieval writings on optical science, in the succession of Ibn al-Haytham (Alhazen), the Islamic philosopher active at the end of the tenth and the beginning of the eleventh centuries, also lead him to a greater understanding of 'visual delusions'. This branch of optics dealt with such general phenomena as our inability to see something moving too fast, and to perceive clearly anything that was overwhelmingly

4. Based on Leonardo, *Double Intersection of Light Rays in the Eye*, Paris, Institut de France, Ms D 10v

bright or excessively dark. It also explained such specific effects as 'persistence of vision', which occurs when we look at something moving rapidly. Leonardo described the oscillating appearance of a knife struck in a table and twanged from side to side, just like (as he said) the vibrating string of a lute. He also notes that a whirling firebrand leaves a circular trail of light in our eye, and that we can see through the spokes of a revolving wheel. His explanation was that the *imprensiva* could not react fast enough to keep up with the optical tracks of the objects. These effects lay, somewhat disconcertingly, beyond the practical scope of painting even in Leonardo's hands (though not for Velasquez a century later), and he acknowledged that they were the sole province of the 'speculators' on optical phenomena. Perhaps, as he increasingly realized towards the end of his career, his beloved painting had definable visual limits after all.

Whatever the slippery complexities of perception in his later theories, the fact that the eye worked geometrically remained inviolable. What it was designed to see were the marvels of light and shade, which told us about the external world. He systematically studied the effects of light on single and multiple bodies from single and multiple sources of varied size, shape, and distance. It was on this basis that he reformed the way

that light and colour were described in painting, developing a 'tonal' system in which the foundations of light and shade took precedence over colour in the conveying of what he called *relievo* (roughly equivalent to 'plasticity'). He looked at the way that cast shadows diminished in intensity the further they were from the opaque body casting them, obeying the proportional law of diminution that applied ubiquitously to light and other dynamic systems. He worked out the relative intensity of light on surfaces according to the angle of impact, and plotted the secondary rebounds of light from illuminated surfaces into shaded areas. This latter phenomenon he used to explain the so-called *lumen cinererum* (ashen light) on the shaded side of the moon, which he correctly argued came from reflections off the earth's surface. His studies of light striking the contours of a face from a point source (**Fig. 5**) show him aspiring to create modelled forms according to a system like that of ray tracing in computer graphics. The more direct the 'percussion', to use Leonardo's own term, the greater the light intensity—though the actual rule is, as we now know, Lambert's eighteenth-century cosine law rather than Leonardo's simple, proportional rule. For Leonardo, the result of a percussion was always in proportion to its angle of impact. Thus a glancing light will not

5. Based on Leonardo, *Angular Impacts of Light on a Face*, Windsor, Royal Library, 12604r

illuminate a surface as strongly as one that falls perpendicularly on it. The same rule applied to a blow struck with a sword, the bouncing of a ball, or the hammering of a nail into wood. In this latter case, the extent that the nail is driven into the wood would also be proportional to the weight of the head of the hammer and the force of the arm delivering the blow.

Proportion was the way that God's perfect design was manifest in all the forms and powers of nature. The beauties of proportional design had been a primary concern for Florentine architects, sculptors, and painters at least since the time of Brunelleschi. Leonardo was the first to tie the artist's notion of proportional beauty into the wider setting of the proportional action of all the powers of nature. The most authoritative source for proportion in architectural design was the treatise on architecture by the ancient Roman author Vitruvius. As the supreme guide for the architect's conception of beauty, Vitruvius drew attention to the way that the human body, with arms outstretched and legs akimbo, could be inscribed within a circle and a square, the two most perfect geometrical figures. Within this schema, the component parts of the body could be seen to be organized according to a system of related dimensions, in

which each part, say the face, was stood in a simple, proportional ratio to every other. Leonardo's re-working of Vitruvius' scheme (**Fig. 6**) has become its definitive visual realization, and is widely used in popular imagery as an immediately apparent symbol of the 'cosmic' design of the human frame. As Leonardo said, the proportional design of the human body was analogous to the harmonics of music, which were founded on the cosmic ratios described by the Greek mathematician Pythagoras. It was the mathematical basis of music that gave it the most serious claims amongst the arts to rival painting—though he was at pains to point out that musical harmonies needed to be heard sequentially, rather than, as in a picture, being appreciated simultaneously in a single glance.

Standing Up and Moving Around

Almost needless to say, Leonardo was not satisfied with the old Vitruvian formula, and attempted to define what happened to our proportions as we adopt different postures, such as sitting down. More than this, he set the proportional design of architecture in a wider framework of how living things sustain themselves in harmonic balance. As he wrote to the

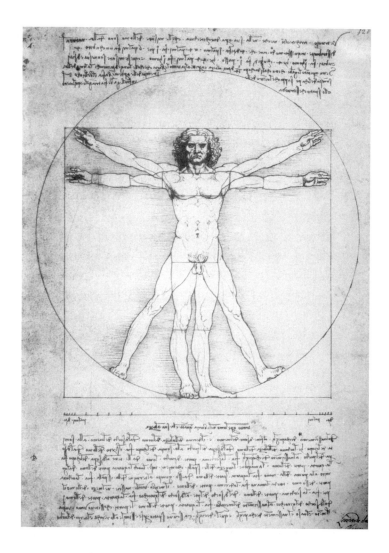

6. *Demonstration of the Geometrical Design of the Human Body, based on Vitruvius,* Venice, Accademia

cathedral authorities in Milan when he was attempting unsuccessfully to win the commission for the crossing dome:

> It is necessary for doctors who are the guardians of the sick to understand what man is, what life is and what health is, and in what way a balance and harmony of these elements maintains it, and how similarly when they are out of harmony it is ruined and destroyed, and whoever has a good knowledge of the aforesaid characteristics will be better able to heal than he who is lacking in it . . . The very same is required by an ailing cathedral—that is, a doctor-architect who well understands what a building is, and from what rules correct building derives, and from where such rules are drawn and into what number of parts they are divided . . . I shall endeavour . . . to satisfy you partly with theory and partly with practice, sometimes showing effects from causes, sometimes affirming principles with experiments, making use, as is convenient, of the authority of the ancient architects.

We may suspect that the architectural commissioners were a little surprised to be given a lecture on medicine, but, for Leonardo, the harmonic balance of a living body, in which everything should be in due proportion, and the harmonic design of an excellent building were basically the same thing. It is this sense of common foundations that accounts for the 'organic'

feeling of his finest architectural designs—above all those for centralized, domed 'temples', in which complex permutations of geometrical solids cluster around a central core like the exoskeleton of a new kind of organism.

In our terms, the architect is concerned with statics rather than dynamics. For instance, the designer-builder would need to understand the ratios of downward thrust exerted by stones at different points in a rounded arch. Leonardo was also much exercised by the more abstractly theoretical analyses of statics favoured in medieval 'physics', such as the mathematics of balance arms. In the Middle Ages, Jordanus of Nemore had expounded the rule that, for two arms to be in balance, the arm length multiplied by the weight must be equal. That is to say, a weight of three pounds placed one unit of distance from the point of suspension would be balanced by a weight of one pound placed at a distance of three units. Leonardo's proliferation of combinations of diverse weights at varying distances on arms (**Fig. 7**) seems at first sight to be over-gilding the medieval lily, and to go beyond any useful application. However, if we regard his variations as complex exercises in the magic of proportions—as the inherent music of the science of weights—the effort he put into them becomes

7. Based on Leonardo, *Compound Demonstration of Weights on Balance Arms*, Milan, Biblioteca Ambrosiana, Codice atlantico, 235r

more understandable. Much the same applies to his many variations of multiple pulleys, which were dynamic systems of practical utility in lifting weights, such as heavy stones, but he typically studied them to a point of theoretical exhaustion.

Static proportions could take us only so far in understanding the nature of things. 'Force', the immaterial and invisible agent responsible for providing all living things with motion and endowing animate things with the semblance of life, was ultimately much more fundamental. It was force—'born in violence and dying at liberty'—that transported all things beyond their natural position and disrupted their natural state of rest. The framework within which he characterized force was entirely traditional. It was drawn from the Aristotelian theories that prevailed until the reforms wrought by Galileo and Newton in succeeding centuries. The basic disposition of the four elements from which all matter was composed was concentric. At the centre stood the earth, surrounded successively by the spheres of water, air, and fire. Each element would find its natural level, and, if transported away from that level, would 'desire' actively to return. Thus a stone falls from the air, while fire ascends. Whatever the very long-term prospect that all the elements would eventually settle in stable

concentricity, the present situation is continuously dynamic. The divine clockwork that set everything in motion, or the metaphorical hand that stirred the elements in the bucket into turbulent motion, still had a long way to go. Or, to express the set-up in Leonardo's own terms, the 'Prime Mover', the ultimate agent of cosmic mobility that encircled the finite limits of the universe, was the direct expression of the divine act of setting things in motion, whether perpetual or not.

When force was applied to an object, it was obvious why it moved. It was less clear why an object would continue to move when separated from the force. Why, for instance, did a thrown stone continue to fly through the air when removed from the hand or catapult that had propelled it? The late-medieval answer, adopted by Leonardo, was impetus. When a mobile object was subjected to force, it was endowed with a certain amount of impetus, just as an object placed over a flame would be endowed with a certain amount of heat. The impetus would progressively drain, like heat, from the body, dictating its performance in terms of speed and distance over a given period of time. The extent to which impetus drained from the body was subject to the same proportional laws as governed light—we are dealing with a kind of perspective of impetus.

The performance was inexorable—that is to say, the projectile had of necessity to travel a certain distance in a certain time regardless of its path. Thus the zigzag path of a bouncing ball would be the same, in terms of distance and time, as that of a ball that did not bounce. The actual distance the path of a projectile would travel was proportional to the force that moved it—in theory at least. Leonardo came to realize that the Aristotelian proposition that a body moved by twice the force would travel twice the distance, or that a body of half the weight moved by the same force would also travel twice the distance, could not be applied in practice. If it could, we would find that big cannons could fire small missiles over enormous distances, which, as he discovered (and as any gunner could tell him), was not the case. Although he recognized the dilemma of reconciling theory with his beloved 'experience', he did not have any way of resolving it within the dynamic theory he had inherited.

There were also cases where motion did not diminish. One was the acceleration of a falling body. Even if Leonardo could not explain the concept of gravitation, he could at least subject it to his proportional law. He reasoned that the falling body gains increments of speed according to the pyramidal

law in reverse—that is to say, the speed at each stage was directly proportional to the distance travelled. Falling operates according to a kind of inverted perspective, in which something becomes bigger the further it is from its starting point. Another anomaly was the vortex, which he observed to accelerate towards its centre of revolution, often in the most forceful manner. In this case, the explanation lay in the rapid concentration of the impetus into an ever-narrower compass, with the result that it could expend itself only in furious revolution, speeding up rather than slowing down in the normal way.

The Vortex

The phenomenon of the vortex became the subject of intense interest for Leonardo. He was instinctively drawn to its formal properties and intellectually attracted to its extraordinary dynamic implications. As the characteristic motion of an element 'within itself'—that is to say, when it was not removed into another sphere—the vortex was manifested ubiquitously throughout nature. Of the three naturally mobile elements, water was at once the most observable and impinged most dramatically on human lives,

both constructively and destructively. He devoted huge amounts of observation and speculation to the motion of turbulent water. At one point he announced that he had outlined '730 conclusions on water' in eight folios of the manuscript known as the Codex Leicester (owned for many years by the Earls of Leicester). He endeavoured to bring some order into this growing chaos by devising a scheme for his planned book on water:

> Book 1 of water in itself;
> book 2 of the sea;
> book 3 of underground channels [*vene*];
> book 4 of rivers;
> book 5 of the nature of the depths;
> book 6 of the objects [impeding the flow of water];
> book 7 of gravels;
> book 8 of the surface of water;
> book 9 of the things that move in it;
> book 10 of the means of renovating rivers;
> book 11 of conduits;
> book 12 of canals;
> book 13 of machines turned by water;
> book 14 of how to make water ascend;
> book 15 of things consumed by water.

Here, as in other instances when he planned the structure of his projected treatises, his ideal was that of a medieval encyclopedist, but his instincts for the complexity and interrelatedness of phenomena continually undermined the achieving of an orderly synthesis. He did not want, after all, to be accused of 'abbreviation'.

No one who listed sixty-four terms descriptive of water in motion could be so accused. The list begins: 'Rebound, circulation, revolution, rotating, turning, repercussing, submerging, surging, declination, eleva-tion, depression, consumation, percussion, destruc-tion ...'. The effect is akin to a piece of percussive poetry, in which the verbal outpouring and torrent of sound come to assume the nature of the phenomenon itself. What had occasioned this outpouring was a more limited effort to arrive at precise definitions of *pelago* (sea, large lake), *fiume* (river), *torrente* (torrent), *canale* (canal), *fonti* (sources), *argine* (bank), *ripa* (higher bank), *riva* (shore), *lago* (lake), *paludi* (marshes), *grotte* (caves), *caverne* (caverns), *pozzi* (wells), *stagni* (pools), *baratri* (chasms), and *procelle* (tempests of water). Each term is accorded a definition in a sentence or two, and he is particularly concerned to differentiate between those that could have overlapping meanings. He then moves on to processes: *polulamenti e surgimenti* (bubblings

and wellings-up), *sommergere* (submersion), and *inter-segatione d'acque* (intersection of waters), each with definitions. Finally he plunges into his sixty-four-term list, with what may have been a growing sense of desperation, since he does not provide detailed definitions of any of them.

His attempts to categorize and describe the intensely complex configurations of water in turbulent motion recall the old party game of challenging someone to describe a spiral staircase without arm and hand motions or other visual aids. He came to despair of words as descriptive vehicles for phenomena of such complexity, feeling that only his drawings could provide adequate visual accounts.

The most complex of his drawn studies (**Plate 6**) are not some kind of miraculous photographs by eye, but rather represent an intricate synthesis of observations and theoretical constructions, with neither separable from the other. They present the remaking of 'effects from causes', as he said in his letter to the cathedral authorities, but with the direct experience of the effects ever present in his process of visualization. They possess an extraordinary beauty in their spatial choreography of impetus. In this case the watery spirals are dancing not just to their own music but also to the accompaniment of spherical bubbles

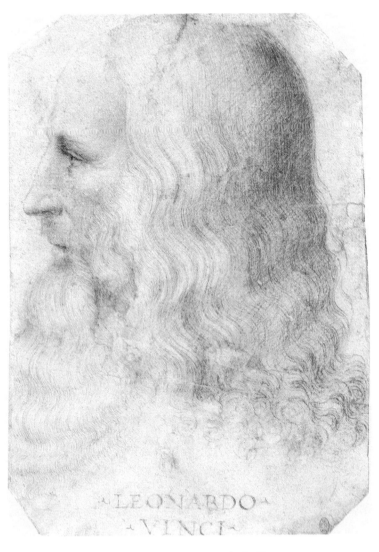

LEONARDO
VINCI

1. Francesco Melzi (?), *Portrait of Leonardo da Vinci*

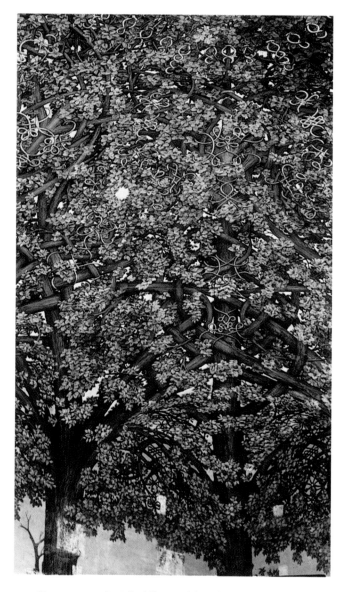

2. *Decoration of the Sala delle Asse* (detail)

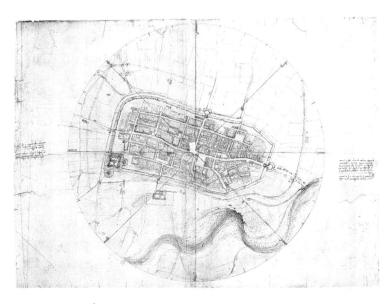

3. *Map of Imola*

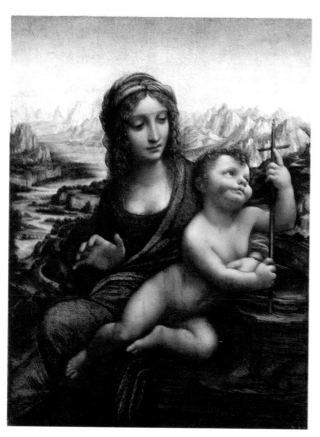

4. *Madonna of the Yarnwinder*
 (*the 'Lansdowne Madonna'*) (ABOVE)

5. *Madonna, Child, St Anne, and a Lamb*
 (detail of landscape to the right
 of St Anne's head) (LEFT)

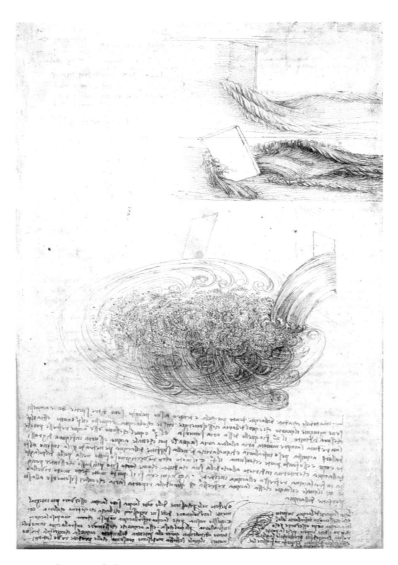

6. *Studies of Turbulence in Water*

7. *Study of a Sleeve for the Right Arm of the Virgin in the 'Madonna, Child, St Anne, and a Lamb'*

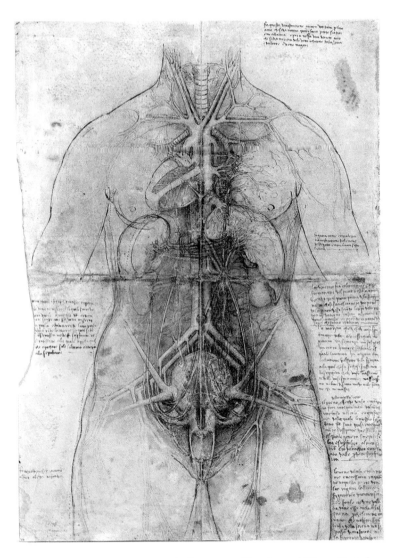

8. *Composite Demonstration of the Respiratory, Vascular and Urino-Genital Systems of the Female Body*

9. *Map of Chain Ferry, Weirs and Damaged Embankment*

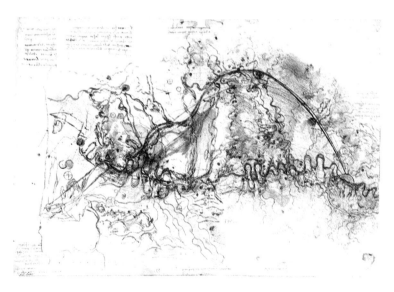

10. *Map of the Arno East of Florence and Route for a Proposed Canal*

of air, which have been thrust down into the alien realm of liquid before leaping gleefully to the surface in a series of exploding rosettes.

Human interaction with water was complex and vital at this time, in a way that we have generally lost sight of in our present age. It provided a major source of power; its transportation from one place to another, sometimes by creating a head of water artificially, was a matter of life and death for farmers (and for those who just needed a drink); the management of water in rivers and canals was of great economic import; and floods were a severe menace. As a 'master of water' consulted by the authorities of Venice and Florence, Leonardo strove to bring theory and practice together, aspiring to demonstrate why vortices were consuming banks, and to show how the inexorable power of water in motion should be used to achieve the desired results, rather than opposing its nature. But even the best-equipped master stood helpless when the elements moved on the largest scales. Ultimately no human force was of avail when the winds crashed through the air, bearing water, dust, leaves, branches, and even whole trees in a furious chaos of visual cacophony:

> Let the dark and gloomy air be shown battered by the rush of contrary and convoluted winds, mixed with the

weight of the incessant rain and bearing hither and thither numberless branches rent from trees and mingled with numberless leaves. All round you may see ancient trees, uprooted and stripped bare by the fury of the winds. The ruins of mountains may be seen, already scoured by the racing of the rivers, collapsing above these rivers and blocking the valleys; the pent-up rivers burst forth and inundate many lands and their inhabitants.

The suite of *Deluge Drawings*, dating from the later period of his life, combined distanced analysis and emotional immersion in a way that is shared with only the greatest masters of *intelletto* and *fantasia*.

In his analysis, the form of the vortex could be resolved into two components: the primary direction of motion in a straight line; and the revolving motion that results from the element encountering its own mass. Characteristically this formulation reminds him of something else:

Note the motion of the surface of water, which conforms to that of the hair, which has two motions, one of which responds to the weight of the strands of the hair and the other to the direction of the curls; this water makes turning eddies, which in part respond to the impetus of the principal current, while the other responds to the incidental motion of deflection.

Not only hair. The helical configuration insinu-
ates itself into all phenomena in which linear and
curving components are involved. The drapery of a
sleeve, in which a thin, diaphanous layer is longitudin-
ally compressed over a stiffer under-layer, rises and
falls in a series of helically disposed hills and valleys
(**Plate 7**). When he draws *The Star of Bethlehem*, the
leaves of a plant push outwards from their core,
swirling in graceful curves, which are perhaps more
demonstrative of spiral phyllotaxis than any plant
quite achieves in its natural situation.

Such things provide necessary lessons for the
human designer. When he decided to design a wig for
Jupiter's graceful partner, in the lost painting of *Leda
and the Swan*, he worked sumptuous artificial variations
on the ubiquitous spirals of hair and water (**Fig. 8**).
As if to stress the continuity between artificial and
natural things, the strands of hair that seep out from
the front edges of the wig and surge through the
apertures at the centre of the lateral whorls celebrate
the same tendency to curl that he had amplified in his
highly compressed design of plaits and spirals. Being
Leonardo, he feels that he has to design the rear of the
wig, for understanding to be complete. He always
feels that he had to answer questions beyond those
that directly inform the practical needs of composing

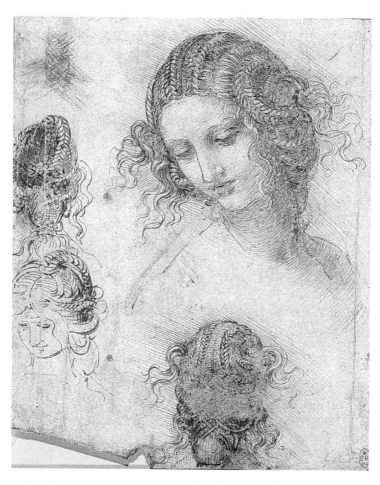

8. *Study for the Wig of Leda in 'Leda and the Swan',* Windsor, Royal
 Library, 12516

a particular picture. Well might patrons doubt his capacity to finish anything in a reasonable span of time—though, as it happens, the *Leda* was finished, to feature as the most highly valued item on Salaì's list and to become a treasured item in Francis I's Appartement des Bains at Fontainebleau. It would be ironic if the watery environment of Francis's suite of rooms hastened its end.

'Necessity', 'Continuous Quantity', and the Primacy of Geometry

Governing everything we can see is one overriding principle. This is the principle of 'Necessity'. It dictates that form always perfectly fits function in nature, with no insufficiency or redundancy; it compels every force to expend itself in the most direct way available to it; it prescribes that the simplest design to achieve a given end will be followed; and it must be respected by any human contriver of artificial things. 'Necessity is the mistress and teacher of nature; necessity is the theme and inventor of nature, the curb, the rule and the theme.'

The universal architecture of Necessity is geometry. To understand its primacy for Leonardo, we need to grasp why he revered it over any other branch of

mathematics. He recognized that number is important, and was much interested in numerical proportions as expressed in music. But number was ultimately inferior to geometry, since arithmetic relied on 'discontinuous quantity' while geometry dealt with 'continuous quantity'. Number was limited to separate units, rather plodding kinds of things, and lacked the magic of geometrical proportions, which dealt with surfaces, shapes, and space. For Leonardo there was something superior about the ratio of a diagonal of a square to its sidelength (i.e. $\sqrt{2}{:}1$) when compared to a ratio like 2:1. He knew that $\sqrt{2}$ could not be perfectly expressed arithmetically, since it is what we call an irrational number. He did not, however, realize that the ratio between the radius and diameter of a circle (now designated as π) was irrational in such a way as to prevent his squaring the circle—that is to say, achieving the age-old prize for creating a square that was absolutely identical in area to a given circle. He laboured mightily on this problem, and other conundrums involving curvilinear and straight-edged areas, adopting a variety of strategies. He occasionally sensed that the prize was in reach before it again disappeared into the future. What emerged on many of his sheets of geometrical improvisations were shapes akin to those of nature—shells and flowers in particular.

In order to explain the design of forms in nature, as determined in principle by the supreme creator, numbers did not seem to deliver the solutions Leonardo sought. They were, in Leonardo's eyes, good for counting and determining proportions in statics and dynamics, but his science was not primarily about quantification. When he looked at the way that shells assumed a helical shape, at how leaves and petals originated from stems, and at the reasons why a heart valve worked with perfect economy, geometrical analysis delivered the results he desired. This geometrical substrate of God's design was directly expressible in his art, providing the foundations for the shape of the things he observed in the natural world and wished to record in perfected form in drawings, painting, sculpture, and architecture. We will see this occurring repeatedly in the chapters that follow.

The supreme expression of the majesty of geometry resided in the five regular (or 'Platonic') solids, which had been revered in classical philosophy and mathematics. These are the only solid bodies that are composed of identical polygons and are symmetrical around all their vertices. They are the tetrahedron (four equilateral triangles—i.e. a pyramid), hexahedron (six squares—i.e. a cube), octahedron

(eight equilateral triangles), dodecahedron (twelve pentagons), and icosahedron (twenty equilateral triangles). They can be truncated—that is to say, sliced symmetrically from their vertices to be transformed into semi-regular solids. He was particularly entranced when the truncation of two different polyhedra resulted in the same semi-regular or 'Archimedean' body. For example, the truncations of the dodecahedron and the icosahedron both produce an icosidodecahedron composed of alternating pentagons and triangles (**Fig. 9**).

Leonardo became directly embroiled in the beguiling mathematics and formal beauties of the regular and semi-regular bodies when he collaborated with the mathematician Luca Pacioli, who arrived in 1496 at the Sforza court. The main project of Pacioli's four years in Milan was his treatise *De divina proportione* (On Divine Proportion), which dealt with the geometry of the five solids on the basis that they could be related to the so-called Divine Ratio (also sometimes called the Golden Section). This was the ratio (irrational) that resulted when a line was divided in such a way that the short portion is to the longer portion as the longer is to the whole. It could not be expressed in terms of the 'discontinuous quantities' of numbers. Although Leonardo did not accord this

9. Based on Leonardo, *Skeletal Version of the Icosidodecahedron*, from
 De divina proportione, Florence (Paganius Paganius), 1509

section any privileged status over other geometrical ratios, he was no doubt delighted by the 'continuous quantities' involved in the design of the solids. He provided Pacioli with a set of illustrations, known in two manuscripts and in the printed edition of 1509.

What Leonardo devised was a highly skilful way of showing the solids in perspective, systematically shaded as if they are real objects, rather than as geometrical diagrams. He also invented a way of revealing their spatial configurations in skeletal form, with each face treated as a framed window. The illustrations are testimony to his gifts of spatial visualization. It is clear from other sheets of drawings on which he experiments with different configurations and truncations that he could do such three-dimensional geometry in his head by thinking of the bodies as real, concrete objects. He was more generally fascinated by what he called 'transformation'—that is to say, when a given volume of material in a defined form is reshaped into another. One nice and typically unexpected example is his discovery that, when a cube of malleable material is compressed steadily along an axis perpendicular to one of its faces—say, a wax cube is pressed down by a glass sheet from above— it is eventually transformed into a flat cylinder. Continuous quantity indeed!

Leonardo insisted that every motion of everything takes place in continuous space, and cannot be broken down into the separate steps of numbers. Looking at the human figure, he saw how the compound system of pivots at the major joints of shoulder, elbows, hips, and knees resulted in a series of orbiting extremities like the epicycles that had been invented to save the Ptolemeic model of the revolving heavens. It is a vision that we can reasonably describe as cinematographic. We can sense that Leonardo would have loved his drawings to move, and sometimes, as in his thumbnail sketches of a man hammering (**Fig. 10**), he comes as close as he could to achieving the effect of a continuous sequence.

In a way, 'continuous quantity' serves as a perfect metaphor for Leonardo's own system of thought. He never looked at anything without thinking of something else. Everything existed in a continuity of cause and effect, under the command of Necessity, which, far from causing uniformity amongst created things, resulted in the most wondrous variety of forms fitted to perform uncountable functions in every nook and cranny of the natural world.

10. *Small Sketches of a Man Hammering*, Windsor, Royal Library, 19149–52v

BODY AND
MACHINE

THE MAJOR OBLIGATION placed on a Renaissance artist was to exhibit a mastery of the human figure, providing fit subjects for devotion and, in the case of narratives, knowing how to use gestures and expressions with due eloquence. The key properties were spirituality, beauty, and decorum. An understanding of decorum was crucial for the painter, as Alberti had stressed, since it involved the fittingness of form to function—that is to say, every figure should be portrayed in a way that is appropriate to its character, social station, sex, and age, and to the emotion of the particular situation in which it finds itself. Leonardo recorded one heinous

instance in which the rule was transgressed: 'I recently saw an Annunciation in which the Angel looked as if he wished to chase Our Lady out of her room with movement of such violence that she might have been a hated enemy; and Our Lady seemed as if in despair she was about to throw herself out of the window.' It is possible that Botticelli was the unnamed transgressor. The increasing numbers of secular subjects required of painters did not affect the basic stipulation of decorum, since the great heroes and villains of ancient myths and modern history all needed to be shown true to type.

Lorenzo Ghiberti, the sculptor of the gilded *Porta del Paradiso* on the Florentine baptistery, had in his *Commentaries* stipulated that the painter should 'know anatomy', a prescription with which Alberti agreed. The dominant senior artists in Florence when Leonardo was learning his trade, Antonio Pollaiuolo and Andrea Verrocchio, had become masters of bone, muscle, and sinew, consciously emulating the renowned masters of classical antiquity. Whether any Renaissance artist in the generation before Leonardo and Michelangelo actually dissected is unclear. If Pollaiuolo's knowledge was based on surface inspection alone, he must have conducted his studies with remarkable tenacity and visual penetration.

Observation and Received Wisdom

Leonardo has become renowned as a dissecting artist, probing, as legend tells us, the forbidden inner secrets of decaying corpses in the face of what he himself acknowledged as the repellent aspects of undertaking 'an anatomy'. Supposedly, this was an illicit and sacrilegious activity, which placed him outside the realms of the Church. Late in Leonardo's career in papal Rome, one of his troublesome German technicians denounced his dissections to the Pope, but the drawn and written records of Leonardo's anatomical investigations tell a generally different story. The one fully documented and comprehensive dissection of a complete human cadaver—probably the only one he conducted—was of a 'centenarian' whose 'sweet death' Leonardo witnessed in the Hospital of Sta Maria Nuova in the winter of 1507–8. Claiming to be 100 years old, the *vecchio* ('old man', as Leonardo calls him on his pages of drawings) was presumably part of the system of consent, involving the hospital, that allowed the artist to conduct an autopsy, followed no doubt by a proper burial. Such a procedure was more widely sanctioned than legend suggests. Leonardo certainly conducted other human dissections, but these seem to have been of particular parts

or systems of the body. More often, he turned in the traditional way to animal material, which was not believed to differ significantly from human anatomy except in shape and dimensions. His greatest studies of the brain and the heart, the two key centres of human life, were based on organs from an ungulate, probably an ox. He also dissected at least one horse, probably in connection with his project for an equestrian monument in Sforza Milan. Unsurprisingly, in his efforts to master flight, he anatomized a bird's wing. His known dissection of the foot of a bear seems to have been motivated by the unique opportunity that had presented itself.

Given Leonardo's involvement with dissection and his repeated emphasis upon 'experience' rather than book learning, it may seem surprising that his anatomical studies are so deeply permeated by traditional wisdom. The two-chamber system of the heart, to which he adhered for a long time, is a case in point. But we should remember that a dissected body, particularly in the era before preservatives, is a messy thing, which does not lucidly disclose its forms and functions to anyone who peers within. The anatomist needs to know how to dissect (which bits to cut and in what sequence) and how to make visual sense of the unfamiliar landscape of glutinous and collapsing

forms. Seeing, as always, is a highly directed business. Additionally, for Leonardo, anatomy was not 'descriptive' in the modern sense but 'functional'; in other words, he was always looking at form in terms of its function within the framework of natural law. If he was confident that he knew the function, he could reasonably suppose that the corresponding structure existed—like the item of plumbing that he inserted to connect the spinal chord to the penis in order to transmit the vital spirits into the sperm.

The overarching framework was derived from ancient medicine. It comprised the four humours—blood, phlegm, white bile, and black bile (corresponding to the qualities of pairs of the four elements)—and the four temperaments—sanguine, phlegmatic, choleric, and melancholic. These account for what Leonardo called the 'four universal conditions of man'. When he wrote to the cathedral authorities about the need for 'balance' in a healthy body, he was specifically referring to the need to balance the humours, so that one of them does not gain dangerous dominance. It was certainly not good to have an excess of melancholy. The dynamics of the living body were driven by fluids that conveyed the 'spirits'—animal and vital—responsible for vivifying the body. Blood ebbed and flowed in the vessels (Harvey's advocacy of

circulation was long in the future), while the *medulla* in the hollow centre of the nerves pulsed with incoming information and outgoing messages. Leonardo did nothing to alter radically the physiology he had inherited, but he did develop an unprecedentedly integrated vision of the dynamism of the living body in three dimensions, in which the magic of his draughtsmanship serves both as a mode of representation and as a form of research. Not infrequently, the act of drawing becomes an experiment in form and function, serving as the final validation and proof that he really could tell us how things worked.

The medical texts he knew, particularly that of Mondino de' Luzzi, which regularly served as a handbook for ritualized dissections in an anatomy theatre, provided basic descriptions and some rudimentary illustrations of the shape and location of the main organs, but there was nothing remotely like the compelling plastic visions Leonardo was to provide. His aspiration was not just to transform us into eyewitnesses of what could be seen in dissection but also to allow us to reach a true understanding of the marvellous forms and functions of the body in its whole and in its parts. To this end, he shows the components of the body not only in their solid form (often within the transparent outlines of the body),

but also sectioned in various ways, drawn apart from each other in 'exploded' diagrams, sometimes in see-through versions, and transformed into line diagrams explanatory of their actions. Every technique of anatomical illustration that was to be used in textbooks up to the nineteenth century was precociously tested by Leonardo.

Form and Function

> Although human ingenuity makes various inventions, corresponding by various machines to the same end, it will never discover any inventions more beautiful, more appropriate or more direct than nature, because in her inventions nothing is lacking and nothing is superfluous.

The 1489 skulls series, to which we have already been introduced, immediately declares his ambitions. He believed that, if a form was visible, it must have a function, since nature does nothing in vain. Thus, every bump and depression on the cranium must be respectfully recorded, whether or not Leonardo immediately knew what it did. When the skull is vertically sectioned, the frontal sinus (behind the eyebrows) became apparent for the first time and is duly recorded. Great design was both functional and

beautiful. Thus he asks the skull to reveal the secrets of its proportions, one of which is that its geometrical centre corresponds to the point on which all the sensory impulses converge. Characteristically, he begins to think about the forms and functions of the teeth in relation to their position on the mechanical levers of the jaws—crunchers near the fulcrum (like cracking a nut) and cutters on the less powerful distal regions of the lever, as he later explained in full.

We have already noted that one of the main motivations in the skull studies was his speculative location of the mental faculties in the light of what he was deducing about the paths of the cerebral nerves. He was seeking to understand the very centre of the intellectual, imaginative, and communicative system that is man's particular gift from God. It was a hier-archical system, like the courts in which he served: 'the nerve branches with their muscles serve the nerve cords as soldiers serve the officers, and the nerve cords serve the *sensus communis* as their officers serve their captain, and the *sensus communis* serves the soul as the captain serves his lord.' The input mechanism from the senses was designed to transmit information, first and foremost visual, for analysis of the true state of affairs in the observable world. The painter was the supreme recreator of this state. The output of

voluntary action was also of great moment for the artist. A network of nerves (**Fig. 11**) transmitted *il concetto dell'anima* (roughly translatable as 'the purpose of the mind') to the face and limbs in such a way that every element of expression, motion, and posture speaks of the state of the person's thoughts at any particular time. On one of his diagrams of the brachial plexus (the net of nerves in the shoulders and upper back) he writes, 'this demonstration is as necessary to good draughtsmen as is the declension of latin vocabulary to good grammarians'. Thus, in the *Last Supper*, the innocent St James the Greater throws open his mouth and arms in spontaneous shock at Christ's announcement of his forthcoming betrayal, while the guilty Judas starts back, the whole of his posture rigidly locked in fear, like the corded tendons of his neck. In Leonardo's parlance, the nerves were often called *chorde* (cords or threads), and their substance was continuous with the tendons and the fibre of the muscles. In this sense, the human being is literally a nervous machine.

The most sustained and brilliant of Leonardo's surviving studies of the mechanism of the bones, muscles, and tendons come from a series undertaken in 1510, when he wrote that he intended 'to make an end of all this anatomy'. The bones and muscles of

11. Based on Leonardo, *Studies of the Nerves on the Neck and Shoulders*, Windsor, Royal Library, 19040r

the shoulders, arms, hand, and foot are particular
focuses of attention (**Fig. 12**). Combining acute
observation with brilliant mechanical visualization
in three dimensions, he shows the forms stripped
down progressively to the bone, sometimes with flaps
of muscles partially lifted away to disclose forms
beneath. He works out that the turning of the lower
arm is surprisingly effected by the biceps in the upper
arm. In order to reveal the complex forms and articu-
lations of the vertebrae of the neck, which produce
compound motion in a 'continuous quantity', he
shows them a little separated from each other, in the
type of 'exploded' demonstration that later became
standard in manuals of machinery: 'Show the bones
separated and somewhat out of position so that it
might be possible to distinguish better the shape of
each bone by itself. And afterwards join them together
in such a way that they do not diverge from the first
demonstration except in the part that is concealed by
their contact.'

He particularly delights in the supremely ingeni-
ous system of strings and stays in the hand, 'the
instrument of instruments', as it was termed in
the Aristotelian tradition. The interpenetration of the
flexor tendons in the fingers, hailed by the ancient
anatomist Galen as the perfect manifestation of divine

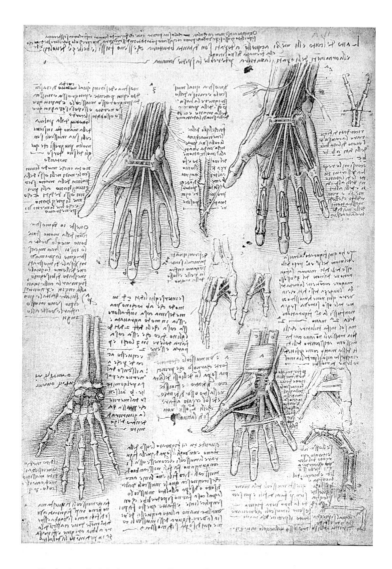

12. *Studies of the Mechanisms of the Hand*, Windsor, Royal Library, 19009

design, receives the benefit of a separate, inset illustration between the two main drawings of the dissected inner surface of the hand. The way that the tendons interpenetrate ensures that they can operate with power and economy within a self-contained system. As so often when he has to demonstrate the action of the muscles and the bones, he reduces the muscles to strings or cords so that their spatial interaction along their lines of force can become more lucidly apparent. It is this page that provides the source of the quotation that stands at the head of the next section of this chapter.

The remarkable range of graphic techniques he was forging granted fresh cogency to his arguments about the superiority of the image over the word. The arguments were particularly pointed in the face of the widespread criticism and avoidance of illustration in traditional medicine. 'With what words O writer will you describe with similar perfection the entire configuration that the drawing here does? . . . You who claim to demonstrate in words the shape of man from every aspect dismiss such an idea, because the more minutely you describe, the more you will lead away from the thing described.' Verbal description will be excessively 'tiresome and confusing'. In essence, these claims for the superiority of visual representation in

anatomy are those that elevate painting above poetry in conveying the wonders of the seen world.

But, in capturing the glory of the human machine, mere mechanics, however wondrous, were not enough. He keeps returning to the processes that stand at the heart of why we are living human beings—the process of generation, the dynamism of 'the purpose of the mind', the motion of the 'spirits' ('animal' in the *medulla* of the nerves, and 'vital' in the blood) coursing through the vascular 'trees' within the body, and the turbulent pulsing of blood in the heart itself. One of his greatest aspirations was to create a total, three-dimensional chart of the irrigation systems of the human body—the ramifying of the bronchi in the lungs, the pumping of the blood into ever smaller 'branches' and 'twigs' in the organs and limbs, the 'roots' of the vessels in the liver and kidneys, the 'seed' of the vascular system in the heart, the intricate 'rivers' of the urinary and genital systems, and the infusion of life and soul within the womb. This vision of the body as a world in miniature will concern us in more detail in the next chapter.

The closest he comes to realizing this complete map of the 'lesser world' is in an astonishing composite of female anatomy (**Plate 8**) in which even his graphic techniques collapse under the sheer weight of

his ambition. Some forms are more or less solid, some sectioned, some transparent, some both sectioned and transparent. The notes crammed uncomfortably around the margins of the figure have typically been triggered by thoughts occurring during the act of drawing. They deal with rather scattered anatomical and physiological matters, including an argument with Mundinus' textbook about the roles of the testes in generating sperm, and speculation about cycles of birth and decay in the human body. As always, Leonardo's thoughts move laterally.

Questions of life and death had been highlighted by his involvement in the winter of 1507–8 with the autopsy of the 'centenarian', the *vecchio*, and many of the details are drawn from the results he synthesized from the dissection of his aged male subject. Although related to this major dissection, his characterization of many of the key organs is still set in a traditional framework. The heart remains two-chambered (an idea he was shortly to abandon), and the womb has assumed a cellular structure within and is provided with external 'horns', in line with standard views. As always in his more developed drawings of the internal workings of human anatomy, there is a sense that the apparatus provided by nature should exhibit beauties of shape and proportion to no

less a degree than the outer appearance of the body. The aim, as in his representation of an ancient paragon of classical beauty (like Leda), is not so much a raw picture of what is encountered in real life as a distillation of the ideal form that lies beneath the vagaries of individual appearance. The totality of what lies inside this lady's body is worthy of an antique Venus—or, more specifically, of *Mona Lisa* herself.

Undeterred by the way that this compound demonstration has resulted in an optical density verging on confusion, he promises to repeat it from the side and from the rear. He has also pricked through the outlines of the body and main organs for transfer to another sheet. There is no indication that the full set of surveys was ever realized.

In the event, it was in the representation of the parts that his visions were most fully resolved. No drawing of an embryo in a womb (**Fig. 13**) ever came closer to capturing the very spirit of generation, as well as the foetus's nested position—even if the exaggeratedly spherical womb displays the cotyledonous (multiple) placenta of a cow rather than the single placenta of a human. The whole page is a feast of visual exposition. A series of small sketches of the womb shows the layers of its wall progressively

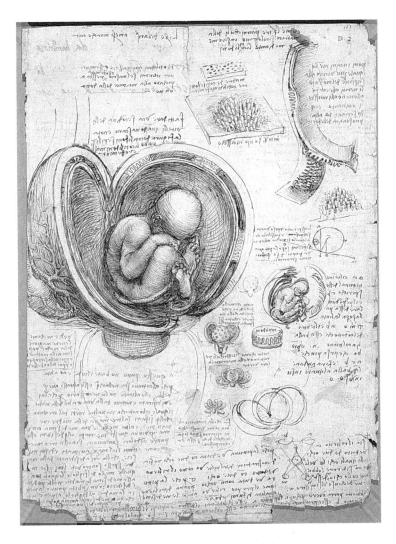

13. *Studies of the Foetus in the Womb, the Uterine Wall and Placenta, with Mechanics and Optics*, Windsor, Royal Library, 19102

opened, disclosing the germ of life within, like a chestnut within its protective seed-case. The inter-digitations of the placenta and uterine wall are depicted in a solid section, drawn apart like a Velcro strip that is in the process of being peeled back. Typically, he speculates on why 'the same soul governs these two bodies, and the desires and fears and sorrows are common to this creature as to all the other animal parts'. A mechanical diagram demonstrates how an asymmetrically weighted ball can stabilize itself on a slope—a mechanical meditation probably triggered by the question of the weight of the foetus's head and the rotational motion that occurs before birth. Finally, in the lower right corner, he speculates as to why even the most fully realized representation of the three-dimensional form will never appear to have the same 'relief' as the same form seen simul-taneously with two eyes. Even Leonardo's brilliance in perspective and the modelling of forms in light and shade has to surrender in the face of the parallax that comes with binocular vision.

In functional terms, the most fully satisfying of his anatomical expositions concerned the pulmonary aortic valve of the heart. A three-cusp structure located in the narrowing neck of the aorta, it is characterized by Leonardo as a piece of solid geometry in action,

driven by the ionic volutes of the blood vortices as they recoil in the constricted diameter of the vessel (**Figs. 14** and **15**). Blood is thrust from below the valve, as the chambers of the heart—now four in number— contract. The three cusps collapse away from the centre to leave a triangular aperture, the geometry of which Leonardo inevitably strives to define. Subsequently, the spiral turbulence of the expelled blood in the neck of the aorta reinflates the cusps and snaps the valve shut, so that the dilating chambers of the heart can draw in blood from other vessels. The trick is to make sure that, when the blood was being forced into the pulmonary system to reach the lungs, it should not be able to flow back into the heart, particularly as the chambers redilate to draw in blood from other vessels. For once, he has been able completely to raise anatomical explanation to the level of maths. 'Let no one who is not a mathematician read my principles,' he wrote on one of his anatomical studies, paraphrasing Plato. 'Necessity' rules, as always.

He is so certain that he is right about the valves that he announces his intention to make a model of the set-up in glass with artificial membranes. His pride was justified. Recent studies of the operation of the valve and imaging of the vortices within the neck

14. Based on Leonardo, *Six Views of the Pulmonary Aortic Valve in Isolation, shut and open*, Windsor, Royal Library, 19079v

15. Based on Leonardo, *Studies of the Vortices of Blood within the Neck of the Pulmonary Aorta*, Windsor, Royal Library, 19117v

of the aorta have revealed his extraordinary insight into the valve's operation. Essentially Leonardo had learnt all that is needed to work out the mechanics of the kind of artificial heart valve that extended my mother's life by a goodly span of years.

The Elements of Engineering

> Do not forget that the book on the elements of machines with its beneficial functions should precede proofs relating to the power of man and of other animals; on their basis you will be able to verify your propositions.

Faced with the divine fittingness of form to function, what is the human engineer to do? Clearly the standard had been set, and no one was going to be able to rival what God had accomplished in the totality of the human body. At one level, the human engineer could only piously follow in nature's wake, inventing devices that obey the principle of 'Necessity', ensuring that all designed forms perform their functions with no redundancy and no insufficiency. Yet it was evident that human inventions had gone beyond merely aping nature and had resulted in mechanisms that nature herself had not made. There was, to take one obvious example, no crossbow to be found in nature. Thus he

could claim as an engineer, as he had claimed as a painter, that 'the constituent parts of nature are finite, but the works that the eye commands of the hands are infinite'. The engineer learnt *how* nature designed its forms to fit functions, respecting her principles and the absolute sovereignty of her natural law, in order to become what he called a 'second nature' in the world. In this, the artist and the engineer are at one. They make new things on the basis of the inner workings of nature rather than simply imitating what nature has already done.

We have already seen that there is good evidence of Leonardo working on specific engineering projects for his patrons, both as a roving consultant and as the designer of utilitarian items like tongs, locks, and jacks within his workshop. It is exactly this kind of utilitarian item that has not survived. A drawing of a jack (**Fig. 16**) gives some idea of what he may have accomplished for those who employed his services. In order to minimize what we call frictional forces (which are particularly severe with wooden machines, especially in the absence of modern lubricants), he has combined a worm gear with a circular roller bearing, a ring bearing in modern terms. A drawing of the mechanism separated from its containing frame and a section of the bearing demonstrate his concern

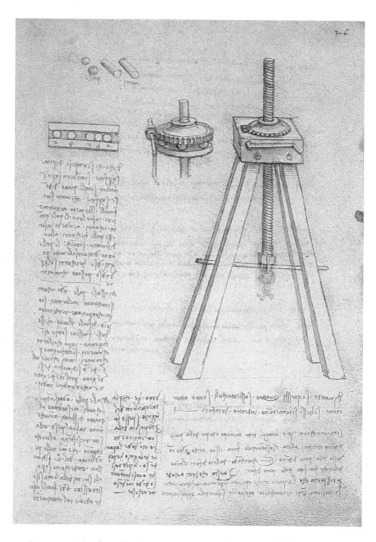

16. *Design for a Jack with Details of the Bearing,* Madrid, Biblioteca Nacional, Codex Madrid I 26r

to separate the rolling balls, so that their counter-rotating faces should not encounter each other. In another design he showed how intervening rollers, shaped like concave cotton reels and revolving independently on their axles, could achieve the desired separation.

Lifting devices were of notable importance in any operations that required large loads, such as blocks of stone, to be lifted from the ground—particularly for loading onto transportation. The builders of medieval and Renaissance cathedrals had devoted great ingenuity to the invention of devices that could raise mighty stones to construct soaring vaults and lofty domes. Brunelleschi's famed machines survived in the workshop of the Florentine cathedral, and were sketched by Leonardo. Leonardo's senior colleague Francesco di Giorgio Martini of Siena, one of whose manuscripts on architecture and engineering Leonardo owned and annotated, expended considerable effort on lifting devices, particularly ones that could raise large columns into upright positions. The two masters were in Pavia together in 1490, advising the cathedral authorities on structural matters. In more ways than one, Francesco provides a close precedent for Leonardo. He was a painter, sculptor, architect, and engineer, particularly renowned for his mastery of

fortifications. He etched out a very substantial career for himself, much in demand from leading military and civil patrons, like Federigo da Montefeltro, Duke of Urbino. His native city of Siena went to considerable expense in an effort to attract and retain his services. In the hierarchies of court and civic employment, engineers were far bigger fish than painters—unless the painter was both. When Leonardo was listed alongside Bramante as one of the top engineers in the Sforza court, he had moved into a league above that available to a maker of pictures.

Francesco's ingenious disposition of walls and bastions in fortresses, relying upon an intricacy of geometry rarely applicable to other forms of architectural design, was taken up and developed by Leonardo, who characteristically rethought the configuration of every part of a fortress in response to the 'percussive' blows dealt out by new-style artillery. The design of a fortification becomes an exercise in impacts, deflections, and rebounds, so that the bombardment can be neutralized. His drawings assume the character of dynamic trigonometry (**Fig. 17**), as he strives to maximize the fire lines from the bastions—so that there should be no dead ground in which the enemy can manœuvre—at the same time as creating angles such that incoming projectiles strike only

17. *Three Alternative Plans for a Fortified Wall with Fire Lines,* Milan
Biblioteca Ambrosiana, Codice atlantico, 767r

glancing blows. Where there is necessarily a vulnerable opening in the walls to emit fire from the defenders' armaments, the apertures are designed so that anything other than the most direct hit expends its impetus impotently in successive rebounds. Canted gun ports had long been in use, but Leonardo works with a series of curved profiles, so that the majority of the blows might glance tangentially off the surfaces, much like the 'percussion' of light on the chin of the man drawn in profile (**Fig. 5**).

Where Leonardo is fundamentally innovatory is not so much in the details of his design as in developing the principle that military architecture, like every other form of invention, should be founded on set rules drawn from the relevant laws of nature. Even Francesco, who was notably interested in Aristotelian ideas, had not conceived the marriage of theory and practice in quite this way. Looking into the future, we can see how the abutting of bookish physics and practical operations, which was to stand at the heart of the scientific revolution effected by Galileo and others, was already present in what Leonardo was striving to accomplish. What he was not able to achieve was to revise in a fundamental way the laws of dynamics he had inherited from Aristotelian natural philosophy. That reform was to await Galileo and

levels of mathematical analysis to which he could not aspire.

An excellent example of how he thought about military devices is his design for a giant crossbow (**Fig. 18**). Although repelled by the effects of war, which he called 'beastly madness', he was drawn deeply into the design of ever-more destructive weapons— drawn both by the wishes of his patrons and by his own fascination with the challenge of systems that could amplify human power a thousandfold. This highly finished design looks at first glance like one of the kinds of unrealistic 'treatise' designs, intended to impress patrons rather than to be actually constructed. On such a scale, the problems become formidable, not least the thickness of the arms of the bow, for which he has conceived sliding laminations to overcome their propensity to crack when drawn back with the enormous power required. When the giant bow was actually built for a television programme, the limbs cracked alarmingly—though the builders mistakenly set off on a track dictated by their confidence that they knew more about laminations than Leonardo, who was working in a context where wood technology had been developed to levels no longer available. In contrast to what looks like the unrealistic aspirations of the design, a series of preparatory sketches, not

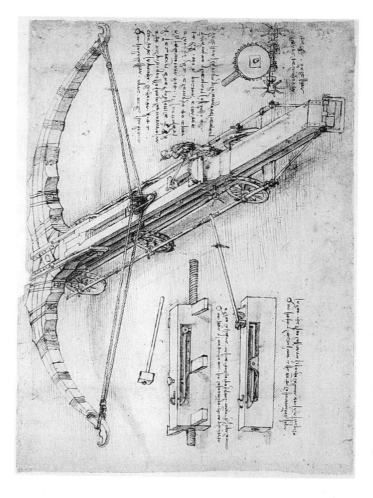

18. *Designs for a Giant Crossbow*, Milan, Biblioteca Ambrosiana, Codice atlantico, 149rb

least for the release mechanism, indicate that he was taking the practical aspects of the design very seriously indeed. In theory, the increased scale should (according to the proportional laws of dynamics) allow a missile to be hurled immense distances or, as is more probable here, permit the firing of extremely heavy projectiles to breach stout defences. Elsewhere he was concerned with the design of explosive shells, which could make such a missile-launcher even more penetrative.

Being Leonardo, the issue of the ratio of the force exerted by the released bow string and the depth of its withdrawal is an issue to be confronted. The obvious formula to apply would be to take the force as directly proportional to the depth of pull—that is to say, if the string is withdrawn to double the distance of the first pull, it would be doubly as effective. However, this will not work. The act of drawing back the ends of the arms upsets the geometry. The points of attachment of the bow string will be drawn towards the direction of the pull, and the distance between them will become less. The simple proportional triangles beloved of Leonardo become inoperable. However, there must be a definable proportional ratio, otherwise Leonardo's principles would have collapsed in a way that he considered unthinkable. He settles on

the power of the withdrawn bow string as being inversely proportional to the angle it makes at its point of withdrawal (that is, where the base of the projectile is lodged). Thus, if the string inscribes an angle of 45°, the force that thrusts the projectile towards its target will be double that generated when it inscribes a 90° angle. Since he had no trigonometry, he cannot take the mathematics of this hypothesis any further, but he is content that he has the right answer because it feels right within his system of thought. We might say, anachronistically, that the rule of the angle of the bow string harmonizes properly with the aesthetics of dynamic law.

Every device—a lever, a pulley system, the gearing required to equalize the power of an unwinding spring, a jack, a pair of tongs—acted in similar accordance with the underlying structure of natural law. The action of biceps in the arm, the biting power of our jaws, the levers operated by muscles attached to the ribs to accomplish breathing, all conformed to the same 'Necessity' of mechanical law. He explained that the muscles in the neck that were necessary to sustain our heavy head in an upright position worked according to exactly the same set of principles as applied when the designer of a system of stays to support the mast of a boat was trying to give it maximum stability.

Given this insistence on the rational anatomy of machines, it makes sense that Leonardo should attempt to design sets of those stock components that might be permutated to create any variety of new 'body'. Previous engineers had concentrated on complete machines. Leonardo turned his attention to the 'elements of machines', components that potentially exercised their utility beyond that of a single context. A properly designed component, in which all the mathematics was right, should be of universal applicability. Thus we find wonderfully succinct drawings for ring bearings, axles, hinges, gears, ratchets, cams, couplings, springs, and so on. Any kind of new body could potentially be assembled to undertake any designated function. At their best, his designs have that air of compact inevitability that makes one wonder why no one else had thought of it. A patron who received a pair of tongs made by a German technician at Leonardo's behest was, in effect, being presented with an implicit lesson in theoretical mechanics and the proper practice of engineering design.

The *Uccello*

The great prize for Leonardo the engineer was flight—the making of the *uccello*, the 'great bird', on

which he set such store. Anyone who could master the skies could indeed claim to have become a 'second nature' in the world. The ambition to fly had mythological roots, with the ancient inventor Daedalus, who tragically sacrificed his son in the quest. A similar fate befell a sixteenth-century aviator at the court of James V in Scotland. For his part, Leonardo recommended that his machine be tested over a lake by a flyer equipped with a life belt in the form of inflated wineskins.

It was Daedalus' more successful exploits and general renown that had led Carlo Marsuppini, the humanist Chancellor of Florence, to compare Filippo Brunelleschi's renowned inventions with those of his ancient predecessor. Amongst the medieval *magi*, Roger Bacon, whose quest for a universal science was a source of inspiration for Leonardo, was famed for his desire to create man-powered flight. Bacon, the thirteenth-century Franciscan philosopher and theologian, had set an agenda very close to Leonardo's, embracing such fundamental sciences as optics and dynamics as well as the invention of ingenious contrivances. Leonardo was well aware of the immortality that awaited him if he succeeded in soaring into the air: 'the great bird will take its first flight on the back of the great Swan [i.e. from the slopes of Monte Cecceri near Fiesole] filling

the universe with stupor, filling all writings with its fame, and bringing eternal glory to the place of its birth.' He was equally alert to the potential for derision if he failed in full public gaze. He writes at one point that he should test a trial wing on the roof of the Corte Vecchia away from the side that was overlooked by the workmen constructing the crossing dome of the cathedral. In all respects, the activity was best kept secret until he could unveil his *uccello* with assured success and to universal acclaim.

The foundations as always lay in nature, in this case very directly. Birds and bats showed that it could be done, and demonstrated the means to that end. This is not to say that Leonardo considered following the legendary precedent of Daedalus by attaching feathery bird's wings to his arms in the hope of flapping aloft. He knew from the first that power-to-weight ratio was a problem. He knew enough about anatomy to understand the human arm was not built for flapping with a power equivalent to that of a bird's wing. Characteristically, he embarked on researches into the flight of birds, since he needed to understand the principles on which he could proceed, if he were to succeed in creating analogous results using only human power. In his earliest sustained attempts to design an ornithopter in the years before 1490, he

conceives wing designs with skeletons closely inspired by those of flying creatures, but he attempts to bring other human muscle groups into play, particularly those of the legs. Perhaps his pedalling feet could amplify his arm and chest muscles sufficiently to achieve the desired lift. The wings themselves use assemblages of wooden bones, rope tendons, and leather ligaments to achieve the sinuous motion created by the 'hand' of the bird's wing. The vision was beautiful, but he came to realize that none of his cherished schemes would work in the required way.

In the second major phase of his assault on this problem when he was back in Florence, he took a different tack. The small codex in Turin devoted to the flight of birds and dated 1505 shows that he renewed his studies of birds gliding in the thermals high above the Tuscan hills—particularly of the great birds of prey who circle without flapping as they survey the ground below for potential victims. He made sketches of the vortices of air below the concave palm of a bird's wing, worked out what the shifts of the bird's centre of gravity might accomplish, and how small motions of the tail could achieve great things. He now adopted the strategy of active gliding, in which whatever motions were given to the wings and tail were directed at controlling the pitch, banking,

and path of the glide rather than achieving unaided lift-off. The wing design was still based on those he had observed in nature, in terms of principles and general disposition rather than precise imitation. The aviator, probably with a tail to help with steering and stability, was to hang below the wings using his centre of gravity to control the flight as best he could. He wrote optimistically:

> A bird is an instrument working according to mathematical law. It lies within the power of man to make this instrument in all its motions, but without the full scope of its powers; but this limitation only applies with respect to balancing itself. Accordingly we may say that such an instrument fabricated by man lacks nothing but the soul of man.

Although he knew nothing about aerofoil design in the modern sense, and had only a tentative grasp of the different pressures exerted by compressed and rarefied air, his consultation of nature's engineering did ensure that he was on more or less the right track. One of his later wing designs (**Fig. 19**) has been built by Skysport of Bedfordshire in England and tested by Judy Leden (world hang-glider champion), with triumphant success. The key feature of this design, laconically but clearly drawn and labelled by Leonardo,

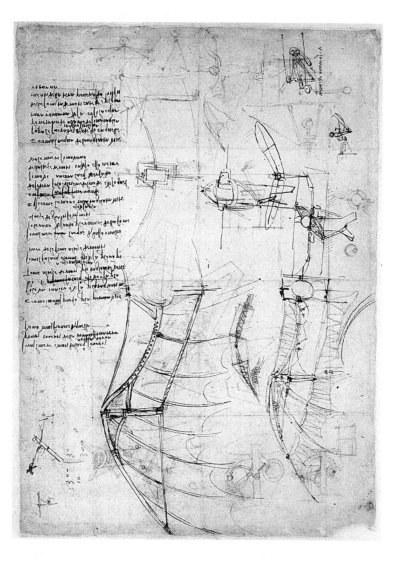

19. *Design for the Wing of a Flying Machine*, Milan, Biblioteca Ambrosiana, Codice atlantico, 858

is that the cloth (*panno*) covering the upper layer of the wing was to be wrapped over the leading edge and secured well back on the lower side. Together with the shape and structural integrity of the wing's skeleton, this formation resulted in sufficient lift to secure a flight that exceeded the first attempts by the Wright brothers in 1900. There is no evidence that Leonardo himself actually built this wing design, let alone launched it from a Tuscan hillside in a way comparable to its maiden flight on the Sussex Downs in 2003. His sheer inventiveness often presented him with so many alternatives as to paralyse his choice. But the pious re-creation of his design does show that his insights as to how the human inventor might proceed were valid, even if in this case he got the right result for the wrong reasons—at least in terms of the physics at his disposal. He was indeed close to realizing his *uccello*, at least as a gliding bird.

The notions of human and animal bodies as machines and machines as kinds of body were to enjoy long histories. Descartes argued that animals were mere automata, while increasingly ingenious constructions of mechanized animals and humans succeeded in performing animate tricks in a remarkable way. A duck invented by Vaucanson in eighteenth-century Paris even digested grain in a 'chemical' stomach.

Perhaps inevitably, the question of *l'homme machine* became a major bone of philosophical and theological contention. The idea that a mechanical device might actually achieve something equivalent to a super-human also has a long history—rendered more urgent by the advent of computers and the contentious field of artificial intelligence. Some fragmentary designs suggest that he might even have been thinking of a kind of man-automaton. In any event, in his general vision of the body-machine, Leonardo demonstrated an unerring intuition as to where some of the very biggest issues of human intellectual endeavour were to lie. It was not the only field in which he manifested such intuition.

THE LIVING EARTH

The earth has a vegetative spirit in that its flesh is the soil, its bones are the configurations of the interlinked rocks of which the mountains are composed, its tendons are the tufa, and its blood is the water in the veins; the lake of blood that lies within the heart is the oceanic sea, and its breathing is the increase and decrease of the blood during its pulsing, just as in the sea is the flux and reflux of the water; and the heart of the spirit of the world is the fire that is infused throughout the earth, and the seat of the vegetative spirit is in the fires, which in various locations in the world spouts forth in mines of sulphur and in volcanoes.

THIS QUOTATION FROM the Codex Leicester, now owned by Bill Gates, was written in about 1508, in the wake of Leonardo's dissection of the 'centenarian'. It expressed one of his most long-standing and central tenets. Almost twenty years earlier he had outlined the same general analogy and distinct parallels. In the earlier note he specifically said that 'by the ancients man was termed a lesser world'. Elsewhere he associates the idea with Ptolemy, the revered ancient authority on the earth and the heavens. The basic concept was that the body of the human being was a microcosm, mirroring in its whole and parts the macrocosm, or greater world. It was not so much that the lesser and greater worlds literally looked similar, but that the principles of organization—of the fittingness of form to function in the context of universal flux—were shared at the profoundest level. Rules remain valid independently of the scale of the phenomenon.

There was no shortage of 'ancients' to whom Leonardo might have been referring. Plato, for example, was an important adherent to the idea. Perhaps the Roman author and orator Seneca is closest to Leonardo in how he relates the overall notion to the behaviour of the parts:

The idea appeals to me that the earth is governed by nature and is much like the system of our own bodies in which there are both veins (vessels for blood) and arteries (vessels for air). In the earth are some routes through which water runs, some through which air passes. And nature fashions these routes so like the human body that our ancestors even called them 'veins' of water . . . As in our bodies, when a vein is cut, blood continues to ooze forth . . . so in the earth when veins are loosed or broken a stream or river gushes out.

Closer to home, geographically and chronologically, Dante's *Quaestio de aqua et terra* provided him with a sophisticated discussion on the role of waters in the body of the earth. Whereas he could read Dante's *Divina commedia* in the vernacular, Dante's *Quaestio* made demands on Leonardo's shaky Latin, as did the works of his ancient predecessors. Judging from his earliest manuscripts and the limited nature of his access to the treasury of ancient learning throughout his career, it seems unlikely that Leonardo learnt Latin to a high level at an early age. His later efforts to master it resulted only in a laborious ability to grapple with those texts that he considered really crucial. Although Leonardo claimed, with inverted pride, to be a man 'without learning' who relied only on 'experience', he well knew that a great deal of

important wisdom was locked in Latin treatises, and he went to considerable trouble to consult a wide range of authors on 'natural things', both classical and medieval.

The microcosm was common philosophical property in ancient and medieval thought, and Leonardo's espousing of the theory is unremarkable. What was remarkable was the way he expressed it and the powerful uses to which he put it. His novelty of expression is above all visual. It is not just that no one had provided compelling visual demonstrations of the whole and the parts in microcosmic terms, but that no one saw how the processes of representation itself acted as a theoretical lever in developing the analogy so that it might work with maximum potency. It seems likely that the analogy he developed between the motion of water and the curling of hair—with its mathematical underpinning—was the outcome of Leonardo's interlocked acts of drawing and thinking. Using the unique power of his visual thinking and graphic skills, he was able to pass beyond the generality of the analogy and to transform representation into a powerful analytical tool that could bear upon related physical phenomena at any conceivable scale.

Analogy was an age-old strategy in the intellectual craft of reasoning, and it is still much used today as a

way of enhancing understanding, by referring to something difficult and unfamiliar in terms of the known. For Leonardo, as for many of his predecessors, it was not simply a strategic tool in argument but was also an expression of the fundamental commonality in the organization of all things. Thus, if there was a satisfactory explanation of one phenomenon, and another could be observed to share its essential patterns of behaviour, it was possible to be confident about the 'causes' (*ragioni*) operating in the second case. It was on this basis that the otherwise absurd goal of universal understanding became thinkable.

Branches of Knowledge

Whenever Leonardo wrote about the systems of the human body, natural analogies and metaphors abounded. In particular, we encounter a veritable forest of trees, with roots, trunks, and branches. When he devised the scheme to demonstrate the nervous and vascular systems in isolation, showing their ramifications in full three dimensions, he naturally called them 'trees'. This in itself is hardly surprising, and is no more than contemporary scientists might do when looking for a convenient name for something they have devised. But Leonardo

put the idea to specific use. I will look at one developmental question that he believed the microcosm could solve, and at one detailed issue of design and function.

The developmental question concerned the origins of the vascular system from either the heart or the liver. Leonardo settled this dispute to his own complete satisfaction through analogy. On one of the sheets of studies of the vascular system undertaken close to the time of the 'centenarian' dissection, he appends two inset drawings of a heart with its main vessels and a germinating seed with roots and branches (**Fig. 20**). It is visually apparent that the seed is to the plant as the heart is to the 'tree of the vessels'. Indeed, he points out that it is evident that the vascular system is rooted in the 'dung of the liver'. By drawing the analogy, rather than merely outlining it in writing, he makes the force of the analogy self-evident.

The issue of design and function involves the branching of the air passages in the lung. Looking at the beautiful coralline structure of the bronchi in the lungs, he writes: 'the total amount of air that enters the trachea is equal to that in the number of stages generated from its branching like . . . a tree in which each year the total estimated size of branches when added together equals the size of the trunk of the

H S

20. Based on Leonardo, *Comparison of the Heart with its Major Vessels and a Germinating Seed* (detail), Windsor, Royal Library, 19028r

tree.' There is a fundamental and universal rule at work here, applicable to all branching systems. Expressed in modern terms, it means that the total cross-sectional area at any level in the system should equal every other. The reason is drawn from dynamics. Leonardo realized that the amount of fluid passing through a tube at any point was proportional to the area of the cross section of the tube (essentially the law credited to Bernoulli in the seventeenth century). If, at a point of branching, the volume of fluid passed into a space too large for it, or too small, turbulence would result, which would both be inefficient and potentially destructive of the walls of the tubes. The rule of 'Necessity' would have been subverted with bad consequences. In the bronchi the efficient bifurcation is into two similar tubes, each of cross-sectional area one-half of the parent bronchus, but the same rule would apply to asymmetrical branching. Cross-sectional areas of one- and two-thirds could work equally well.

He well recognized, for example, that trees themselves did not bifurcate symmetrically, and that individual specimens were full of cussed particularities that distinguished them from other trees. But he sustained the general rule. He explained that, if an arc centred on the trunk is drawn through the

branching system, the total sum of cross-sectional areas across the arc would be the same as the areas at any other arc drawn from the same centre (**Fig. 21**). He explained: 'If in every year the branches which each tree has acquired when they have finished growing are added together in thickness, these are equal to the branch created the previous year and which has given rise to them.'

The reason for this equality lies in the flow of the sap: 'between one ramification and the next ... the tree will be of uniform thickness, because the sum of the humour that feeds the beginning of this branch continues to feed it until it produces the next branch, and this nourishment of equal cause produces equal effect.' That is to say, the humour (sap) behaves in the same way as water in rivers or air in the bronchi. This manoeuvre to sustain the rule of law in the face of individual variation in branching pattern may stand as exemplary of Leonardo's whole endeavour. The relationship between the great generalizations and the behaviour of particular things has always been the biggest trick in science. Leonardo managed it through visualization. It is a trick that operates as much in the *Mona Lisa* as in the branching of a tree. She is at once a demonstration of universals and a picture of particulars.

21. Based on Leonardo, *Studies of Equalities of Cross-sectional Areas in the Branching of a Tree*, Vatican, Library, Codex Ubrinas, 346r

The same law of transmission applied to an open conduit as to a closed one. The volume of water passing at a particular point in a river or canal would be proportional to the cross section of the stream of water at that point. This provided a lesson of which the water engineer must take heed. It provided, for instance, a basis on which Leonardo could calculate the way to measure the amount of water to draw from the Lombard water course in order to receive the full value of concession granted to him by the French king. Over the long years, the natural water courses in the body of the earth have been involved in a continual quest to obey the law of flow, seeking the most direct route to achieve the end of regular and non-turbulent motion, though it was in the nature of the constant flux in the universe that the quest was perpetually continuing rather than demonstrably completed.

Master of Water

It was prestigious to be numbered amongst the 'Masters of Water', as Leonardo was when the Florentine authorities were considering digging a canal to bypass Pisa. Water then played a more overt and threatening role in human affairs than it does in

modern technological civilizations. It provided the main source of large-scale power, the best means for the transportation of heavy loads, a necessary source of human sustenance (not to be taken for granted in an area before mains water supplies), an essential wherewithal for the conduct of agriculture, the chief medium for international trade, and the necessary domain for any secular power that hoped to exert its might beyond the confines of its land. If a ruler wished to be seen as beneficent, the construction of public fountains was a wise move. But water out of control was also a potential source of cataclysmic havoc.

Leonardo was convinced—presumably as anyone regularly involved with its practical management was bound to be—that it was better to work with water than against it. Water could not be readily pushed around. His theoretical stance was that water exhibited a 'natural desire' in any dynamic situation, and that it would wish to accomplish its ends in the shortest and most expeditious way. He was well aware of the power of impeded water, recording, for instance, that turbulent vortices could scour shapes like 'vases' out of hard rock. When he considered how to prevent a house on the bend of a river from being fatally undermined, he did not recommend straightforward

shoring up of the banks, knowing that the remorseless nature of erosion was such that the problem would return after a certain period of time. Rather, he proposes a weir upstream to cajole the water into a different flow pattern, so that it would exercise its erosive force somewhere else and would tend to deposit transported sediment on the banks adjacent to the house. A 'Master of Water' would know the character and customs of his charge, and would negotiate solutions other than the obvious.

In one particularly telling coloured drawing of weirs and banks just downstream from a chain ferry (**Plate 9**), labelled left to right for someone else to read, he records how the current that pours through a central aperture in a weir turbulently twists and spirals into the banks at a certain distance, excavating an area of damage in spite of the fortifying wall. The current then wheels further along the bank causing a secondary zone of destruction. In the notes appended to the drawing, he records the extent of the damaged banks in *braccia* (standard arm-lengths). The drawing is in effect a graphic report by a consultant, explaining that rebuilding the banks would be a short-term remedy only. Presumably he was ready with a longer-term solution to address the fundamental problems caused by the basic form and positioning of the weir.

The sense conveyed by this drawing is that Leonardo was indeed involved in providing practical services as a 'Master of Water'. This impression is reinforced by his employment by the state of Venice in 1500, where he stayed briefly after the fall of Ludovico il Moro in Milan. He became involved with the Venetians' enduring efforts to combat the threat of the Turks, not only by sea but also on land. He was asked to see how the River Isonzo might serve as a more effective barrier to curb possible Turkish incursions via Dalmatia. He recommended managing the river in such a way that 'a small number of men aided by this river might do the work of many', to quote from his draft report, which only survives in fragmentary form and is accordingly difficult to follow. In this instance, we are fortunate to have evidence that Leonardo's ideas were put into practice in whole or in part. He later wrote a memorandum reminding himself about the 'sluices I made in Friuli', the Venetian border region.

The Florentine authorities, who were presumably the intended recipients of the report on the destructive weir, specifically consulted Leonardo on their pet scheme to divert the Arno around Pisa—or rather what appears to have been the pet scheme of Niccolò Machiavelli, who was then secretary to the wartime

council. The coastal city of Pisa, at the mouth of the Arno, had traditionally presented Florence's most ready access to the sea, though the Signoria also cultivated the Lord of Piombino to maintain alternative port facilities, sending Leonardo to assist Jacopo IV Appiani with his defensive preparations.

When Charles VIII's French forces passed through Tuscany in 1494, disturbing the diplomatic balance and inadvertently triggering the expulsion of the Medici from Florence, the Pisans had taken the opportunity to free themselves of Florentine domination. By 1500 Florence had for too long been embroiled in an inconclusive war to regain mastery of Pisa. The master stroke would be to negate Pisa's great asset. If a canal to the sea could be dug from the Arno west of Pisa, bypassing the city, who would need the Pisans' port? And the Pisans themselves would be deprived of water in their river. Traditionally it has been considered that Leonardo was instrumental in promoting this scheme, and must bear significant responsibility for the fiasco that ensued when the Arno refused to be diverted into its new channel. As far as we can tell from the surviving documentation and his own manuscripts, Leonardo was indeed dispatched to the war zone, acting as a consultant on particularly vexing aspects of the project, but there

is nothing to indicate that it was his brainchild. His instincts would have been far from endorsing any intervention in nature that went against the 'natural desire' of the Arno.

He was, however, concerned to mastermind an even grander scheme to connect Florence to the sea, or rather to link the Arno at Florence with the navigable section of the river west of Pisa. Even today, the Arno downstream of Florence passes over some rocky riffles and meanders unsuitable for boats of even modest draught. The project he devised involved the bypassing of the unnavigable reaches with a great canal, arching to the north. He identified a route, certainly not the most direct as the crow flies, that passes through low-lying lands close to Prato and Pistoia (**Plate 10**) and avoids extensive excavation and even tunnelling. The basic soundness of his survey is confirmed by the modern routing of the A11 autostrada from Florence to Pisa. The project might seem like pie in the sky, but he had studied the great schemes of canalization in Lombardy (albeit across a flatter topography), and was aware of how such an enterprise might be financed. Others before him had toyed with the idea. His proposal, in keeping with the pioneering capitalism of the Florentine economy, would have involved the rich Florentine Wool Guild putting up

the money and gaining long-term income from tolls and the sale of water concessions. He notes that 'since it [the canal] will be without locks and more continuous, it will be more remunerative in the places it flows through'.

The maps in which he thinks through his scheme are extraordinary. They are less like conventional charts—though he is at pains to include scales—and more like living demonstrations of geography in action. The illustrated example (**Plate 10**) is the Jackson Pollock of the map-maker's art, in which order and chaos blend in a rhythmic ensemble that goes far beyond simple description. Having thus brainstormed, Leonardo pricks the main lines for transfer to another sheet. Whenever he draws a map, it always conveys the living body of the earth as a vital thing. Even in the *Map of Imola* (**Plate 3**), the most precisely measured product of his cartography, the river pursues an actively turbulent course, and the town itself breathes the character of an organism as much as an inert plan.

His far-ranging efforts to master the topography of Tuscany had important fall-outs in his subsequent thought. He became convinced that the ancient landscape was very different from what he and his contemporaries could see. He concluded:

In the great valley of the Arno above Gonfolina, a rock was formerly united to Monte Albano, in the form of a very high bank that kept the river pent up, so that before the Arno could flow into the sea ... it formed two great lakes, of which the first was where we now see the flourishing city of Florence together with Prato and Pistoia ... From the Val d'Arno upwards, as far as Arezzo, another lake was formed, which discharged its waters into the former lake. It was closed at about the spot where we now see Girone, and occupied the whole of that valley above for a distance of 40 miles in length.

This truly grand, long-term vision was to have profound consequences on how he viewed the history of the earth, as we will see. One direct precipitate is the landscape in the *Mona Lisa*. It has been claimed that her landscape is based closely on the topography of a specific location in Tuscany, and the bridge has been identified as the Ponte di Buriano near Arezzo. In the environs of the Gherardini family villa, the landscape is alternatively recognized as that visible from the window in which she supposedly sat. The truth is that Leonardo was concerned to remake nature, not to create a portrait of a particular spot, however scenic. The topography behind Lisa is deeply nourished by specific observations, not least of the peculiar hills

visible to the modern traveller from the Florence to Arezzo railway, but they are distilled into general configurations in which Leonardo, Godlike, creates *his own* earth. Lisa's two-level landscape, the higher of the bodies of water on the right residing above its natural position, is a distillation of what he had learnt thinking about high and low places in Tuscany. The implied instability of one of the mountains to the left of her head, which is severely undercut, implies that things are to change radically at some undetermined point in the future. A vast transformation is in prospect, in which the quietly meandering courses in the lower lands below her balcony, with their neatly fabricated bridge, are to be overtaken and reconfigured by a *force majeur* before which any human engineer will be impotent.

Characteristically with Leonardo, the specificities of particular projects, in this case concerned with managing the Arno, are transmuted into the generalities of his great vision of the nature of the world— and, as will become apparent, even beyond. The more immediate implications are apparent in his most famous picture, which was being painted at the very time when he was most deeply involved in the theory and practice of the body of the earth. The sheet of the anatomy of the 'great lady' drawing (**Plate 8**), on

which he meditates on the most profound cycle of transformations in the human body, and the study for the arching canal are, in effect, as much preparatory studies for the *Mona Lisa* as any drawing he might have made in her actual presence.

Vene d'acqua

Thinking about subterranean water courses, he called them, as Seneca had done, 'veins [or vessels] of water' (*vene d'acqua*). The vascular system of the 'body of the earth' was not simply a surface feature, involving seas, lakes, rivers, streams—vivifying the flesh/soil that clothes the bones/rocks—but also involves *vene* that penetrate the whole of its body. This vision, founded entirely upon traditional concepts, as we have noted, is developed in his later thought into an unprecedentedly dynamic picture of the earth and its waters—in the short, middle, and very long terms.

Looking at the mechanisms of the earth as a whole, such natural processes result in continuous flux that permeates every part of nature. In theory, since every element 'desires' to return to its due place in the order of things, the set-up should be moving towards a position of stasis, in which the spheres of earth, water, air, and fire settle into neatly concentric zones.

Manifestly, looking at nature, this is not the case now and there are no obvious signs that it is achievable in any foreseeable future. The earth protrudes decisively through the sphere of water, establishing wide plains and raising great mountains high into the air, while the earth has sunk in huge tracts below the natural level of its own sphere, to be filled with seas and lakes. To understand the basic situation he elegantly reduces the complexity of the irregular earth to a simpler geometrical configuration: 'If you take a cube of lead the size of a grain of millet, and by means of a very fine thread attached to it you submerge it [in a drop of water], you will perceive that the drop will not lose any of its original roundness, although it has increased by an amount equal to the size of the cube which has been shut within it.' The larger the cube, or, as in the illustrated diagram, the larger the pyramid (**Fig. 22**), the less the sphere of the water will be able to cover the corners of the geometrical body, and they will begin to extrude into the air.

But this would again provide a stable situation. What he is faced with is a compound system subject to continuous change. Rains fall on the mountains, carrying eroded rocks, soil, and silt into lower regions. Mountains collapse and dammed-up lakes burst their confines, inundating the lands below. The internal

22. *Diagram of a Pyramid Partially Surrounded by a Sphere of Water*, Seattle, Bill Gates Collection, Codex Leicester, 35v

parts of the body of the earth are, if anything, even more unstable. The substance of the earth is not of uniform density, and is permeated by great caverns of water, stream, air, and fire. Catastrophic internal collapses occur, precipitating vast tremors, eruptions, and sinkages in the earth's crust. The net effect is that the centres of gravity of the earth and the sphere of the waters move significantly in relation to each other, which in turn throw newly uncovered lands into the air and thrust previously habitable lands beneath the waves.

We have already noted his great theory about the prehistoric lakes that once submerged wide expanses of Tuscan land. On an even grander scale, he supposes that in the fullness of time the Mediterranean ocean will 'reveal its bed to the air, and the only water course remaining will be a very great river'. The process is one of utterly radical 'transformation', which can be understood through the geometrical model in which one shape is moulded radically into another without loss of overall volume or mass, but it is infinitely more complex. It is driven by the life force infused in the cosmos by the 'Prime Mover'—the *primum mobile* of Aristotelian cosmology, which stood as the 'unmoved mover' beyond the finite limits of the clockwork of the universe. The result on the body that resided at

the centre of this system, our privileged earth, was to create an essentially animate body. He speaks at one point about the 'breathing of the terrestrial machine', which is visibly manifested in the cyclical surging of the tides.

His vision extends characteristically from the whole to the parts, as it must if his explanations are to function at the level of true proof. One notable phenomenon continued to bother him, as it had his ancient and medieval predecessors. It was evident that water emerged with surprising force from springs high in mountains. How could this occur, when the natural upper level of the water—what we would call the head of water—was far below in the surface of the seas? One explanation, wholly valid in the light of the theory of the microcosm, was that the springs originated in the same way that sap oozes from the top of a severed vine or water spouts from a cut vessel in the head. The earth possessed its own form of pneumatic physiology. A mountain spring was the earth's kind of nosebleed. However, this form of explanation came to seem unsatisfactory, since he was increasingly inclined to seek the specific mechanisms behind even analogous phenomena. He exhorted himself to 'return to the study of natural things', rather than falling back upon traditional wisdom.

He considers various hydraulic explanations for the springs. Perhaps the *vene d'acqua* set up a series of siphons. The siphon was a phenomenon he had spent much time studying as one way of lifting water above its natural level. Or maybe the caverns in the mountains acted like a still, condensing the vapours exhaled by the 'breathing of the terrestrial machine'. Or it might even be that the heat of the sun draws the water upwards, just as water is drawn up into a heated bottle when its neck is inverted in water and it is subsequently cooled. All these are considered and ultimately found wanting for one or more reasons. Eventually he concludes that the springs result from the gathering and expulsion of rains that fall on the highest regions of the mountains—an explanation that is more prosaic than the others but proved difficult, in the final analysis, to gainsay.

What is happening in this episode is typical of the later stages of his thought about physical phenomena. He was increasingly concerned to devise a tight, hard model for every process, every form and function, in which the analogy itself would not do the whole job of explanation. He needs to be able to say, this is the physical law, this is the end in view, and this is the mechanism that performs the necessary functions. Looking at things in this way, he realizes

that the bodies of earth and humans behaved in crucially different ways. For instance, whereas the *vene* of the human body progressively silt up—he concluded that the 'centenarian' had died because of the silting of the vessel that encircles the heart—the water in the caverns of the earth progressively enlarge their cavities. His most radical conclusion is that 'the origin of the sea is contrary to the origin of the blood, because the sea receives into itself all the rivers that are only caused by the water vapours raised into the air'. He had already demonstrated that the 'rivers' of the human body were fed by the sea of blood, which definitively originated in the heart.

We see here and elsewhere the erosion of received wisdom, and indeed of received modes of explanation. This affects almost every aspect of his investigations from about 1507 onwards. He came to realize that the sciences of balances and pulleys, the neatly proportional laws of dynamics, and the one-to-one match between the behaviour of water and air, were what we would call theoretical abstractions. Balances used real arms of finite weight and thickness that complicated their physical performance. Pulleys were full of internal resistances that prevented them from achieving their drawing-board efficiency. If the proportional laws were valid in practice,

a very small object should be moved as rapidly as thought itself . . . If one shoots a small grain with gun powder . . . it should by this reasoning be sent a million miles in the time when a thousand pounds of ball will go three miles . . . You investigators should therefore not trust yourselves to authors who by employing only their imaginations make themselves interpreters between nature and man, but only those who have exercised their intellect with the results of experiments.

The conclusion that the neat theories of proportions in dynamics needed to be qualified by the 'experience' of what actually happens was one that he had already begun to reach in the 1490s. His sense of how actual materials behave is reflected in his realization that air is compressible in a way that water is not, providing a vital component in how birds (and perhaps his flying machine) were able to remain aloft.

As an act of intellectual integrity, his revision of the requirements he placed on explanation is hugely impressive. What remains unsatisfactory is the gap between the erosion of received wisdom and the advent of any new framework of natural law that could supply adequate models for the phenomena. He posited qualifications to the traditional laws, limiting their practical applicability, but he did not doubt that they retained their ultimate validity. If only he knew in

ever more detail what happened in each particular instance, he would be able to validate the mathematical procedures to which he remained committed. It did not cross his mind that a different kind of mathematics might be required, and a different set of basic assumptions about dynamics.

This limitation was shared by all his predecessors and contemporaries. The only reason why we notice them so evidently with Leonardo is that he possessed the imagination and intellectual honesty to lay bare some of the basic problems when bookish theory collides with the practical realities of how things actually behave.

The Deluge

This limitation does not apply when the observations yield to qualitative analysis. The most dramatic case in point when Leonardo is looking at the body of the earth involves his extensive debate about the origin of fossils in relation to the biblical Flood. Ancient philosophers had recorded the strange presence of shells from marine creatures high on mountainsides and other geological evidence of huge transformations in the topographies of land and sea. For many classical authors, such as Seneca, it was apparent that the

disposition of the earth and waters could not always have been as it is now. The Christian story carried a different message. The fundamental interpretation of Genesis was that, when God divided the earth and the waters, he set them up for all time in their present arrangement. This would, of course, include the placing of the shells on mountains, but there seemed little point in such gratuitous placement when everything else in nature appeared to be so deeply purposeful. One medieval explanation was that 'fossils' (including both organic remains and peculiar stones) were 'sports' of nature, arising as the result of some kind of magic deposit or astrological activity. Needless to say, Leonardo dismissed this contention out of hand.

He also had great problems with the idea that the strata of shells testified to the reality of the biblical account of the total inundation of the earth and the preservation of God's creatures aboard Noah's ark. On the face of it, the explanation appeared quite reasonable, but when Leonardo began to look in detail at the evidence, the story did not hold up. We know he did look in detail. There is one nice story, which he himself recorded a decade or so later, of how some peasants who had been working in the mountains near Parma and Piacenza brought to him a sack full of

'multitudes of shells and corals filled with worm holes ... still adhering to the rocks'. Obviously Leonardo had served notice that he was keen to receive such curiosities.

Looking at the specimens, and at their occurrence *in situ*, he encountered a series of discrepancies between the supposed biblical cause and the observed facts. From an elaborate and sometimes tortuous review of the possibilities, he emerges with some killer arguments. The shells were visible in a number of distinct strata, which indicated that there must have been a series of inundations, each reaching different levels. They did not, however, reach to the very tops of the mountains, which were covered entirely with water in the biblical event. There were clear signs that the shelled creatures were once alive where they now appeared, and that they could not be passively washed there when dead. Slow-moving molluscs could not have travelled such great distances from the sea during the course of the 150 days of the Flood. There should be signs of marine creatures stranded in high lakes, which is not the case. This is not to say that no one had paraded any such arguments previously, most notably the 'ancients', who were not constrained by the biblical account, but the clarity with which his explanations insistently return to tangibly credible

evidence and processes is undeniably impressive. He is able in his mind to model the changing earth with extraordinary visual and material cogency.

It is this very ability that erupts most spectacularly in the extraordinary series of graphic visions known as the *Deluge Drawings*, six in number with a series of four or five related sheets of apocalyptic events. The drawings, mainly in grainy swirls of black chalk (**Fig. 23**), are full of fearful noise. The air is rent by huge cataracts. Gigantic vortices scour the lands below, snatching rock, dust, water, and human habitations indiscriminately from their tranquil seats and whirling them to destruction in a furied dance. The enraged elements render human resistance futile. In one, the battle tents of encamped adversaries are wrenched from the moorings and cast into oblivion. Sometimes he shows cowering men and animals, bonded into mutual society by shared peril, in defiance of their natural enmity.

> You might have seen on many summits of mountains terrified animals of different kinds, collected together and subdued to tameness, in company with fleeing men and women with their children. The fields are covered with waters which bear on their waves tables, beds, rafts and other contrivances made out of necessity and fear of death, on which were jumbled men, women and children,

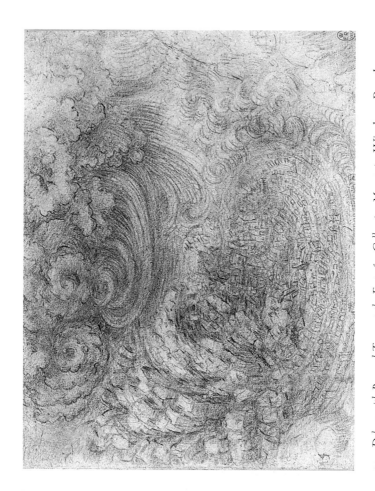

23. *Deluge with Ravaged Town at the Foot of a Collapsing Mountain*, Windsor, Royal Library, 12378

with diverse lamentations and cries, terrified by the fury
of the winds, which in the great tempest [*fortuna*] rolled
the waters over, under and around the corpses of the
drowned.

He also wrote of his intention to show Neptune
astride the foaming waters, and Aeolus, the blustery
god, raging in the heavens, accompanied by his team
of winds with bulging cheeks and blaring trumpets.
But in what may be the most developed of his visions,
the divine, human, and animal actors are nowhere to
be seen. The vortices take centre stage. They are charac-
terized with a *terribilità* worthy of Michelangelo's *Last
Judgement*, but they orchestrate their terrible destruction
according to the remorseless laws of the motion of
fluids. His descriptions of the deluge or *fortuna* are
typically laced with the language of medieval impetus
dynamics, which I have deliberately retained in the
following translated excerpt:

> The swollen waters gyrate in the lake that contains them,
> and with eddying vortices percussively strike diverse
> objects, and leap into the air with muddy spume, and
> then falling back and making rebounds in the air with the
> percussed water. And the circular waves that fly from the
> place of percussion march with transverse impetus
> against the motion of the other circular waves that

move against them, and after making their percussion they leap up into the air without being separated from their bases . . .

The passage continues in this extraordinary vein, blending physics and fantasy, for many more lines before the storm of his imagination stills. It takes someone of Leonardo's supreme powers of three-dimensional visualization to hold all these processes together in the ceaseless dialogue between his mind and his hands. There is no element of the kit of attributes that set him up as a 'second nature' in the world that is not being deployed. Eye and intellect, *fantasia* and *memoria*, *invenzione* and *ragione*, *volontà* and *disegno*, all play their full roles in recreating as great an elemental drama as can be conceived in the dynamic history of the body of the earth.

TELLING TALES

THE INTERPRETATIVE PULL on Leonardo's legacy
in the twentieth century was towards the
prophetic scientist and technologist. The
'science' of his pictures, something by which he him-
self set great store, has accordingly been emphasized.
It may come as something of a surprise, therefore, to
find that, when he listed 116 books in his possession
(a substantial number for all but the wealthiest biblio-
phile at that time), between thirty and forty can be
broadly characterized as literary in type, including
grammars and dictionaries to help him improve his
grasp of Latin. Another group of a dozen or so are
concerned with religious stories and tracts, which
would have served him well as a painter of religious
subjects. Those dedicated to what we would call

science, medicine, and philosophy number forty or so (accepting that our classifications do not work all that well with a Renaissance collection). A wide variety of literary works was represented: poetry on amatory, burlesque, and philosophical themes; fables and tales of moralizing import (no less than three Aesops, one in French); and a few historical works. When he disparages poetry in his *paragone*, he does so not in ignorance of its range but with a full awareness of the types of poetry that would have been consumed in the household of the Medici and in the court of Milan. The occasion for his making this list was the storing of his books in chests for safekeeping, probably in 1504 when he went to Piombino as a military consultant. It does not necessarily include all the books he owned at one time or another, nor does it indicate the full extent of his reading, but it does give a good cross section of the kinds of texts he valued.

His combating of the claims of poetry to occupy the highest rung on the ladder of the courtly arts should not be taken as dismissal of the poetic imagination as such, in favour of the visual truths of painting. His point was that the poets necessarily had recourse to inferior powers of communication, since they could not directly avail themselves of the immediacy of the highest sense of all. Their art had

to pass through the ears, or their words needed to be read sequentially on the page. In matters of *fantasia* (imagination or fantasy), they were less potent than the painter, who could make the spectator 'see' what was intended immediately. Leonardo held absolutely to the exercise of what Dante called *alta fantasia* ('high fantasy'). It was just that he believed that he could convey the visual fruits of imaginative invention more effectively than any poet—presumably including Dante himself. It could fairly be argued that descriptive vividness is not poetry's chief claim to artistry, but for Leonardo direct representation of visual things was the *sine qua non* for engaging the spectator or listener in the most compelling manner.

For his part, Leonardo practised the art of literary composition quite extensively in his notebooks. He composed, paraphrased, and transcribed various kinds of short tales, including fables, prophecies, riddles, and humorous anecdotes (sometimes of a ribald nature). Some are entirely derivative, while others appear to be his own inventions. Their compilation appears to be directed towards equipping himself with a repertoire of stories as part of his courtly equipment rather than for any aspiring publication. He had a particular taste for pithy and entertaining snippets with stings in their tails. Typically, pride and

pretension comes before a fall. None of the stories is original in type, but a few do speak of his special engagement with the world of nature:

> The water, finding itself in the proud sea, its own element, was overcome with a desire to rise above the air, and encouraged by the fiery element, raised itself as a subtle vapour, appearing almost as rarefied as the air; and moving higher it reached more rarefied and chilly air, where it was abandoned by the fire, and the minute particles became constrained, were united and made heavy; whence fell its pride and it was thrown into flight and fell from the sky; then it was swallowed up by the dry earth, where it was imprisoned for a long time doing penance for its sin.

And he could, if he so wished, capture the essence of the story and its protagonists in a few eloquent lines of his pen—in drawing not writing.

The stories he recorded about animals, largely derived from Pliny and bestiaries, provided a rich repertoire of characters that could be cast in allegorical dramas and displayed individually when a symbolic allusion was needed. The ermine, present in the portrait of *Cecilia Gallerani*, is an obviously relevant example. 'The ermine, on account of its moderation, never eats but once a day, and it would rather let itself

be taken by hunters than flee into a dirty lair, in order not to stain its purity.' It is easy for us to regard such things as mere 'legends', to be used lightly as appropriate. For Leonardo and his contemporaries, the book of nature was replete with learning, with lessons placed there for our edification. Science and symbol did not live in separate domains in Leonardo's imagination.

He also practised longer passages of word painting, imagining the sublimity of a great mountain, evoking the wonder and terror of a mighty cavern inhabited by the remains of an ancient fish of monstrous proportions, and conjuring up the image of a grotesque giant. The giant features in the draft of a tongue-in-cheek letter to Benedetto Dei, written purportedly as 'news of things here in the East':

The black face at first glance is most horrible and terrifying to look upon, especially the swollen and bloodshot eyes set beneath awful glowering eyebrows which darken the sky and cause the earth to tremble. Believe me there is no man so brave that when the fiery glare was turned on him whom would not willingly don wings to escape, for the face of the infernal Lucifer would seem angelic by comparison. The nose is arched upwards with gaping nostrils from which protrude many thick bristles. Below this is an arched mouth with gross lips from the extremity of which there were whiskers like those of cats.

This kind of literary exercise belongs very much with the world of courtly poetics, and it is likely that some of Leonardo's written inventions were aired for general entertainment.

The Fiction that Signifies Great Things

Leonardo's own literary products can at their best be described as clever 'trifles'. When he wanted to tackle matters of high moment, he relied on painting. The ideal he set for his *fantasia* was that of conveying great truths on the secure foundation of deep knowledge of all natural things. It was an ideal that shared more with Dante, whose poetry is profoundly imbued with natural philosophy, than with the writers of human-centred *novelle* in the succession of Boccaccio.

The way I am going to look at how Leonardo achieved his ends in his artistic production is not to undertake a chronological survey (which is available *in nuce* in the Gallery at the end of the book) or even an overall review of his modest number of surviving works. Rather, I will attempt to illuminate the means towards his ends, showing the processes by which his works came into being—or, in the case of the incomplete ones, the processes that might have

brought them to a conclusion. I will also show how he consciously reformed the relationship between the image and the spectator.

Brainstorming

From the very first in the conception of the work, Leonardo exercised his *fantasia* in a remarkable and innovatory way. He brainstormed on paper. He scribbled furiously, overlaying alternatives in dense tangles and dashing from one part of a sheet to another, teeming with ideas, some suggested serendipitously by the accidents within the graphic mêlée itself. As he wrote,

> O painter, when you compose a narrative painting, do not draw the limbs on your figures with hard contours or it will happen to you as to many different painters who wish every little stroke of charcoal to be definitive ... Have you never reflected on the poets who in composing their verses are unrelenting in their pursuit of fine literature and think nothing of erasing some of these verses in order to improve them? Therefore, painter, decide broadly on the position of the limbs of your figures and attend first to the movements appropriate to the mental attitudes of the creatures in the narrative rather than to the beauty and quality of their limbs. You should understand that if such a rough composition

turns out to be right for your intention, it will all the more satisfy in subsequently being adorned with the perfection suitable for all its parts.

He was fully conscious of what we call imaginative projection in the process of invention: 'I have in the past seen clouds and wall stains which have inspired me to beautiful inventions in many things. These stains, while wholly in themselves deprived of perfection in any part, did not lack perfection in regard to their movements or other actions.'

All this may sound relatively unremarkable. We somehow expect draughtsmen to compose in a rush, a creative scribbling, allowing intention and chance to combine in the emergence of something really new. But no one had done it in this way before.

Verrocchio had drawn impulsively in pen, following a practice in which sculptors appear to have been particularly adept. Fresco painters had dashed down their intentions on the rough plaster of their walls, using earth pigments and brush, before applying the final layer of smooth plaster on which they were to paint. Sculptors had made rough little models in clay and wax. However, none of them had used paper as a locus for sustained graphic experiment in the way that Leonardo was to do.

He might begin with black chalk, soft and suggestive. Pen lines of great energy could then amplify the motions of emergent forms, not once but across a spectrum of possibilities. The space occupied by forms was, after all, a 'continuous quantity'. The resulting graphic tangle of chalk and ink, in which even he might begin to lose orientation, could then be given some selective plastic definition by the addition of a sepia wash, applied with a brush. As a last resort, the most promising of the myriad of alternatives could be pressed through to the other side of the sheet, which potentially invites the whole process to begin again. This improvisatory procedure happens to a greater or lesser degree in all his projects for Madonna and Child compositions for which exploratory sketches survive. The British Museum drawing (**Plate 11**), which is leading in the direction of the full-scale cartoon in the National Gallery in London, embodies all these phases. Remarkably, the sketchy framing lines around the main composition are pockmarked with precisely measured scales. Precision and chaos live together in Leonardo's creative process.

The end product of such designs is images of figures in unprecedented interaction, as dynamic emotionally as they are physically. The Child and the

Madonna can react with and even against each other, and with respect to external factors and figures, in a way that conveys inner and outer imperatives with unrivalled urgency. They can react in happy concert, as in the *Benois Madonna*, where both gaze at the cruciform flower, or there can be a discernible tension, as is apparent in the *Madonna of the Yarnwinder* (**Plate 4**), where Jesus embraces the 'cross' with a premonitionary eagerness that elicits an uncertain reaction from his mother. The earliest account of the painting, written by Pietro da Novellara from Florence to Isabella d'Este in Mantua when the composition was still evolving, captures this sense precisely:

> A little picture he is doing for one Robertet, favourite of the King of France . . . is of a Madonna seated as if she were about to spin yarn. The Child has placed his foot on the basket of yarns [not visible in the finished picture] and has grasped the yarnwinder and gazes attentively at the four spokes that are in the form of a cross. As if desirous of the cross he smiles and holds it firm, and is unwilling to yield it to his mother, who seems to want to take it away from him.

On a far larger scale, the unfinished *Adoration of the Magi* testifies to the revolutionary outcome of his creative procedures. The subject had long been

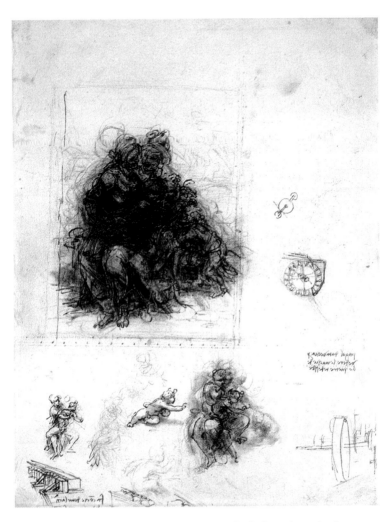

11. *Studies for the Virgin, Child, St Anne (or Elizabeth) and St John the Baptist, with Studies of Hydraulic Engineering*

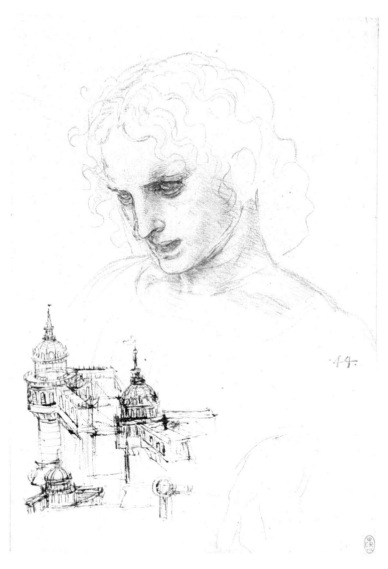

12. *Study for the Head of St James the Greater in the 'Last Supper' and a Corner Pavilion for the Castello Sforzesco*

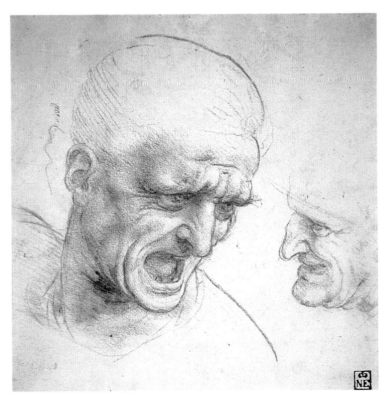

13. *Study for the Heads of Warriors in the 'Battle of Anghiari'*

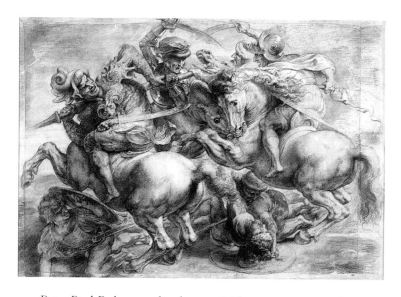

14. Peter Paul Rubens and unknown 16th-century master, *Copy of the Central Portion of Leonardo's 'Battle of Anghiari'*

15. *Last Supper* (details of the table and tablecloth with embroidery at the right)

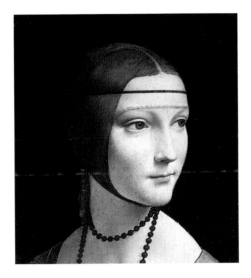

16. *Portrait of Cecilia Gallerani* (detail of head)

17. *St John the Baptist* (detail of head)

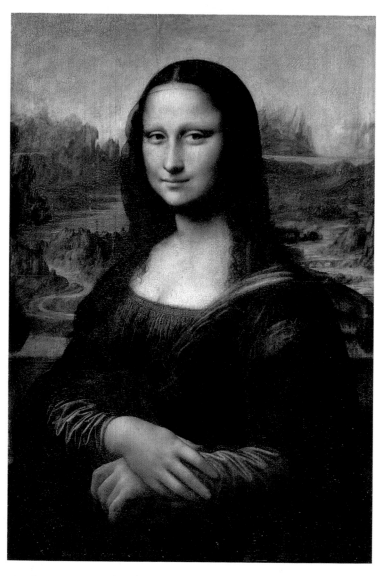

18. *Portrait of Lisa Gherardini (del Giocondo), the 'Mona Lisa'*

19. The Villa Vignamaggio
and the window of
'Lisa's Room' (TOP)

20. *View Across Extensive Valley and Distant Mountains from a High Vantage Point*

characterized in Florence in terms of processional magnificence, with a diverse cast of characters—kings, servants, soldiers, horsemen, midwives, hangers-on, resident natives, and donors—whose diverse reactions presented a great opportunity for demonstrations of artistic skill. The primary actors and much of the supporting cast on Leonardo's pictorial stage are supercharged with nervous intensity, consciously or unconsciously aware that with the birth of a tiny baby the greatest of all dramas was to unfold. Flanked by a contemplative old man and a romantic youth, the players move and gesture in awe and excitement around the calmly spiritual centre of the Virgin. In the background, things run amok at the base of the staircases of the ruined (or incomplete) building on which figures perform various tasks that seem inadequate for the job. The ruined building was itself a stock feature, signalling the birth of the new order from the destruction of the old, but in Leonardo it becomes the setting for the kind of portentous turbulence that typically prefigures earth-shaking events in Shakespeare's tragedies. None of this noisy orchestration could have been accomplished without a manner of drawing that could adequately express the torrent of ideas pouring forth from the artist's imagination.

Organizing the Stage

The background of the *Adoration*, for all its figural chaos, was staked out with mathematical precision. In one of his earliest studies for the complete composition (in the Louvre) he had roughly laid in his ideas for the strange structure, with its twin staircases and arcaded ground floor, without working out its relationship to the foreground stage. Then, an astonishing drawing in the Uffizi (**Fig. 24**) expounds the intended structure with painstaking precision. Linear perspective, with its foundations in surveying, medieval optics, and Euclidean geometry, was the painter's most obvious claim to intellectual fame. He had undoubtedly been schooled in its basic principles while in Verrocchio's workshop, and his own early *Annunciation* shows a very apparent effort to put it into laborious practice. Here he has stepped out the divisions of the pavement along a horizontal line near the base of the drawing, even providing a scale that subdivides one of the paving squares into ninths. He then draws very fine lines ('orthogonals') from the main divisions on the base line to what Alberti called the 'centric point' (our 'vanishing point'). This convergent array can be envisaged as if they are sets of tram lines disappearing into the distance.

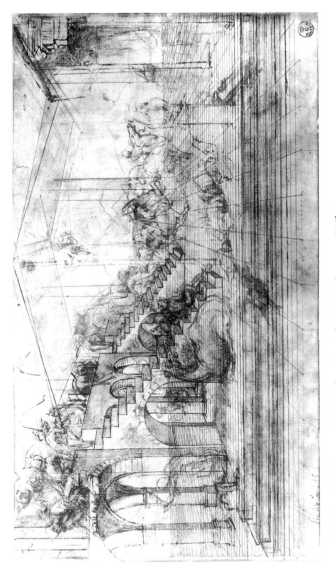

24. *Study for the Background of the 'Adoration of the Magi'*, Florence, Uffizi

The orthogonals of the wider sections of the pavement are cut by lateral boundaries of the composition, and do not therefore reach down to the base line. They must have been defined in a separate construction, so that the vertical locations could be marked along the lines that demarcate the lateral boundaries. The next move is to define the succession of horizontal lines, which become ever more closely spaced as he proceeds backwards. Again, some precalculation must have been involved, so that the vertical locations of the horizontals can be plotted on the surface of the drawing. A line drawn from the corner at the bottom left passes diagonally upwards through successive points of intersection of orthogonals and horizontals. This diagonal cannot have been used to position all the horizontals, since it reaches back only to the twelfth horizontal (level with the top of the upper step). Rather it served, as Alberti recommended, as a 'check' or auxillary guide that the construction was working out correctly. Once these horizontals are laid in, each space framed by two orthogonals and two horizontals denotes a foreshortened square of the pavement. He follows his procedure with a persistence that goes beyond the practical needs of the picture, until, in the deepest regions and in the wider zones of the pavement, the

intervals between the lines becomes so compressed as to be inexpressible accurately even with the fine lines he is drawing. He adds three steps at the front of the pavement, but does not go to the unwanted trouble of adjusting the position of all the orthogonals of the lower regions of the paved space.

On this intensely charted foundation he erects his architecture, all according to perspectival scale; not only the stairs and arcades, but also a skeletal 'shed' of huge proportions (a grand version of the stable in which the Holy Family was lodged) and a fragment of a classicizing building on the right. Within this marked-out space he rapidly sketches the fevered actors and combative horses. In front of the nearest staircase, a resting camel watches anxiously, while shadowy persons perform various semi-legible acts on and around the structure. From a savagely diagonal rent in the pavement, rocks have extruded and plants sprouted. Frenzied energy, untamed forces and fanatical precision work in strange concert. Leonardo knew that unleashed force was something that must expend itself inexorably in space and time.

But even this huge effort of definition was only the flexing of his muscles. The actual performance in the painting carries over only the general structural implications of all this intense perspectival effort.

When we look at the perspective construction in the *Last Supper*, newly restored and pastel bright on its refectory wall, it is possible to see (above all on the right side) a myriad of incised lines mapping out alternative configurations for the coffered ceiling. Even looking at them close at hand, before the conservator's scaffolding was removed, it was not obvious how to disentangle the stages through which the perspectival designs had progressed. When Masaccio painted the audacious coffers in the round vault of his *Trinity*, he too had worked out the construction in great detail with incised lines in the wet plaster, but he had already decided on the basic disposition of the coffers. It was then a question of working out their precise geometry. Leonardo may have begun with a definite idea, but, typically, he thought he could see a better alternative once he was well into its realization—or a number of better alternatives. What he settled on, as far as we can tell from the current state of the mural, was a ceiling six coffers wide, foreshortened in such a way that the vertical space on the wall occupied by the visible part of the ceiling is (surprisingly) equal to just one of the coffer widths as measured at the top of the construction.

The markedly different widths of the tapestries hanging on the lateral wall—the result of their sharp

recession in what is quite a wide-angle view—serves as the kind of visual music that Leonardo recognized in perspective:

> I will . . . found my rule [for the diminution of objects] on a scale . . . just as the musician has done with notes. Although the notes are united and attached to each other, he has nonetheless recognized small intervals between note and note, designating them as first, second, third, fourth and fifth, and in this manner from interval to interval has given names to the varieties of raised and lowered notes.

The essential affinity with music also applied to the proportional design of each object. Musical harmony is 'composed of the conjunction of proportional parts acting simultaneously. It is obliged to arise and terminate in one or more harmonic intervals of time, which circumscribe the proportionality of the parts in no other manner than the contour lines made around the limbs and from which human beauty is generated.' A painting of figures and objects in space should therefore present a kind of plastic and spatial music, available to the eye of the spectator in a single glance.

The ratios of the widths of the tapestries as measured on the wall surface appear to proceed in

a progression from one to a half to a third to a quarter—that is, a musical octave, fourth, and fifth. There is always a chance that such things are the result of the historian's optimistic 'reading-in' rather than Leonardo's calculations, but in this case I am inclined to think that these ratios were indeed plotted by the artist.

The space of the *Last Supper* is compelling and focused, and gives the impression that the refectory in which the monks took their meals (sometimes with Ludovico il Moro himself in attendance) has been extended into another, higher chamber. But it is hugely contrived. For a start, the ideal viewpoint (level with the vanishing point in the central aperture behind Christ) is higher than is accessible to any normal spectator. The architectural elements of the refectory itself align themselves with those on either side of the painted room only from lateral viewing positions, which preclude the alignment of other features. There is no point from which the illusion works perfectly. We can understand why he has done this. A low view-point would have prevented the lucid mapping of the narrative space—table top and all—and too strict an emphasis upon one viewing position would have weakened its efficacy from others. What he has done, much as he did in the *Adoration*, is to use the passages

of geometrical perspective as a kind of scenographic backdrop. If we think about it, the visible portion of the coffers only begins quite deep into the painted room's space, since the screen of cornice and heraldic lunettes conceals as much as half of its total depth. Leonardo wanted a compelling effect, which is what he gets, without driving the illusionistic logic to a point where it effectively breaks down for the mobile viewer. Art conceals art, as they say—or artistic cunning saves the appearance of science.

Actors and Props

The spaces are of course not the be-all and end-all of the pictures. Perspective provided only the opening of the three books in Alberti's *De pictura*. The end in view, as Leonardo would have agreed, was the *historia*, what Leonardo termed the 'fiction that signifies great things'. After the conceptual and graphic brainstorming, and the mapping of the space, the figures required further study. As yet, they were little more than energetic scribbles. Sometimes, as for the *Adoration*, he made sketches of pairs or groups of figures in interaction, perhaps studied from life in the public baths, as he recommended. But the crucial step was the drawing of posed figures from life, generally in the

studio. The youths in the *bottega* might stand in for biblical persons or secular heroes. Or characters with the required features (sometimes with extraordinary faces) might be pressed into service. In a typical note, he recorded that he has found a model for a detail in his *Last Supper*: 'Alessandro Carissimo of Parma for the hand of Christ'.

As it happens we have surprisingly few posed studies from life for whole figures. Far more of Michelangelo's and Raphael's survive. It may be that Leonardo's greatest effort, once he had conceived a pose, went into the heads, hands, and draperies, which were the parts that would be seen. Head studies were his particular forte.

If we set the wonderfully sensitive red chalk drawing in Windsor of the *Head of St James the Greater* (**Plate 12**) for the *Last Supper* beside that of a shrieking warrior in Budapest for the *Battle of Anghiari* (**Plate 13**), we can gain a vivid idea of how dramatically Leonardo can convey the *concetto dell'anima* of men of utterly different character in situations of extremis. St James, full of youthful nervous sensibility, starts back, withdrawing his shoulders and neck at the same time as inclining his head forward to register that the shocking words have indeed been said. His eyes are dark with fear and his mouth open in shocked disbelief. The

warrior was drawn some six or more years later for the doomed battle scene on the wall of the Council Hall of the Florentine Republic. He is recognizable, albeit in reconfigured form, as the central swordsman in Rubens's reworked copy of the lost mural (**Plate 14**). He was probably intended as Niccolò Piccinino, mercenary commander of the Milanese forces, from whom the Florentines are about to wrench his symbolic standard. His face is contorted with rage, his brows gathered into deep furrows and his gap-toothed mouth torn open to its maximum extension. On one of his preliminary studies for the battle Leonardo had depicted heads of a horse, a man, and a lion emitting similar cries of rage through wide-open mouths. The characterization of the warrior conforms to Leonardo's prescriptions for a bestial and wrathful man: 'those who have facial features of great relief and depth are bestial and wrathful men of little reason, and those who have strongly pronounced lines between their eyebrows are evidently wrathful.' When describing how to portray a battle, he explains that those who are losing should be shown 'with their brows knit high and let the skin above be heavily furrowed in pain. Let the sides of the nose be wrinkled in an arch starting at the nostrils and finishing where the eyes begin. [Show] the flared nostrils that cause these crease lines, and the

lips arched to reveal the upper teeth, with the teeth parted as if to wail in lamentation.'

In their respective paintings, the head of St James and the warrior were of course surrounded by types more closely like themselves, but the individuality to which Leonardo aspired could readily differentiate between the youthful saint and the guilty Judas, for instance, and between the savage Milanese and the valorous Florentines. The slighter head on the Anghiari sheet may well be for the Florentine most adjacent to Niccolò. His evident stress is a little less than that of the Milanese commander, and there may be something more benign about his intensity—if we look hard enough and with enough insight. But these are subtle matters, which ultimately depend upon our subjective relationship to the image. At least his study for the head of the other leading Florentine, also in Budapest, is full of handsome heroism that betrays no anticipatory angst.

Hands were also prime subjects of attention, since they speak with an eloquence little less than that of the face. He was intrigued by how the dumb communicate without words:

> The good painter has to paint two principle things, that is to say man and the intention of his mind. The first

is easy and the second is difficult, because the latter has to be represented through gestures and movements of the limbs—which can be learned from the dumb, who exhibit gestures better than any other kind of man . . . Do not laugh at me because I propose an instructor without speech, who is to teach you an art of which he is unaware, because he will teach you better through what he actually does than others can through their words.

When he writes about painting a Last Supper, he details a series of hand and arm gestures: 'One who was drinking has left his glass in its place and turned his head towards the speaker. Another wrings the fingers of his hands and turns with a frown to his companion. Another with hands spread open to show the palms shrugs his shoulders up to his ears and mouths astonishment.' In the Royal Collection at Windsor, eloquent hand studies survive for the *Last Supper* and there is also a terrific sheet of disembodied hands for the *Adoration* at Windsor, which conveys their owners' reactions as surely as any words—or so Leonardo would have us believe.

The other expressive dimension to be utilized to the full was the figure's draperies. They served a range of functions that tend to elude us today. Their basic nature—their style, their social or ethnic type, their

functionality, the quality of their cloth, the fineness of the cut, their luxuriousness or reticence, their historical or contemporary mien, and their modesty or suggestiveness—spoke volumes about their wearers' qualities. Additionally, they were expressive of the body beneath, particularly when the opportunity presented itself to imitate the 'wet-style' drapery favoured by ancient sculptors. Even with more heavy cloths, the thrust of a knee could say much about the figure's deportment. Not least, draperies were a key signifier of motion. A fluttering twist of cloth behind a running woman would leave nobody in any doubt about the pace of her flight. The proper and decorous characterization of clothing was literally a key part of the fabric of the picture.

Some of the most beautiful drapery studies were prepared in connection with the *Madonna, Child, St Anne, and a Lamb* in the Louvre. One in particular, furrowed and furled, looks like the result of a great geological upheaval, while another plays delightful games around the compression of a diaphanous layer over a thicker inner sleeve (**Plate 7**). If the spiralling configuration should remind us of the motion of hair, of water, of air . . . so much the better.

Every component in every painting must be studied with equal meticulousness, first with reverence

towards its own special visual qualities but also so that it might be an active and integrated contributor to the whole sense and meaning of the scene. The restoration of the *Last Supper* has disclosed how little of Leonardo remains, but it has also shown the astonishing quality of what has. For instance, the freshly washed and ironed tablecloth is portrayed with immaculate care. Its reticently beautiful blue embroidery is described with delight, as are the concave and convex creases that have resulted from folding and pressing while it was still somewhat damp (**Plate 15**). The vessels on the table sit discretely and succinctly in space, eloquently foreshortened, with their essential shapes and sheens described with all the economy of a Zurbaran or Chardin.

Lighting

The portrayal of light on such objects, as on all things, was a matter of observation allied to theory. Light was not only used to create what he called *relievo* (relief, plasticity, or modelling), according to the primary rule of its angular impact directly from the source, but it also performed intricate games of rebound and secondary percussion, enlivening the enveloping shadows with seductive glimmers of

acquired illumination. This occurs through Leonardo's autograph works, at least where the condition allows. It is something missed by most of his so-called followers. It is most apparent in such areas as the undersides of cheek and chin, particularly in relation to bared shoulders, as is beautifully evident in the portrait of *Cecilia Gallerani* (**Plate** 16). The London *Virgin of the Rocks* contains a number of such passages, including the delicate glimmer of rebounded light on the underside of the Virgin's outstretched hand. To see equivalent effects in the Louvre version we have to peer through generations of yellowed varnish. As it happens, his optical interest in reflected glimmers was to have astronomical consequences. When he looked (without a telescope) at the 'ashen light' (*lumen cinererum*) on the shaded side of the partially illuminated moon, he knew exactly the kind of explanation to seek, and concluded, as Galileo was to do, that it was the result of borrowed light from the earth—casting as it were its earthlight onto the moon in return for the latter's moonlight.

As if this programme of naturalistic reconstruction of each pictorial item is not enough, Leonardo was also insistent that the painter had to master what happened to the appearance of objects as they moved back into space. Linear perspective did part of this

job, but only part, and was not effective where the scene did not exhibit obvious geometrical elements. At various times he formulated the effects of distance in different ways, using such terms as 'perspective of disappearance' and 'perspective of colours'. We group such effects under 'aerial perspective'. Basically all the 'species'—the optical images transmitted from the surfaces of things—weakened as they traversed space. Not only did the angles get smaller, as linear perspective taught, but they lost intensity. Bright images became duller, strong colours became weaker, shape became more generalized, and details faded from view. Overlying this general enfeeblement was the effect of intervening atmosphere, the veiling quality of vapour in the air, or sometimes, as in battles and deluges, of clouds of dust—denser at their bases than their tops. Since the density of air was greater near the surface of the earth, as when morning mists accumulate in the valleys, the veiling might well be more pronounced in the lower regions of distant features, such as mountains (**Plate** 5). He knew that the prevailing effect of atmospheric veiling was blue—attributed to the optical effect of thin white over dense black—and went to some pains to stipulate the degree to which objects seem bluer the further they move into the distance.

The effects would be different at dawn, midday, and dusk, and would vary according to our position relative to the sun and the scenery. The visual effects of leaves, branches, trees, forests, plains, and mountains should all be orchestrated according to the space and time of their illumination and the distance of their viewing. Leonardo became aware of the action of the pupil and of the accommodation of the eye. He notes how we can see nothing though the windows of houses when we are in the sunlight outside, while we can see well enough when we are actually inside the house. He knows, as we have noted, about the distorting effects of fast motion, extreme glare, and all-consuming darkness. In his later researches into the eye, he became convinced that the eye does not truly know the edge of any body. His famous *sfumato* (the 'smoked' effects that blur contours into ambiguity) is thus given an optical base as well as serving as a visually seductive device. His notes grapple repeatedly with the manifold complexities of light and colour in the space of nature, attempting as always to gel the 'impressions' into a system.

The totality of the agenda he set for what Constable was to call a 'natural painter', of which only a summary picture has been painted here, was truly formidable. He was asking painting to encapsulate so

many simultaneous and often conflicting variables that it was bound to fall short in one or more respects. Inevitably certain aspects of the strange perceptual tricks used in pictorial illusions will be given priority, deliberately or inadvertently. Leonardo's constant priority was *relievo*—that is to say, the illusion of three dimensionality created by the net result of those tricks that seem to endow forms with plasticity and separate them from their backgrounds. Inevitably, to achieve the maximum level of *relievo* possible within the limited compass of pigments on a flat surface, a kind of enhancement is necessary—playing up tonal and colouristic contrasts between objects occupying different planes, making emphatic use of aerial perspective, and insistently modelling forms in light and shade. His remaking or synthesis of effects from causes is dedicated to this end. The result is a peculiar form of naturalism—a kind of 'hypernaturalism' in which things look incredibly 'real' on their own terms without looking quite as they do in nature. There is some similarity to what happens with the most advanced computer graphics, in which the extra-ordinary naturalism carries with it some indefinable sense of synthetic strangeness. In that Leonardo was committed to the idealism of the causes that lay behind natural effects, he would not have regarded

this observation so much as a criticism as a confirmation that he had become a 'second nature in the world'. It is some ambition—and it is not a mean achievement that Leonardo came as close as he did to realizing it.

The Beholder's Share

Leonardo showed an unprecedented awareness of the effect that his works—and works of art in general—could have on the spectator, and of the way that we exercise what Sir Ernst Gombrich called the 'beholder's share'. If the painter succeeded in his aim, those who looked at his pictures should be moved irresistibly, in a way that we would call empathetic and participatory.

> That which is included in narrative paintings ought to move those who behold and admire them in the same way as the protagonist in the narrative is moved. So if the narrative shows terror, fear, or flight, or, indeed, grief, weeping, and lamentation, or pleasure, joy, and laughter and similar states, the minds of the beholders should move their limbs in such a way as to make it seem that they are united in the same fate as those represented in narrative painting. And if they do not do this, the painter's ability is useless.

In his *paragone* he makes it clear that a lover will react to a portrait of his or her beloved with an intensity that is surpassed only by the presence of the real subject. Poetry could never hope to come that close. Children are enraptured by a portrait of a parent, and (taking up the kind of anecdote retailed by the Roman author Pliny) dogs greet their painted master with an enthusiasm no less than that demonstrated towards the real thing. A picture can transport us back to sylvan glades and shady valleys watered by meandering streams, invoking pastoral memories of an idyll of love. Equally it can set terrifying visions before the viewer's eyes, bringing the written horrors of Dante's *inferno* directly into our field of view.

> If the painter wishes to see beauties that enrapture him, he is the master of their production, and if he wishes to see monstrous things that might terrify or that would be buffoonish and laughable or truly pitiable, he is their lord and god ... In fact, whatever there is in the universe through essence, presence, or imagination, he [the painter] has it first in his mind and then in his hands, and these are of such excellence that they can generate a proportional harmony in the time equivalent to a single glance, just as real things do.

In one instance, whether fictional or not, Leonardo wrote that the owner of one of his paintings was unable to retain the proper register of viewing. 'It previously happened to me that I made a picture representing a holy subject, which was bought by someone who loved it and wished to remove the attributes of its divinity in order that he might kiss it without guilt. But finally his conscience overcame his sighs and lust, and he was forced to banish it from his house.'

No artist, not even Leonardo, could make a work of art that infallibly proscribed how the spectator should relate to it.

Viewing in Public

Scale and setting were all important in the act of viewing. The staging of a great battle on the walls of the Council Hall in Florence was obviously a very different business from conjuring up the presence of a beloved lady in a domestic room.

From the first Leonardo was engaged very directly with the public dimension. His first major commission was for the altarpiece of S. Bernardo in the Palazzo or della Signoria in Florence, in front of which those charged with the government would

conduct their devotions and say prayers for divine guidance in their deliberations, both in war and in peace. In the event, the contract of 1478 did not result in Leonardo providing the finished panel, but the picture supplied by Filippino Lippi shows that it was to be a standard Virgin, Child, and Saints, with St Bernard given a necessarily prominent position. As such, it belonged to the stock-in-trade of major Renaissance studios, and served to pit its author in visible competition with his predecessors and peers. We know that the Florentines were not backward in coming forward to comment acerbically about works that did not measure up to the great tradition. We also know, from Leonardo's subsequent experiences with the Confraternity of the Immaculate Conception in Milan, that the provision of an altarpiece could be a fraught and litigious process. In essence, Leonardo and his partners claimed not only that they were being underpaid, but that they were dealing with people who were ignorant about judging the quality and worth of works made by top masters rather than local hacks. Leonardo and the da Predis brothers were not the only artists to be embroiled in such disputes.

The setting of the *Last Supper* in the refectory of Sta Maria delle Grazie in Milan might, on the surface, seem to provide a straightforward audience for the

mural. It was, as was common in Tuscan refectories, to act as a daily reminder for the monks of the eucharistic significance of Christ's last documented meal before his sacrifice. As the monks broke their bread and drank their wine, Christ and the disciples were engaged portentously in the same activity. There is no doubt that the cunning illusionism and overt naturalism of Leonardo's mural in its original state served this function brilliantly, not least through the wonderful still-life passages of the loaves and wine glasses. But it was clear that the prior of the monastery was not the person to whom Leonardo was primarily accountable. The correspondence makes it clear that it was Ludovico Sforza's commission. He was in the process of totally reshaping the church and its buildings, which lay a little distance from his castle. Bramante was constructing a vast new east end as a great centralized structure of the type he was to develop for St Peter's in Rome. It was intended to serve as the setting for Sforza mausoleums. New courtyards were constructed in the latest Renaissance style. The complex of buildings was to be a showcase for the Sforza.

We also know that its actual audience involved what we would call members of the public. We do not know 'the terms of admission' in the years

immediately after its completion, but it is clear that it created a sensation, not least amongst artists, and it was widely and immediately copied on a variety of scales, up to life-size, including wall paintings in Lombardy and full-scale copies in oils on canvas, the best of which is now in the Chapel of Magdalen College, Oxford. At least one early engraving was made, and its essentials were rapidly transmitted to Florence and other ambitious centres of Renaissance art. Important and alert visitors to Milan went to see it, including the King of France and his retinue. All the early testimonies confirm that it seemed to be as much a work of nature as of art, not least to viewers unaccustomed to the latest techniques being forged by the Tuscan masters.

In fact, the *Last Supper* in its actual setting made quite strenuous demands on the viewer's suspension of disbelief. The high viewpoint requires the spectator's collaboration in the necessary artifice, as was relatively standard in narratives set fairly high on walls. We are asked to let the plunging space work without remarking that it stands in a one-to-one relationship with the architecture that surrounds it. Leonardo does not expect us to ask how the clusters of agitated disciples could ever have once been seated in a comfortable row behind the table. Once we collaborate in the

required way, the great deliberation that Leonardo put into making it convincing can have its effect. He tells us in every detail how the light enters the painted room from the windows on the left of the real one. He leads us from the calm centre, with Christ's emphatic movements towards the bread and wine, through the speaking lips and hands of the disciples into their inner turmoil. Christ's fateful words strike each listener with a sharp 'percussion', and the resulting sound of that percussion is dependent on the vessel in which it resonates. Contemporary viewers, more aware than most of us of the character and traditional characterization of the disciples, would have been better able to make full sense of the individual reactions than we are able to do. And an Italian audience is still better placed to read the gestures than a visiting Anglo-Saxon. Above all, it fulfils all the demands that Alberti placed on a *historia* and that Leonardo placed on narratives of the greatest subjects known to man.

The Florentine Council Hall was, in an obvious way, a very different kind of place. Newly constructed by the Republican regime after the expulsion of the Medici, it served as the gathering place of franchised citizens—that is, those owning property in the city. It served, not least, as the space in which the Republic could parade its rhetoric to itself and to others,

verbally and visually, in emulation of its great counterpart in Venice. This is not to say that the hall lacked a religious dimension. At the centre point of one of its longer walls was intended to be an altarpiece, containing the Madonna, Child, St Anne, St John the Baptist, and those saints on whose days important battles had been won. Above the loggia occupied by the *gonfaloniere* ('standard-bearer') and his priors was to be a statue of Christ as Saviour. The secular battle pieces commissioned from Leonardo and Michelangelo, depicting victories over Milan and Pisa respectively, would have been integral parts of an ensemble that stressed the divine basis for the City's temporal actions. Michelangelo's central scene, depicting a moment of false alarm as the Florentine soldiers bathed in a river, spoke of the need to be prepared at all times. Leonardo's centred on the crucial capture of the Milanese standard—a symbolic act that gained additional meaning from its positioning in the same room as the *gonfalone* that signalled the presence of the City's august standard-bearer.

Leonardo's battle, with its fiercely convoluted combat, fluttering standards, arrays of advancing troops, and tangles of foes in disarray would have served its obvious purpose splendidly. It would have told an exciting story with unrivalled power. But

it would also have been full of his personal visual ambitions. Along with the dynamics of the *concetto dell'anima* of the combatants, human and animal, he planned a visual feast of martial physics. On the ground, the red blood of fallen warriors would have mingled with dust and water, combatants fallen into the river would have whipped up maelstroms of vortices, and the air would have been filled with whirling clouds of dust. Almost needless to say, he devoted considerable thought to the optical effects in dust clouds of varied density, and what happened when the clouds, light, and viewers were in different relative positions.

In the event, political circumstances ensured that neither Leonardo nor Michelangelo would complete their murals. Michelangelo's progressed no further than a cartoon, while Leonardo's central knot of combatants was left in an incomplete state on the wall and is known in various copies (**Plate 14**). His central group, painted experimentally in oil, was pointed out to visitors who ascended the stairs into the Council Hall, but, when the returning Medici later converted the large space to serve their own ends, Vasari (biographer of Leonardo) walled over the unfinished masterpiece. Precisely where it was and whether it can ever be recovered remains unclear.

The re-emergence of Leonardo in Florence, at the very moment when the younger Michelangelo was becoming established as a major artist, transformed Florentine art. Leonardo sat on the committee to recommend a suitable location for Michelangelo's huge marble *David* (called the *gigante*), and transformed it in a sketch into a Neptune, while the sculptor for his part drew variants on the older artist's equestrian battle and emulated the complex compositions of his Madonna and Child projects. They each knew the other to be a very major artistic force, but their rivalry appears to have developed into animosity. Ultimately, they held utterly different views on the wellspring of beauty. For Leonardo, as we have seen, it was to be drawn out of nature by empirical struggle and mathematical analysis; for Michelangelo, the seeing of nature, above all the human figure, was directed by a striving for access to transcendental ideas implanted by God in human minds. The even younger Raphael, newly arrived in Florence and less encumbered with philosophical dictats, was able to draw upon Leonardo to transform the way he engineered his compositions, and upon Michelangelo to develop a heroic figure style in the 'ancient manner'.

Such large-scale projects as the projected battle scenes by Leonardo and Michelangelo obviously had

a public dimension. More surprisingly, Leonardo also seems to have brought drawing into a public domain in a new way. When he returned to Florence in 1500 after his substantial period at the court of Milan, he apparently conducted a public demonstration of his powers as a draughtsman—as if to remind the Florentines of what they had been missing. He embarked on a cartoon of the Madonna, Child, and St Anne with a Lamb, a good Republican subject, since the tyrannical Duke of Athens had been expelled from Florence on St Anne's Day in 1343. Vasari tells us that it was, as it were, put on exhibition for some days, attracting a large number of eager spectators. We know for certain that others were allowed previews of his works on paper and on panel. In 1501 Fra Pietro da Novellara, reporting to Isabella d'Este in Mantua, wrote twice about works he had seen in the artist's *bottega*. One was the as yet incomplete *Madonna of the Yarnwinder*. The other was the cartoon that made such an impact. His descriptions show that he understood exactly how Leonardo was treating the Madonna and Child groups as if they were narratives:

> He is portraying a Christ Child of about a year old who is almost slipping out of his Mother's arms to take hold of a lamb which he then appears to embrace. His Mother,

half rising from the lap of St Anne, takes hold of the Child to separate him from the lamb (a sacrificial animal) signifying the Passion. St Anne, rising slightly from her seated position, appears to want to restrain her daughter from separating the Child from the lamb. She is perhaps intended to represent the Church, which would not have the Passion of Christ impeded. These figures are all life-sized but can fit into a small cartoon because they are all either seated or bending over.

It was in the nature of Renaissance art, and Florentine art in particular, that the activities of artists as star performers were beginning to be a matter of public interest. Leonardo stood at the cusp of this development, in which a few super-artists decisively transcended that status accorded to artists in general. Giotto had exceptionally accomplished this in the fourteenth century. Ghiberti and Mantegna provide conspicuous instances of *quattrocentro* masters who were successful in promoting their status beyond what was expected of even the most superior craftsmen. Leonardo, and Michelangelo (in his own way), pressed the issue even further. Much of the exaggerated insistence on the superior worth of painting in Leonardo's *paragone* is dedicated to this end. From the standpoint of patrons, individual and collective, acquiring the service of the most renowned masters

was beginning to be something of more than passing prestige. When the Pope demanded Michelangelo's services, the Florentine government reluctantly agreed, and the *Battle of Cascina* was abandoned. In a similar way, the competition between the French authorities in Milan and the *Signoria* in Florence for Leonardo's services, when he was meant to be painting his *Battle*, is a clear sign of their recognition that he had something special to offer—if they could manage to get him to deliver it. The result of the competition was that Leonardo returned to serve the French in Milan, leaving the Florentines to write impotent letters about how the painter had received goodly sums of money for a project that he had abandoned.

Viewing in Private

Whatever advances Leonardo made in the art of public communication, they pale beside the way he transformed the one-to-one relationship between the individual spectator and his domestically scaled works. He set up a new kind of field of psychological tension (to use an anachronistic term) between the viewer and the subject in the painting. Perhaps the clearest instance of this is an invention that does not seem to

survive in a fully autograph version (if there ever was one). He devised an *Angel of the Annunciation* who speaks his message of the coming of Christ directly to us. The Angel had always announced, as he should, to the Virgin, even when the two participants were portrayed in separate panels, as happened quite often in altarpieces. In Leonardo's composition, the Angel smilingly addresses us, pointing with bent forearm and upraised finger to the invisible, heavenly source of Mary's impregnation. It is not so much that we stand in for Mary, which would have been heretical, but that we are meant to understand the nature of the act of annunciation with a new intensity. The spiritual mystery is conveyed by glance and gesture—a glance that engages us, and a gesture that alludes to something beyond sight. It was on this invention that he drew when he painted his deeply mysterious *St John the Baptist* (**Plate 17**). Even allowing for the picture's darkened condition, it must always have been enigmatic, and veiled in *sfumato*, suggestive of the ineffable mystery surrounding the arrival of Christ on earth. Unsettling, androgynous, and other-worldly, exploiting a spiritualized sexuality in a way that was far from rare in Italian art, *St John* is the visual counterpart of Leonardo's acknowledgement that there was a dimension to the universe that was not knowable to the

human intellect, however penetrative our visual powers.

The most obviously personal works in terms of the individual relationship between subject and viewer are the portraits. At least that is what we tend to think in the light of our experience of the great masters of the genre—Titian, Rembrandt, Velasquez, Houdon. However, that was not generally the case in the era before Leonardo. Fifteenth-century painted portraiture was a largely formal business of recording features and status, not infrequently in profile and often with Romanizing references to static marble busts. A vividly portrayed physiognomy could not but convey some sense of a character for the spectator, and there was certainly a need to suggest the particular *virtù* of the sitter. Men were strong and wise, often visibly experienced; women were beautiful and poised, rarely matronly. But no one expected the artist or viewer to be much concerned with the complexity of human thought in the sitter's brain. Leonardo had a great deal to do with our change in expectation. He did not do so single-handedly. Antonello da Messina and Giovanni Bellini in Venice were notable portrayers of personality, and it is significant that Isabella d'Este asked Cecilia Gallerani to lend her Leonardo's painting of Cecilia to compare with Bellini's portraiture.

Some of his portraits operated in the formal mode. Most notable in this respect was his full-scale drawing of Isabella herself, which the Marchioness pestered Leonardo to turn into a painting, or even into a replica drawing when her husband gave away the first one. Although Leonardo had pioneered some complex poses and facial angles, he resorted in this case to a profile, combined in a complex arrangement with a frontal bust and stylish hands. The formal convention becomes an active statement about the sitter's status and regal sense of distance from prying eyes. The portrait of *Cecilia Gallerani* (**Plate** 16), by contrast, offered a highly personal tease. The young mistress of Ludovico il Moro in the years around 1490, she was an accomplished person in her own right. Cradling a svelte ermine, emblematic of her purity and virtue, she turns graciously to look and smile reticently at some unseen recipient of her glance to our right. She does not have the undirected stare of conventional Renaissance portraits, but neither does she look at us. Leonardo has set up a three-part relationship between his subject, ourselves, and the unseen third person— who is by implication the Duke himself. The poem written in honour of the portrait mirrors this complexity, being cast in the form of a dialogue with envious nature, who feels outdone by victorious Vinci.

Ludovico is acknowledged in the poem as the true beneficiary of our thanks—as the absent agent in the dialogue, just as he is the unseen agent in the picture.

Only one of Leonardo's portraits looks directly at the spectator (**Plate 18**). This alone makes the *Mona Lisa* special. Moreover, she smiles at and even through us. She is not behind the conventional parapet that separated us from Isabella, but in front of it. Her chair is close to us, or rather to the very front of the picture, as pressed forward as the disciples' table in the *Last Supper*. She is immediate and engaging. We cannot but feel that the artist has been uniquely engaged on his own part with Lisa Gherardini, wife of Francesco del Giocondo. (I am taking her identification as established by the 1525 document of Salai's 'Leonardos'.)

Before romance, let us begin with some facts. Lisa, daughter of Antonmaria, was born in 1479 into the ancient and landed Gherardini family, whose fortunes had been dented but not destroyed by their dispute with the Florentine Republic in the years around 1300. She became the wife of Francesco del Giocondo, rich Florentine silk merchant, on 5 March 1495—marrying young by our standards. Her husband was 35, and had been twice widowed, probably as a result of both wives dying in childbirth. Lisa was more fortunate. In

December 1502 she gave birth to her second son, and Francesco moved his family into a new Florentine home during the following year. We do not know precisely when Leonardo began to make her likeness, but it must have been after Leonardo's return in 1500. The basic disposition of the innovatory image seems to have made an impact on Florentine artists by 1506, if not earlier. Its commencement can best be located in the period after 1503, when he was based in Florence and was working on his *Battle*. Whether it was completed expeditiously is another matter. The lower parts of the picture seem to be painted in the thinner manner of his very last works, and it seems likely that the picture underwent an extended execution, accompanying him on his travels from Florence to Milan, from Milan to Rome, and from Rome to Amboise—to say nothing of lesser intermediate journeys.

Why did Leonardo become so involved with and attached to the image of a woman about whom we know nothing to suggest that she was extraordinary? Why did he pour such effort into her portrait when his engagement on more prestigious commissions was fitful? There are some tantalizing hints, at which we will glance in the final chapter, that he may have enjoyed some special contact with the Gherardini. But Lisa was

little more than a baby when Leonardo left Florence for Milan, and any relationship between them is unlikely to have developed before 1500. In the absence of any clear reason why Lisa Gherardini meant anything special to him, we can only assume that he found the image developing into a vehicle for the deepest ideas that he thought painting should embody.

Looking at the picture, and finding her looking at us, it is not difficult to feel that we are to be the silent witnesses to the kind of secrets promised by the smiling and enigmatic ladies in Dante's Divine Comedy. The *Angel of the Annunciation* and *St John* promise similar revelations of the ineffable. However, the smile may actually have begun prosaically as an emblem. Just as Ginevra de' Benci in Washington is accompanied by a juniper bush (*ginepro*) as a play on her name, so the wife of del Giocondo was ripe to be identified as 'she who smiles'—*La Gioconda*. It is true that the reticent smile had become something of a Leonardo hallmark, but the other smiling portrait, that of Cecilia, does not look assertively at us. Here the smile is overt and direct, declaring itself as the subject (or at least as integral to the subject) of the picture. Whatever the truth of the immediate meaning of the smile, it was transformed, as all the other elements in the picture, into something more universal

than individual. Pater's nineteenth-century romanticizing of the mysteries of which she is the guardian (to be quoted in the last chapter) goes too far, but Leonardo himself was hugely conscious of the resonances he was able to establish between the implied thoughts of his subjects and those of the spectator. Watching the image form on his primed panel, he cannot but have been captivated by the way his portrait was beginning to exercise a hypnotic effect. He must have known that no painted portrait, not even Antonello's at their most direct, was engaging the spectator in this way. Presuming it predates his own *Angel* and *St John*, no painting of any subject had made such claims upon our personalized attention.

The only real precedents lie with sculpture. Donatello's stone figures of saints and prophets established an extraordinary level of direct communication with spectators, and some of the portrait busts by Florentine sculptors, not least those by Verrocchio, had knowingly exploited the special relationship we inevitably develop with any life-size head in three dimensions. It looks as if Leonardo was again capitalizing on his direct training in the Florentine sculptural tradition to rework the way that painting worked.

The whole set-up in the *Mona Lisa* is extraordinary. Enough of her ample body is present to give us an

irresistible sense of her physical occupation of the narrow space between the balcony and the elusive front plane of the picture. The balcony, with its visible sliver of columns, does just enough to suggest a majestic loggia in a hilltop palace or villa. The vista that Francesco di Giorgio exploited in the loggias outside Federigo's personal suite of rooms in the lofty Montefeltro palace at Urbino, and that is emulated if not imitated in Piero della Francesca's portraits of Federigo and Battista, is not more imposing. The landscape contains only the bridge to define it as dating from the human era. For the most part it is in an elemental state, a more than naked body, with its bones laid bare, in which the raw processes that shape the world are pursuing their remorseless course. These huge processes find their microcosmic mirrors in the flow of Lisa's miraculously fine hair, in the rivulets of cloth gathered at the neckline of her dress, in the spiralling scarf that twists across her breast, and even in the coursing of the vivifying spirits that we and Leonardo know to be responsible for her very life.

No image has ever been more particular in the way it engages us with a specific human presence. No picture of an individual has ever born such universalizing truths about the indissolubility of our lives with the life of the world.

LISA'S ROOM.
LEONARDO'S
AFTERLIFE

MARCO THE GARDENER points up at the window (**Plate 19**). 'That's where she was sitting.' He is pointing to one of the rooms—large, high-ceilinged, and gracious—in which we are staying in the Villa Vignamaggio, formerly the property of the Gherardini family. The window enjoys a sweeping view across the valley and to the hills beyond. Traces of the bridge have been discovered, he assures us. Marco is not a naïve peasant; he is involved in recreating medieval street theatre in stony Tuscan towns.

The Nunziante family own the villa now,

producing fine Chianti and olive oil, and welcoming paying guests as part of the Italian *Agriturismo* programme. They help with their knowledge of the history of the Gherardini, involved simultaneously with the cold facts of the archive and the warm legends that hover in the hinterland between belief and scepticism. Gloria, wife of the *avvocato* (lawyer) Gianmatteo Nunziante, whose father owns the villa, kindly hands us a sheaf of photocopies of historical essays about the Gherardini and their properties in the valley of the River Greve. The family history is picturesque and turbulent, caught up in the deadly disputes between the 'Black' and 'White' Guelfs that famously led to the exile of Dante as a supporter of the doomed 'White' cause. The Gherardini, ensconced within their fortified base in the Castello di Montagliari, were condemned with other 'Whites' as 'malefactors' and 'bandits' by the Florentine *popolo*. In 1302 an itemized decree was issued stipulating that the Gherardini *castello* should be razed to the ground to such effect that there would be 'no hope of its being rebuilt'. So effective was the Florentine obliteration of the castle that its precise location above the Greve remains a matter of dispute. It is generally held that it is on the other side of the valley from the Vignamaggio, but the possibility remains open that its foundations lie deep

beneath the very spot on which I am sitting on the terrace of the villa.

In any event, the family progressively reinstated themselves in Florentine favour and settled into the role of Tuscan landed gentry, with a city residence in Florence. Correspondence from Amideo Gherardini in the early fifteenth century speaks of wine that he has 'barrelled' in the Vignamaggio. Writing from 'Montefichalli' (now Castel di Montefioralle), he invites Francesco di Marcho of Prato, perhaps a relation of the celebrated Francesco Datini, 'Merchant of Prato', to take some more of the wine—'if you do not have enough'. The ghostly voice of one of Lisa's forebears! That she would have known the villa, like other Gherardini properties in Chianti, cannot be in much doubt, but to be more specific about her actual residence there is impossible at present. Intimations of the shades of the Gherardini, roaming the Val di Greve, have encouraged historians on excursion to seek to identify Leonardo landscapes in the vistas across the steep valleys—most notably in the famous drawing in the Uffizi dated on 'the day of S. Maria delle Neve [Holy Mary of the Snow] 5 August 1473' (**Plate 20**), and, of course, in the *Mona Lisa*.

Leonardo's earliest dated or securely dateable drawing, the 1483 pen sketch, depicts a plunging

vista from precipitous hills, past a substantial castle on a promontory, to lowland fields hatched in rough perspective and distant mountains. The day was named in honour of the miraculous snowfall in Rome that had laid out the precise ground plan of S. Maria Maggiore. It is not the most prominent date in the ecclesiastical calendar. But there was another locus for the celebration of the miracle. It was adjacent to the Gherardini properties in the hills above the Greve, in the area of Montagliari where it is presumed their destroyed castle to have been. The present oratory or chapel of S. Maria della Neve, visible across the valley from Vignamaggio, was constructed in the seventeenth century by the Gherardi, successors to the Gherardini. Were the Gherardini of Leonardo's day devotionally attached to the miracle on 5 August? Was Leonardo's view taken in the valley that was Gherardini territory? We journey around the tortuous roads clinging to the hillsides. Perhaps the castle denotes the fortified hill town of Panzano. Each bend promises to disclose Leonardo's vantage point, but our hopes are repeatedly frustrated—as they had been when I had once searched for its location in the hills above Vinci. In reality, the vertical or near-vertical faces of the hills in the drawing look much more clifflike than the wooded slopes that plunge steeply into the valley of the Greve.

The view has always been taken as a uniquely early record of a specific place on a specific day. Numerous attempts have been made to match it with an identifiable site in Tuscany. None has quite worked. What if it is a confection drawn in a hot Florentine studio, not a *plein air* view? What if it is a longing reminiscence of his experience in the hills on the day when the miracle was celebrated in the Chianti hills? What if the castle is his re-envisaging of the destroyed Castle of Montagliari in homage to his Gherardini hosts? Too many 'what ifs' for a responsible historian. But it is difficult not to clutch at intriguing straws.

Returning to the subject of the landscape in the *Mona Lisa*, I point out, as the family obviously realize, that it does not closely resemble the view from the villa. Indeed, I stress that it is my belief that the landscape in the picture is a typical Leonardo re-creation of the body of the earth rather than a literal depiction of any particular place. My reason for saying this is not to be dismissive, pouring buckets of cold water on cherished stories. I delight in the way that the local beliefs convey people's feeling for the living presence of Leonardo and his cast of Tuscan characters, many of whom, like the Gherardini, were once of considerable moment in their own right. In a sense, the author of this book and the purveyors of local wisdom are in

the same business. We are drawing historical figures and their works into the present. There is a trans-historical dimension to this, inevitably. I would not be engaging with Leonardo if I felt that he could say nothing in today's world. I am concerned to test my constructions as rigorously as I can against the documented facts. Yet I am driven by a personal feeling for his works, by that spine-tingling sensation I experience when I see one of the drawings in the flesh, by the certainty of being in the presence of something very special. The work of the researching scholar stands at one end of the spectrum of the guardians of history—but it is a continuous spectrum.

Different places now lay claim to Leonardo. The cities of Florence and Milan have the biggest claims, judged in terms of Leonardo's professional career. Milan, the home of the Raccolta Vinciana, with its extensive collection of literature on Leonardo, is a prime centre of Leonardo research. The importance of Florence is obvious to anyone with even a passing knowledge of European cultural history. The small city of Vinci, a neat hill town near Empoli, has an undeniably unique status as his birthplace. A specific house, a modest stone structure isolated amidst olive trees above the town, is claimed as the very place where Caterina gave birth to her illegitimate son after

her dalliance with the young Ser Piero. Leonardo is thus a child of nature, immersed in a land of sawing cicadas and darting lizards. The lofty *castello* in Vinci is now a museum devoted to his memory, with a collection of models of his brilliant mechanical inventions. The adjacent Biblioteca Leonardiana collects literature on the master, and hosts the annual Lettura Vinciana. Vinci's proud 'ownership' of Leonardo is understandable, but the time and place of birth are, unless one believes in astrology or predestination, an accident, and there is no objective reason why the residence of Leonardo's parents in the town should reflect well on any of its present inhabitants. But their pride is warming and admirable.

Even places with thin claims push their cases. Arezzo is the most vigorous newcomer, exploiting the belief that Lisa's landscape, like those in other paintings, is taken directly from topographical features adjacent to the city. A series of attractive exhibitions have been sponsored by the local society of those engaged in commerce. Leonardo was certainly involved in thinking deeply about the topography around Arezzo, as we have seen, but no documentation testifies to any activities in the city itself. Arezzo is home to the glorious frescoes on the legend of the True Cross by Piero della Francesca, who is no less remarkable

than Leonardo as an artist-geometer, but Piero does not apparently do the job of thrusting Arezzo forward in international culture with sufficient vigour.

In France, Amboise is a natural place of pilgrimage. Leonardo spent his last years in the manor house of Clos Lucé, a little way down the hill from the Renaissance chateau of the French kings. Like the *castello* at Vinci, it houses a set of models. He was buried in the Chapel of St Florentin (appropriately enough), but this no longer exists. What are claimed to be his remains now rest in the tiny chapel of St Hubert, set precipitously in the high castle wall. On the river bank below, Leonardo reclines as a naked river god in patinated bronze, displaying details of his anatomy not vouchsafed in any known source. Inquisitive hands have polished his male member, conspicuously, if not quite with the same insistence as the lips that have eroded the burnished toe of St Peter in the Vatican.

I think it is possible to formulate a general law to the effect that the extent to which a place cultivates the myth of someone associated with it is in inverse proportion to its size and its other claims to fame. The law operates to some extent with Leonardo, but his myth is so big that he dominates even the grandest places. No museum has a higher international profile

than the Louvre in Paris, and its treasures are not obviously surpassed elsewhere. Yet the *Mona Lisa* is the dominant public icon, signposted from all corners and subject to extensive merchandising. The modestly sized panel, framed and glazed, and set for many years behind a fortified window in a graceless box, is surrounded by an almost ceaseless crush of voyeurs and photographers. It is not visible in any really intimate sense, yet it effectively elbows aside other masterpieces in the room. Giorgione and Raphael can but yield. The way in which her presence skews the viewing of adjacent pictures is one significant reason why the Louvre authorities have decided to assign her to a separate room, specially designed for the purpose.

Gathering his Remains

There are plentiful signs that those who came into contact with the living Leonardo knew that he was something special. Perhaps it is this that helped patrons put up with his erratic delivery of finished products. Louis XII, on his invasive arrival in Milan in 1499 with his French troops, was reported as enquiring whether the mural of the *Last Supper* could be transported to France—which obviously reflects his admiration but may also indicate that he had

received intelligence about the unlikelihood of a new commission resulting in speedy delivery.

Even the economic signs are exceptional. The notary who was responsible for the inventorying of the dead Salaì's possessions in 1525, to facilitate the division of the spoils between the dead operator's sisters, listed a series of twelve paintings. They were not specifically attributed to Leonardo, but everyone knew what they were. At the top of the list comes the *Leda and the Swan*, valued at 200 ducats, to be followed by a 'St Anne', and two portraits of women, the second of which is 'called La Ioconda'. The St Anne and La Ioconda are each accorded values of 100 each. These are big sums for second-hand paintings. Surprising as it may seem to us, existing paintings even by major masters were not accorded high valuations in Renaissance inventories. There was no developed market for such things, in contrast to the thriving trade in luxurious second-hand clothes. For 100 ducats a patron might hope to commission his own, tailor-made image of a nude woman from a major master. The notary had obviously been instructed that Leonardos already possessed a rarity value.

What immediately happened to the top paintings in the late Salaì's possession is unclear. A puzzling Milanese notarial document of 1531 lists a group of

seven pictures, including the 'Ioconda' but not the *Leda*, apparently indicating that some were still in the possession of Salaì's surviving family. Since we know that the *Leda* and the *Mona Lisa* were housed in Francis I's Appartement des Bains at Fontainebleau during the 1540s, it is reasonable to suppose that he obtained them directly from Salaì's heirs. It may seem surprising that Francis ever allowed the pictures to leave France after the artist's death in his service, but we know that he granted Leonardo special permission to make a will bequeathing his estate to whomsoever he chose. Such permission was required for foreigners in France. The King thus found himself in the odd position of having to buy back pictures by his court 'familiar', presumably at a high price. A seventeenth-century source says the *Mona Lisa* cost him the huge sum of 12,000 francs. However, the sum total of the documentation only adds up to the conclusion that the precise history of the portrait after the painter's death remains uncertain.

With the major pictures in the French Royal Collection at Fontainebleau, with the *Last Supper* decaying on the walls of the refectory in Milan, with the unfinished *Battle of Anghiari* shortly to be walled up in Florence, there were relatively few 'autograph' works to be seen even by the most enthusiastic traveller some

thirty years after his death. A host of sub-Leonardos, particularly smiling Lombard Virgins 'sfumatoed' to the point of self-parody, increasingly stood in for the real thing. Optimistic inventories and sale catalogues expand his œuvre to a point in which he seemed to rival his most productive contemporaries. This situation was to persist well into the nineteenth century. What 'a Leonardo' looked like in the eyes of those well informed about his fame came to bear little resemblance to the real thing. In Barberini Rome, Cassiano del Pozzo, indefatigable antiquarian, collector, patron, and enquirer into everything curious, was recorded as owning a 'Leonardo' St John in 1695, but there is no evidence that it was an autograph painting. Cassiano was a very scholarly student of Leonardo's manuscripts, enlisting Nicolas Poussin in the illustration of what became the first printed edition of Leonardo's *Trattato* in 1651. If he did not know what was what, there was no one else in the seventeenth century who was better placed.

The legacy of notes and drawings, treasured by Francesco Melzi, subsequently passed though various hands. A notable collection of codices were taken to Spain by Pompeo Leoni, the sculptor, but only two were to remain there and are now housed at the Biblioteca Nacional in Madrid. The 'Treatise on

Painting', which Melzi had studiously compiled in his neat italic hand from Leonardo's scattered and scribbled notes, became the most widely known of the manuscripts. Versions were circulating quite widely in artists' studios around 1600, and undoubtedly played a role in the reform of painting effected by the pioneers of Baroque art. But the lesson learned depended on how the text was read, and how the text was read was conditioned by the visual images that the readers attached to the prescriptions. Poussin, who made unflattering remarks in public about the treatise, saw Leonardo's descriptions of figures expressing *il concetto dell'anima* in terms of the canonized postures of ancient marbles. The academic rhetorics of gesture implicit in the disciples of the Last Supper was taken as sanctioning Poussin's editing of Leonardo's own illustrations (via Melzi's transcriptions) into static, muscular poseurs who spell out their actions of aggression and submission with all the fixed deliberation of an oratorical address.

Rubens, who owned transcriptions of some Leonardo material and had seen original manuscripts in Italy, and probably also in England, received a quite different message. He intuited that Leonardo's accounts of figures in action were about communicative urgency in space and time, unstable and dynamic

rather than fixed. When Rubens reworked another artist's sketch of the central knot of fighting warriors from the *Battle of Anghiari* (**Plate 14**), he elaborated the compact frenzy of Leonardo's knot into high Baroque complexity. Whether Leonardo would have liked what either Rubens or Poussin did to his figures is not, of course, demonstrable. Some things he could recognize in both, but not the same things. And both inevitably did things that were individual to themselves rather than to Leonardo.

Some important and prestigious collectors acquired Leonardo's manuscripts and drawings with particular enthusiasm. Milan was, unsurprisingly, a major centre of activity. The leading figure was Count Galeazzo Arconati, who presented twelve manuscript volumes to the Biblioteca Ambroisiana in 1636. These were amongst the many treasures scooped up from Italy at the behest of Napoleon Bonaparte and taken to Paris. Only the *Codice atlantico*, a large and diverse compilation, was returned to its former owners, with the result that the Institut de France now holds the most extensive surviving collection of separate manuscripts. Only one major nation of Leonardo collectors could claim no obvious connection with the living man. British connoisseurs moved into the market in the seventeenth century, remaining there for at least

300 years. The Earl of Arundel, patron of Rubens, owned important manuscript material, including the Codex Arundel now in the British Library. Some of the Leonardo drawings in Arundel's possession were etched and printed by Hollar in 1646. The bound volumes of artistic drawings and anatomical studies now in the Royal Library at Windsor were also brought to Britain by Arundel, and subsequently entered the Royal Collection, but it is not known how or when.

Most of the works on paper remained known to a relatively small circle of cognoscenti. The drawings were appreciated for their obvious qualities, but the notes and illustrations possessed mainly antiquarian interest, and few had either the skill or the inclination to read them. An exceptional incident is Giambattista Venturi's publication of some of Leonardo's notes in physics and geology in his *Essai sur les ouvrages physico-mathématiques de Léonard de Vinci* in 1797. In the limited compass of his small book, the Italian mathematician and physicist (and something of an *uomo universale* on his own account) provided a truly precocious insight into Leonardo's way of thinking. Otherwise, the publication of the manuscript legacy for the most part had to wait until the two final decades of the nineteenth century, as we will see.

Written Fame

Leonardo's posthumous renown was transmitted—ironically given his own views—through the written words of professional authors. The striking and highly readable artistic biography by Giorgio Vasari in his *Lives of the Most Famous Painters, Sculptors and Architects* remained the main point of reference well into the nineteenth century. Published in 1550 and 1565, Vasari's accounts possessed the advantage that he had learnt his craft as a painter-architect in Florence at a time when Leonardo was still very much a recent presence. He may well have known both Lisa and Francesco. On his extensive journeys Vasari met many people who had first-hand knowledge of Leonardo, including Melzi. The *Life* of Leonardo fully recognizes his subject's founding of the third and mature age of Florentine art—what we call the High Renaissance—and he is placed with Raphael and Michelangelo in the 'divine' triumvirate who stood at the summit of what art could attain in the emulation of nature's beauties and the surpassing of the ancient masters.

Vasari's *Life* of Leonardo loses nothing in vividness beside that of Michelangelo, his ultimate hero. Vasari had a nose for picturesque anecdotes and extraordinary, out-of-the-way characters. Raphael met

neither of these requirements as readily as Leonardo and Michelangelo. If the stories he gleaned and elaborated allowed some general lessons to be drawn, so much the better. Leonardo's supreme giftedness was not in doubt. (The quotations that follow are from Horne's 1903 translation, which captures the idiosyncratic flavour of Vasari's prose.) In Leonardo we find:

> beauty, grace, and ability, being beyond measure united in a single person, in a manner that whatever such a one turns to do, his every action is so divine, that surpassing all other men, it is plainly recognized as a thing bestowed by God, and not acquired by human art. . . . Beyond a beauty of body never to be sufficiently extolled, there was an endless grace in all his actions; and so great and of such a kind, was his genius, that to whatever difficult things he turned his mind, he solved them with ease.

In a particularly apt passage Vasari says that Leonardo 'knew so well how to express his conceptions by draughtsmanship, that he overcame with his arguments, and confuted with his reasons, every stalwart wit'.

The artist's capricious inventiveness is given full rein, as in the story of his round painting of a horrid monster compiled from studies of repellent creatures, which he displayed spotlit in a darkened room to such

good effect that it terrified even his father. Within the highly engaging narrative of Leonardo's career, with its successes and failures, there are finely sustained appreciations of his artistic achievements. By the time Vasari wrote, the *Mona Lisa* was certainly not readily accessible to him, but he could well have seen it before its dispatch to France. Whatever the detailed lapses in Vasari's memory, he brilliantly captures the painting's uncanny impact (and its ability to make the viewer see more than is really there):

In this head, whoever wished to see how nearly art is able to imitate nature, was readily able to comprehend it; since therein are counterfeited all those minutenesses that with subtlety are able to be painted; seeing that the eyes had that lustre and watery sheen which are always to be seen in a living creature, and around them were all those rosy and pearly tints, together with the eyelashes, that cannot be depicted except by the greatest subtlety. The eyebrows, also, by reason of his having represented the manner in which the hairs issue from the flesh, here more thick and here more scanty, and turn according to the pores of the flesh, could not be more natural. The nose with its beautiful nostrils, rosy and tender, seems to be alive. The mouth with its opening, and with its ends united by the red of the lips to the flesh tints of the face, appeared, indeed, to be not colours but flesh. Whoever intently observed the pit of the throat, saw the pulse beating in it.

And in truth one could say that it was painted in a manner that made every able artificer, be he whom he may, tremble and lose courage.

Courtesy of Melzi, Vasari was in no doubt about the prominence of non-artistic activities in Leonardo's life. Since he was a great advocate of the artist as intellectual, replete with learning about anatomy, optics, and other germane sciences, he could not be disparaging about the general tenor of Leonardo's learning. However, he was critical of the way Leonardo's pursuit of unrealizable perfection and arcane knowledge had diverted the painter-sculptor away from the professionalism that Vasari equally prized:

Leonardo . . . began many things, and never finished any of them, since it appeared to him that the hand was not able to attain to the perfection of art in executing the things which he conceived; seeing that he imagined difficulties so subtle and marvellous, that they could never be expressed by the hands, be they ever so skilful. And so many were his caprices, that, philosophising of natural things, he gave himself to understand the properties of herbs; going on and observing the motions of the heavens, the course of the moon, and the going forth of the sun.

When anyone subsequently came to write about Leonardo, Vasari remained the prime source, particularly in the era before the primary documentation and manuscript legacy began to be researched in a sustained way. It was only with Luca Beltrami's fine assembly of Leonardo documents in 1919 and the annotated editions of Vasari's *Life* by Herbert Horne in 1903 and Giovanni Poggi in 1919 that the scaffolding of surviving facts began to be apparent. What had happened in the intervening period was that the inherent fascination in Leonardo regularly attracted those who possessed supreme gifts in writing about visual things. Just two authors, Johann Wolfgang Goethe and Walter Pater, will have to stand in for a distinguished company.

Goethe's subject of attention in 1817 was the *Last Supper*, damaged, faded, and crudely restored though it was. The ghosts and shards on the refectory wall were supplemented by his comprehensive study of copies and prints—he especially recommended his readers to look at the engraving by Raphael Morghen. His essay was occasioned by the careful painted reconstruction made by the artist, antiquarian, and collector Giuseppe Bossi, which had in turn provided the basis for an enduring version in mosaic. Bossi did more than copy the mural; he undertook

extensive scholarly research into the origins and history of the mural, the fruits of which he published in his pioneering study, *Del cenacolo di Leonardo da Vinci*, in 1810.

Some great writers are able to intuit more from fragments and echoes of historic works than lesser minds can make of their subjects when in pristine condition. No one did this better than Goethe. Above all, he somehow understood how Leonardo thought about the role of expression and gesture in his narrative during his many still hours of contemplation on the scaffolding.

Goethe begins by inviting us to envisage the frisson of the illusion for the Dominican monks, seated at three tables in a U-shaped arrangement in such a way that the square was completed by the table in the painted scene. (The quotations are from Noehden's 1821 translation, approved by Goethe himself.)

> For this reason it was consonant with the judgement of the painter to take the tables of the monks as models; and there is no doubt, that the table-cloth, with its pleated folds, its stripes and figures, and even the knots, at the corners, was borrowed from the laundry of the convent . . .
>
> Picture to your mind the decorous and undisturbed calm, which reigns in such a monkish refectory; then you will

admire the artist who knew how to inspire into his work a powerful motion and active life, and, while approximating to nature, as far as possible, at the same time, effected a contrast with the scenes of real existence that immediately surrounded it.

The means of excitement, which he employed to agitate the holy and tranquil company, at table, are the words of the Master: *There is one among you that betrays me.* The words are uttered, and the whole company is thrown into consternation.

There follows a notable reconstruction of the thoughts and words of Christ and the disciples, in their four triads. Only one triad is given here (selected because we have already seen in **Plate 12** the drawing for the head of St James the Greater).

James the elder draws back, from terrour spreads his arms; gazes, his head bent down, like one who imagines that that he has already seen with his eyes those dreadful things, which he hear with his ears. *Thomas* appears from behind his shoulder, and advancing towards the Saviour, lifts up the forefinger of the right hand to his forehead. *Philip*, the third of this group, completes it in a most pleasing manner; he is risen, and bending towards the Master, lays the hands upon his breast, as if distinctly pronouncing: *Lord, I am not he——Thou knowest it——Thou seeist my pure heart——I am not he.*

As a great dramatist, Goethe penetrates in his own way into the heart of the Leonardesque 'fiction that signifies great things'.

Walter Pater, like his contemporaries and pre-decessors, knew as much about Leonardo through non-Leonardos as the real things, but he, like Goethe, achieved insights that transcended the limitations of his knowledge. Above all, in 1869 he was responsible for what is one of the greatest of all set pieces on any single work of art. There is only room here for fragments of his evocation of the *Mona Lisa*'s universalizing power:

> What was the relationship of a living Florentine to this creature of his thought? By what strange affinities had the dream and the person grown up thus apart, and yet so closely together? . . .
>
> Hers is the head upon which all 'the ends of the world are come', and the eyelids are a little weary. It is a beauty wrought out from within upon the flesh, the deposit, little cell by little cell, of strange thoughts and fantastic reveries and exquisite passions . . .
>
> She is older than the rocks among which she sits; like the vampire, she has been dead many times, and learned the secrets of the grave . . .
>
> The fancy of a perpetual life, sweeping together ten thousand experiences, is an old one; and modern

philosophy has conceived the idea of humanity as wrought upon by, and summing up in itself, all modes of thought and life. Certainly Lady Lisa might stand as the embodiment of the old fancy, the symbol of the modern idea.

Modern and Mythical

In the decades following Pater's telling effusions, a new and more concrete Leonardo emerged. The drawings and notebooks began to be published and, above all, illustrated. Photography, and most particularly the making of facsimiles, brought the scattered remains into the public domain. A scholar in a library in Moscow or Massachusetts could read what Leonardo wrote about the 'sea of the blood' and act as a visual witness to his demonstrations of the human body, courtesy of reasonably adequate facsimiles. Of notable importance were the two volumes of *The Literary Works of Leonardo da Vinci*, published by Jean Paul Richter in 1888, which contained a wide-ranging selection of excerpts in Italian and English translation from the manuscripts, grouped under subject headings. Even if the scientific and technical components were given less weight than those more overtly connected with Leonardo's art, the reader was given enough evidence

to appreciate the scope of Leonardo's universality. The first biographical attempts to capture the 'universal' Leonardo began to appear, above all in France, which held the best set of diverse manuscripts as well as the key group of paintings. The most remarkable early achievement was Gabriel Séailles's *Léonard de Vinci, l'artiste et savant* in 1892 and 1906, still too little known and appreciated. Paul Valéry's more famous *Introduction à la méthode de Léonard de Vinci* in 1894, *Note et Digression* in 1919, and *Léonard et les philosophes* in 1929 worked fine literary embroideries on the historical backcloth provided by Séailles, and, like Goethe's and Pater's accounts, exhibit insights that transcend the unreliability of the parts.

Between 1908 and 1925, two Italian scholars, Edoardo Solmi and Girolamo Calvi, contributed particularly crucial researches into the sources for Leonardo's ideas and the chronology of the manuscripts. Amongst the many twentieth-century attempts by art historians to construct the documented Leonardo, those by Kenneth Clark take pride of place. People who recall him only as 'Lord Clark of Civilization' (a generally unflattering reference to his hugely successful TV series) may not be aware that his catalogue of the Leonardo drawings in the Royal Library at Windsor in 1935 not only established what remains

the definitive framework for the chronology of Leonardo's drawn works but also created a monument of art-historical scholarship that compares favourably with anything written in any language. Clark's 1939 monograph, in which he elegantly synthesized the picture of Leonardo he had gleaned from his researches, remains substantially accurate and aesthetically satisfying in equal measure. His only obvious paragon for grace and insight was the French art historian, André Chastel, both in his general writings on the period and the studies he devoted specifically to Leonardo.

More recently, as publication has followed publication, as exhibition has followed exhibition, as each attempt to satisfy the public appetite seems merely to stimulate new hunger, the single-minded researches of Carlo Pedretti have laid the foundation for a more minutely detailed understanding of Leonardo's written and drawn legacy than anyone had previously thought possible. In Milan, the torch of the City's fine tradition in Leonardo scholarship has been taken up by Pietro Marani.

The modern Leonardo is, at one level, the product of a more secure factual base than the Vasarian one. But it is nonetheless 'modern' in the period-specific sense. His science and technology, in particular, have been drawn into the web of assumptions that fuelled

the modern age. He becomes a 'man before his time', the pioneer of flight, of the horseless carriage, of the submarine, of the bicycle, of weapons of mass destruction, of fluid dynamics, and, no doubt somewhere, of the refrigerator. A sketch of a spiral toy for a festival becomes the first helicopter. A few graphic hints are assembled into a full human robot. The postmodern Leonardo is more elusive, perhaps because he automatically deconstructed himself to such good effect. But attempts to reveal him as the author of obscene drawings are very much in tune with the times.

We, like every other age, make the Leonardo we want. This is particularly true when practising scientists visit his life and works. What Leonardo left us is so rich, diverse, suggestive, enticing, and indefinite that he provides plentiful opportunities for anyone to squeeze himself in the interstices of the historical record. Geometrical obsessives etch crisscross lines—equilateral triangles, pentagons, circles, golden sections—in dense fretworks across small reproductions, thrilled when they randomly strike a 'significant' feature. Gynaecologists decide that Lisa is pregnant (not a daft idea, as it happens). Psychologists, encouraged by Freud's entry into the Leonardo stakes, make radical deductions from the different levels of the lands to the left and right of her head.

Computer overlays are used to demonstrate this and that, most notably that the *Mona Lisa* is a self-portrait in a more literal sense than that conveyed by Leonardo's injunction that 'every painter paints himself'. Hardly a month goes by without some kind of media revelation that a specialist in one thing or another has 'cracked' some aspect of Leonardo's enigmatic truth.

I personally have the dubious distinction of being (probably) the only art historian to appear twice on page 3 of the *Sun*, the English tabloid newspaper. Each day, page 3 notoriously features topless beauties whose pneumatic physiology has concentrated all its efforts on their chests. On one occasion I was commenting on researches that 'showed' the sitter of the *Mona Lisa* (not Lisa herself) to have been a notorious 'lady of the night'. The other involved the theory that she is smiling with her mouth closed because her teeth had been blackened by mercury treatment for venereal disease. This latter argument is typical of the compelling power of absent evidence, which is absent precisely because it has to be concealed—like the necessary secrecy surrounding Leonardo's faking of the Turin Shroud! In reality, for any Renaissance woman to be portrayed showing her teeth, American-style, is unthinkable. The silly season for the *Mona Lisa* never closes.

Almost inevitably, Leonardo has been signed up for secret societies, such as the Knights Templar, the Priory of Zion, and the Rosicrucians, the kinds of mysterious, closed, or underground organizations beloved of historical conspiracy theorists. The more 'secret' the conspiracy, the more latitude is afforded to the historical fantasist. If the Holy Grail is involved, so much the better. For the writer of fiction, the licence is almost unlimited. Dan Brown's phenomenally successful *The Da Vinci Code*, published in 2003, lists 'Leonardo da Vinci 1510–1519' as one of the 'Grand Masters' of the 'Prieure de Sion' in 'Les Dossiers Secrets—Number 4° lm 249' in the Bibliothèque National in Paris. Amongst his companions in the strange list of 26 Grand Masters are Botticelli, Newton, and Debussy! An opportunity has been missed; 27 is traditionally a much more mysterious number. The *Last Supper* contains the hidden clues, the most significant of which is that St John, portrayed in stock mode as tradition required— youthful and somnambulant—is actually Mary Magdalene, who is pregnant with Jesus' child. The murderous mysteries that ensue depend upon the suppression and intended annexation of this awesome truth by St Peter and his papal successors. In the service of fiction, such unfounded 'facts' are fine; as

history they perpetrate nonsense. The problem with Brown's *Code* is not its invention of 'truth'; but that it has been taken seriously by those who cannot recognize fiction as fiction.

What, as I asked in the Introduction, is all the fuss about? To some extent, in a media world driven by celebrity and fame, Leonardo and Lisa are famous for being famous. But such celebrity customarily fades in time. My answer is that Leonardo was and remains extraordinary. To encapsulate the quality in one (perhaps over-elaborate) sentence, I would say that no one ever used the tools of visual representation more compellingly and with more inventiveness to communicate the eternally fresh thrill of visual insight, as we learn to 'see' in the sense of 'to understand'. Like all great masters of visual magic, he instinctively knows how to draw us into his world of sensory delight and how to feed our eyes and our intellects to just the right degree, while leaving room for us to bring what we can to the completion of the cycle of communication between the thing, the artist, and the spectator.

The portrait of Lisa del Giocondo (née Gherardini) stands supreme and emblematic in this respect. Seeing it ('her'?) out of its frame is a nerve-wracking business. Can the experience ever match the centuries

of 'hype'? I wait with some anxiety as the lady on the balcony is released from her armour-plated prison, and loosed from her traditionally gilded and glazed frame. The actual presence of such a small panel covered with mere pigments and dirty varnish is beyond description. As the light changes, even by a fraction otherwise imperceptible to our naked eyes, and as our viewing position changes a little, the image 'breathes'. Few painters have ever managed this at the very highest level. Giovanni Bellini did, in the same years as Leonardo, and so did Rembrandt, almost infallibly. Leonardo does it by filtering the white brilliance of the panel's priming through enticing layers of warm glaze, so thin as to tax even modern scientific analysis. He does it by pitching soft red against a soft green of equal tonal value, opaque pale blue against translucent browns, definite line against elusive roundness, and by teasing us with things that invite us to see them as defined when they are veiled in ambiguity. Her expression works in the same way, setting overt invitation against tantalizing uncertainty. The image plays on our simultaneously oscillating feelings that she is and is not a real person who actually sat before Leonardo's analytical eye. It is difficult to express such things without providing fodder for 'Pseud's Corner', the column reserved in

the English satirical magazine, *Private Eye*, for art criticism that weaves fancy words into dense patterns that glorify the writer rather than illuminate the subject. Perhaps I should stop here. At least I am confident that Leonardo will continue to exert his spell, whether I have done a good job or not.

TOBIAS AND THE ANGEL
possible contribution to the painting by
Andrea del Verrocchio and his studio,
London, National Gallery, c.1473

A typical painted product of Verrocchio's studio, clearly exhibiting the work of different hands, one of which may be Leonardo's. If so, the vividly painted fish is the best candidate for his intervention.

THE BAPTISM OF CHRIST
contribution to painting by Andrea del Verrocchio,
Florence, Uffizi, c.1476

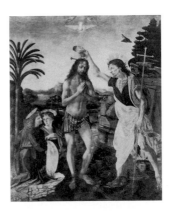

Early sources attest to Leonardo adding an angel (the one nearest the spectator) to the painting made for San Salvi in Florence. The distant landscape, the water, and the oil glazes over much of the surface of the painting also bear clear signs of his intervention.

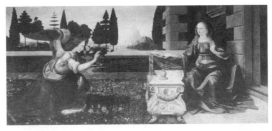

ANNUNCIATION
Florence, Uffizi, c.1473–4

Leonardo's earliest known independent painting, compiled using motifs from Verrocchio's repertoire, and with a laborious perspectival scheme, but with passages of observation and an intensity of representation that are highly original.

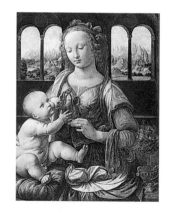

MADONNA AND CHILD WITH A CARNATION
Munich, Alte Pinakothek, c.1475–6

Highly ambitious and straining uncomfortably for effect (not least in its use of the oil medium), this shows Leonardo's first steps in reanimating the genre of the Virgin and Child. The landscape may reflect his interest in Netherlandish art.

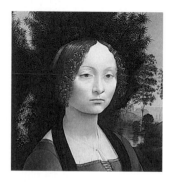

GINEVRA DE' BENCI
with painted reverse, Washington, National Gallery of Art, c.1476–8

The sitter was a member of the circle of Lorenzo il Magnifico in Florence and subject of courtly poems celebrating the love she had aroused in Bernardo Bembo, Venetian Ambassador. The set-up of a Verrocchio sculpted bust is combined with brilliant naturalism of surface effect and atmosphere. The emblematic motif on the reverse shows that the bottom of the picture has been cut off, and probably contained the sitter's hands.

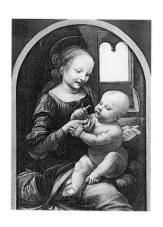

MADONNA AND CHILD
(THE BENOIS MADONNA)
St Petersburg, Hermitage, c.1479–80

A very small, concentrated painting in which Leonardo has endowed the relationship between mother and child with new complexity, energy, and intensity of emotional reaction. The composition results from his innovatory, 'brainstorm' drawing style.

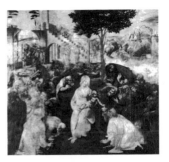

ADORATION OF THE MAGI [unfinished]
Florence, Uffizi, c.1479–81

Subject of a written document in 1481, setting out the complex terms of the commission, the large panel for San Donato a Scopeto, outside Florence, was left unfinished when the painter left for Milan. He has laid down the essential ingredients of what was to be called the High Renaissance style in the combination of great figural complexity with majestic compositional orchestration.

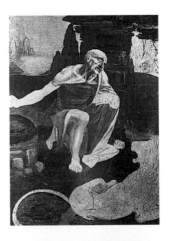

ST JEROME [unfinished]
Vatican, c.1480

Presumably undertaken in parallel with the Adoration and left in a comparable state of unfinish. It exploits Leonardo's studies of the anatomy of oldish and thin figures, as recorded in his list of works from around 1481.

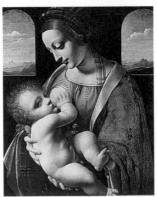

MADONNA LITTA, WITH GIOVANNI ANTONIO BOLTRAFFIO (?)
St Petersburg, Hermitage, c.1481–97

Leonardo was working on a Madonna in profile around the time of his departure for Milan, but the painting was (to judge from drawings attributable to Boltraffio) substantially brought to completion by Leonardo's pupil in the master's Milanese workshop.

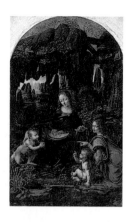

VIRGIN OF THE ROCKS
Paris, Louvre, 1483–c.1490

Commissioned in 1483 by the Milanese
Confraternity of the Immaculate Conception
for the large sculpted altarpiece in their
chapel in San Francesco Grande in Milan,
as part of a series of painted components
and polychroming by Leonardo and the
brothers Evangelista and Giovanni da Predis.
A protracted and horribly complex dispute
ensued, which was only resolved in 1508 with
the placing in the altarpiece of what seems
to be the London version (*see below*).
The picture now in Paris may have been
intercepted by Ludovico Sforza before its
delivery to the Confraternity. The treatment
of light, shade, and colour shows how
Leonardo reformed their relationship in
painting, using tonal description (i.e. the
scale between white and black) as the basis
of the definition of form.

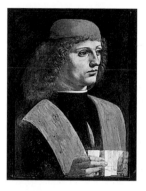

MUSICIAN [unfinished]
Milan, Ambrosiana, c.1485

Although the sitter has not definitely been
identified, and the attribution is disputed,
the modelling of the face and the intensity
of the eyes support Leonardo's authorship.

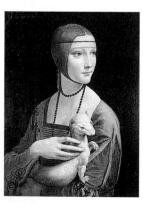

CECILIA GALLERANI (THE LADY WITH
THE ERMINE)
Cracow, Czartoryski Museum, c.1490

Cecilia was Ludovico Sforza's mistress for
two years or so as a young woman of artistic
accomplishments. The ermine puns on her
name (*Galee* in Greek) and speaks of her
purity, since the ermine would supposedly
die rather than soil its white winter coat.
The sense of the sitter reacting to an unseen
presence is unprecedented, as is the parallel
between the gracious deportment of the
woman and the somewhat oversized weasel.

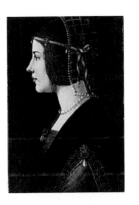

PORTRAIT OF LADY IN PROFILE
probably with his studio, Milan, Ambrosiana, c.1493–5

Leonardo also produced traditional portraits in profile (as shown by his drawn portrait of Isabella d'Este in the Louvre). The quality of drawing in the head suggests that he was responsible for laying down the basis of the image.

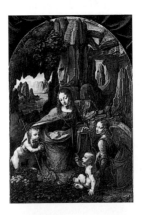

VIRGIN OF THE ROCKS
with his studio, London, National Gallery, c.1495–1508

This is the painting that came from the altarpiece in San Francesco Grande (*see above*), and was presumably the one eventually provided in 1508. Although there may be studio intervention in subsidiary parts of the picture, the figures are entirely consistent with Leonardo's style in the mid-1490s in Milan, when he presumably began the 'replacement' version. Areas of the flesh show the finger-print technique that is widely apparent in his works before 1500.

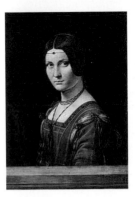

PORTRAIT OF LADY
('LA BELLE FERRONIÈRE')
Paris, Louvre, c.1496–7

Reasonably identified as the portrait of Lucrezia Crivelli, mistress of Ludovico in the later 1490s. The slightly averted glance testifies to Leonardo's conception, and much of the picture is finely executed, though the studio may have contributed to some of the more routine details.

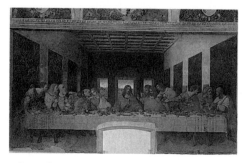

LAST SUPPER
*Milan, Refectory of Sta Maria
delle Grazie, c.1495–8*

A letter from Ludovico to his secretary in 1497 asks that Leonardo should be pressed to complete the mural. Painted experimentally in a technique more like tempera (using an egg binder) rather than traditional fresco (painted into wet plaster), it was subject to paint loss from an early date. The restoration at the end of the twentieth century disclosed striking details but confirmed how little of Leonardo's original paint survives in many areas of the picture. The eloquence and grandeur of the narrative set new standards for 'history painting'.

CRISTO FANCIULLO (YOUNG CHRIST)
terracotta, possibly by Leonardo, private collection, c.1496

Of the many candidates claimed to be a Leonardo sculpture, this has the best chance, though we have no certain sculptures surviving with which to compare it. We know that Leonardo worked in terracotta on such subjects, and the sense of movement and emotional communication separate it from the general run of busts of Christ.

SALA DELLE ASSE
with assistants, Milan, Castello Sforzesco, c.1498–9

We know that Leonardo was working in the large corner room in the castle in 1498. The trees originally arose from rock-entangled roots, and intertwined with a gold rope in a complex knot motif, interspersed with Sforza heraldic shields. The decorative scheme survives only in a fragmentary and reworked form.

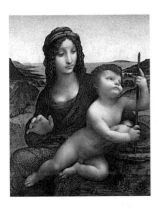

MADONNA OF THE YARNWINDER
with pupils, collection of the Duke of Buccleuch,
c.1501–7

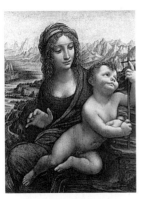

MADONNA OF THE YARNWINDER
(THE 'LANSDOWNE MADONNA')
with pupils, private collection, c.1501–7

Leonardo was documented as working on
a small picture of this subject in 1501, after
his return from Florence. The Patron was
Florimond Robertet, Secretary of State to
successive French kings. He appears to have
received his picture in Blois in 1507. Technical
examination has revealed strikingly complex
and similar underdrawings in both versions,
indicating Leonardo's direct involvement in
making two pictures of this subject. Which
went to Robertet is presently unclear.

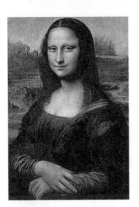

MONA LISA
Paris, Louvre, c.1503–16

The sitter can with some confidence be
identified as Lisa Gherardini, wife of
Francesco del Giocondo, a prominent
Florentine citizen. The basis for the picture
was established in Florence around 1503–4,
where it was seen by Raphael amongst
others, but it appears to have been finished
much later.

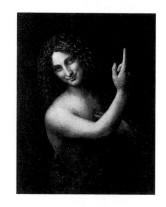

ST JOHN THE BAPTIST
Paris, Louvre, c.1508–16

Derived from a lost Leonardo painting of the *Angel of the Annunciation*, St John pronounces the arrival of Christ directly to the spectator, exuding an air of cosmic mystery. The darkened state of the picture makes its original effect hard to judge.

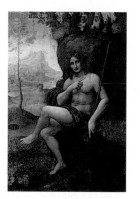

BACCHUS (BEGUN BY LEONARDO AS A ST JOHN?)
Paris, Louvre, c.1513–16

In its present state, transformed into Bacchus, the picture seems to show little that could be by Leonardo, yet the pose and draughtsmanship of the saint's figure are beyond anything that pupils and followers accomplished.

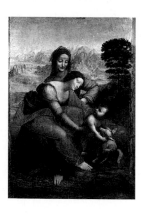

MADONNA, CHILD, ST ANNE, AND A LAMB
Paris, Louvre, c.1508–17

The culmination of a series of essays on the theme in drawings and cartoons, this is probably Leonardo's last painting. The fluency of figure movement, emotional complexity, and atmospheric magic stand at the climax of Leonardo's synthesis of natural effects and exploitation of fantasia for the communication of subtle meaning.

Leonardo's
Life in Outline

Reprinted (in an abridged and edited form) from the chronology by Carmen Bambach in *Leonardo da Vinci: Master Draftsman* (New York: The Metropolitan Museum of Art, 2003), by permission of The Metropolitan Museum of Art, copyright 2003.

1452

15 APR. Saturday, around 10.30 p.m. ('at three o'clock in the night' in Renaissance time), Leonardo is born out of wedlock, as recorded by the artist's paternal grandfather, Antonio di Ser Piero da Vinci. Leonardo's father is the notary, Ser Piero di Antonio da Vinci (1427–1504), and his mother is a young farmer's daughter, Caterina, who in 1453 married Accattabriga di Piero del Vacca.

1457

28 FEB. The 5-year old Leonardo is listed as a dependant in the tax assessment declaration of his grandfather, Antonio.

1462 Leonardo's father is employed in Florence as notary by Cosimo de' Medici, il Vecchio.

First Florentine Period (c.1464/9–1482/3)

1469 The tax declaration of Leonardo's father, Ser Piero, and of his uncle Francesco suggests that Ser Piero is already working as a notary at the *palagio del podestà* (the seat of the chief law officer, today the Palazzo del Bargello) in Florence.

1472 Leonardo appears in the account book of the painters' confraternity, the *Compagnia di S. Luca*, in Florence.

1473
5 AUG. Leonardo inscribes a landscape drawing: 'day of Saint Mary of the Snow/day of *5 August 1473*' (Florence, Uffizi).

1476
9 APR., By now in Andrea Verrocchio's employ,
7 JUNE Leonardo is among those charged of sodomy with Jacopo Saltarelli, a 17-year-old apprentice in a goldsmith's workshop. The charge is not followed up.

1478
10 JAN. The commission for an altarpiece in the Chapel of S. Bernardo in the Palazzo della Signoria of Florence.

16 MAR. First of a series of payments (25 florins) for the S. Bernardo altarpiece.

28 DEC.	Or in the few days that follow, Leonardo draws an eyewitness sketch of the hanged corpse of Bernardo di Bandino Baroncelli (Bayonne, Musée Bonnat).
SEPT.–DEC.	A drawing in the Uffizi is inscribed: '——ber 1478, I began the two Virgin Marys.'

1481	Leonardo undertakes the *Adoration of the Magi* altarpiece.
JULY	The contractual memorandum for the *Adoration of the Magi*, in which the monks record the commission for the main altar of their convent church of S. Donato a Scopeto.
JUNE–SEPT.	Payments in money and commodities for work at S. Donato.
28 SEPT.	Payment in wine for work at S. Donato.

First Milanese Period (1481–1499)

1481–3

SEPT. 1481– APR. 1483	Leonardo leaves Florence for Milan.

1483

25 APR.	Leonardo, with the brothers Evangelista and Giovan Ambrogio da Predis, signs the contract to decorate the altarpiece for the Confraternity of the Immaculate Conception in its chapel in the church of S. Francesco il Grande in Milan.

1485

16 MAR.	Leonardo observes a total eclipse of the sun.
23 APR.	Ludovico Sforza sends a letter to Maffeo da

Treviglio, ambassador to the court of Matthias Corvinus, King of Hungary, in which he states that he has commissioned a Madonna from Leonardo on the King's behalf: 'a figure of Our Lady as beautiful, as superb, and as devout as he knows how to make without sparing any effort'.

1487 Leonardo prepares designs for the domed crossing tower (*tiburio*) of Milan cathedral, and hires the carpenter's assistant Bernardino de' Madis to build a wooden model based on his drawings. Payments for the model are recorded on 30 July, 7 August, 18 August, 27 August, 28 September, 30 September.

1488

JAN. Leonardo collects additional payment for the project of the *tiburio* of Milan cathedral.

1489

2 APR. Leonardo inscribes one of his skull studies '*a dj 2 daprile 1489* . . . book entitled "On the Human Figure" ' (Windsor, Royal Library, 19059).

22 JULY Piero Alamanni, the Florentine ambassador to the Sforza court in Milan, writes to Lorenzo de' Medici, il Magnifico, in Florence stating that il Moro has entrusted the model of the Sforza horse to Leonardo, but that he still needs 'a master or two capable of doing such work'.

1490

13 JAN. Leonardo produces the stage set for Bernardo Bellincioni's *Feast of Paradise* (*La Festa del Paradiso*) performed in the Castello Sforzesco, Milan, to

celebrate the wedding of Gian Galeazzo Sforza and Isabella of Aragon.

23 APR. Leonardo notes that he has resumed work on the Sforza horse.

10, 17 MAY Payments for the model of the *tiburio* of Milan cathedral.

21 JUNE Leonardo accompanies Francesco di Giorgio to Pavia in connection with the project to rebuild the cathedral; they are both paid for their expertise.

27 JUNE Leonardo loses the design competition for the *tiburio*, which is awarded to Giovanni Antonio Amadeo (*c.*1447–1522) and Giovanni Giacomo Dolcebuono.

22 JULY Salaì (Gian Giacomo Caprotti di Oreno), who is 10 years old, arrives in Leonardo's workshop.

7 SEPT. Salaì steals a silverpoint from one of Leonardo's assistants called Marco (d'Oggiono?).

1491

26 JAN. Leonardo is 'in the house of Galeazzo da Sanseverino' to prepare a festival and tournament honouring the wedding of Ludovico Sforza and Beatrice d'Este.

2 APR. Salaì steals the silverpoint of another of Leonardo's workshop assistants called Giovan Antonio (Boltraffio?).

1491–5

In an undated letter, Leonardo and Giovan Ambrogio da Predis complain to Ludovico Sforza about the Confraternity of the Immaculate Conception's poor payment for the *Virgin of the Rocks* and the two flanking paintings of angels.

1492 Leonardo travels to the Lake Como region in Lombardy, visiting Valtellina, Valsassina, Bellagio, and Ivrea.

1493

NOV. An equestrian effigy of Francesco Sforza (Leonardo's actual model of the Sforza horse or an image based on his design) is displayed under a triumphal arch inside Milan cathedral during the festivities for the marriage of Ludovico's niece, Bianca Maria Sforza, to the Emperor Maximilian I of Hapsburg.

20 DEC. Leonardo decides to cast the Sforza horse on its side and without the tail. Bernardo Bellincioni's *Rime* . . . published in 1493 praises Leonardo's *Portrait of Cecilia Gallerani*.

1494

JAN. In Vigevano.

17 NOV. Ludovico Sforza, il Moro, sends the bronze for the Sforza horse to his father-in-law, Ercole d'Este, Duke of Ferrara, to make a cannon.

1495 He goes to Florence, where he acts as a consultant in the building of the 'Sala del Gran Consiglio'.

 Giovanni da Montorfano signs and dates the *Crucifixion* fresco on the south wall (opposite Leonardo's *Last Supper*). The much damaged portraits of Ludovico Sforza and Beatrice d'Este, with their two small sons—painted in oils rather than in *buon fresco*—are inserted in the foreground, and have sometimes been attributed to Leonardo.

| 14 NOV. | A record suggests that Leonardo may be at work on the decoration of rooms in the Castello Sforzesco in Milan. |

1496 Leonardo drafts a detailed petition about the making of bronze doors to the administrators of Piacenza cathedral.

| 8, 14 JUNE | Letters note that the painter decorating rooms in the Castello Sforzesco (Leonardo?) has abandoned the project, and it is suggested that Perugino might be approached. |

1497

| 29 JUNE | Ludovico Sforza sends a memorandum to his secretary, Marchesino Stanga [Stange], expressing his hope that Leonardo will soon finish the *Last Supper* so that he may commence work on another wall in the refectory. |

1498 Leonardo designs the suburban villa of Mariolo de' Guiscardi, near the Porta Vercellina in Milan.

| 8 FEB. | Fra Luca Pacioli dedicates his *De divina proportione* to Ludovico. He praises Leonardo, indicating that the Sforza horse measures 12 *braccia* ('the said height from the nape [of the neck] to the flat ground', i.e. over 23 feet), and would have a bronze mass of 200,000 *libbre* (i.e. 67,800 kilos). |

| 17 MAR. | Leonardo travels to Genoa harbour and makes notes on the ruined quay. |

| 22 MAR. | A letter addressed to Ludovico states that the work in the refectory of Sta Maria delle Grazie is to progress expeditiously. |

20, 21, Leonardo is recorded at work on the murals in the
23 APR. *saletta negra* and the *sala delle asse* in the north-west
 tower of the Castello Sforzesco of Milan.

20, 26 APR. Isabella d'Este, Marchioness of Mantua, asks
 Cecilia Gallerani to send Leonardo's portrait so
 that she might compare it with Bellini's portraits.

1499

26 APR. Ludovico Sforza has given to Leonardo a vineyard
 near Porta Vercellina, between the monasteries of
 S. Vittore and Sta Maria delle Grazie in Milan.

9–10 SEPT. The French troops of King Louis XII storm the
 city, led by the mercenary general Gian Giacomo
 Trivulzio, for whom Leonardo was later to plan
 an equestrian monument.

OCT. King Louis XII enters Milan.

14 DEC. Milan falls decisively to the French. Leonardo sends
 money to his account at the Hospital of Sta Maria
 Nuova in Florence, in anticipation of his return to
 the city in company with Luca Pacioli.

Second Florentine Period (1500–1508)

1500 Leonardo may have accompanied Count Louis of
 Ligny (courtier of Charles VIII, and later of Louis XII)
 on a mysterious trip to Rome, and possibly Naples.
 Leonardo is working for the Venetian Republic
 on a proposal for a defence system against the threat
 of a Turkish invasion in the Friuli region.
 With Boltraffio, Leonardo is possibly the guest of
 Casio in Bologna.

FEB. Leonardo stays in Mantua as the guest of the
 Gonzaga.

13 MAR.	The lute player Lorenzo Gusnasco da Pavia sends a letter to Isabella d'Este from Venice stating that Leonardo had showed him a drawn portrait of her.
24 APR.	Leonardo arrives in Florence, probably residing in the church complex of Santissima Annunziata (hosted by the Servite brothers), where he draws a cartoon of the *Madonna and Child with St Anne*.
	He offers advice on the damage to the foundation of the church of S. Salvatore dell'Osservanza (S. Francesco al Monte) above Florence, and on the construction of a campanile for the church of S. Miniato.
11 AUG.	Leonardo sends Francesco Gonzaga a design for the villa of Angelo del Tovaglia near Florence.

1501

28 MAR.	From Mantua, Isabella d'Este asks Fra Pietro da Novellara (Head of the Carmelites in Florence) to obtain information about Leonardo's activities.
3 APR.	Fra Pietro replies that Leonardo is at work on a cartoon for a Madonna and Child with St Anne and a Lamb.
14 APR.	Fra Pietro sends another letter to Isabella, noting that Leonardo is painting the *Madonna of the Yarnwinder* for Florimond Robertet, secretary of King Louis XII.
19, 24 SEPT.	Letters by Giovanni Valla, ambassador to Ercole I d'Este, enquire of the French authorities in Milan if the Duke may use the moulds of the Sforza horse, which were 'exposed to daily decay as the result of neglect', to cast his own equestrian monument in Ferrara.

1502

12 MAY	Leonardo evaluates drawings of antique vases from Lorenzo de' Medici's collection being offered to Isabella d'Este.
MAY–18 AUG.	Cesare Borgia, il Valentino, Captain General of the Papal Armies, names Leonardo 'familiar architect and general engineer' in the Marche and Romagna.
JULY–SEPT.	Leonardo travels to Urbino, Cesena, Porto Cesenatico, Pesaro, and Rimini in Cesare's service.

1503

	Leonardo writes to Sultan Baiazeth in connection with a project for a bridge on the Bosphorus.
FEB.	Leonardo returns to Florence.
9 MAR., 23 JUNE	The notary for the Confraternity of the Immaculate Conception makes a summary of events regarding the *Virgin of the Rocks*.
JUNE–JULY	During the siege of the city of Pisa, Leonardo stays in the Camposanto and makes topographical sketches, designs for military machines and fortifications for the Signoria of Florence.
24 JULY	A letter by Francesco Guiducci states that Leonardo and others have come to show schemes for the diversion and canalization of the Arno River.
JULY	Leonardo is paid by the *Signoria* of Florence to level the Arno at Pisa.
	He is reinscribed in the account book of the painters' confraternity.
24 OCT.	Leonardo receives keys to the Sala del Papa and other adjacent rooms in the great cloister of Sta Maria Novella, Florence, which will serve as his workshop and living quarters while preparing his cartoon for the *Battle of Anghiari*.

1504

25 JAN. With twenty-nine others, Leonardo participates in a meeting on the final placement of Michelangelo's giant marble *David*.

FEB.–OCT. Leonardo is paid a steady salary for work on the *Battle of Anghiari* cartoon.

28 FEB. Payments for the ingenious movable scaffolding that Leonardo invents to draw the *Anghiari* cartoon, and for a very large quantity of paper.

4 MAY The *Signoria* of the Florentine republic, led by the chancellor, Niccolò Machiavelli, sign a contractual document that summarizes the state of Leonardo's work on the *Battle of Anghiari*, and confirms his monthly salary of 15 florins.

30 JUNE Further payments to various artisans are recorded for Leonardo's work on the *Battle of Anghiari* cartoon.

Leonardo goes to Piombino to work on military engineering projects at the request of Jacopo IV Appiani, Lord of Piombino and ally of Florence during the Pisan war.

9 JULY In the evening, Leonardo's father, Ser Piero di Antonio da Vinci, dies in Florence. The settling of his estate causes acrimonious disputes for almost six years between Leonardo and his seven living, legitimate half-brothers.

30 AUG. Payment for the iron wheels and parts to be used for Leonardo's scaffolding.

AUG. Leonardo's uncle, Francesco, bequeaths him property.

30 NOV. Leonardo records that he has 'solved' the problem of squaring of the circle.

| 30 DEC. | Payments suggest that Leonardo incurs further expenses for supplies for the *Battle*. |
| 4, 14, 27 MAY, 31 OCT. | Letters record Isabella d'Este's intention to commission from Leonardo a devotional painting of 'a youthful Christ of about 12 years old'. |

1505

28 FEB., 14 MAR.	The expenses for Leonardo's scaffolding are reimbursed.
30 APR.	Additional expenses for the *Battle* are recorded. The painting assistants are Raffaello d'Antonio di Biagio, Ferrando Spagnolo, and Thomaso di Giovanni, who 'grinds colours' for Ferrando.
6 JUNE	Leonardo writes: 'On the 6th day of June, 1505, Friday, at the stroke of the 13th hour I began to paint in the palace. At that moment when [I] applied the brush the weather became bad, and the bell tolled calling the men to assemble. The cartoon ripped. The water spilled and the vessel containing it broke. And suddenly the weather became bad, and it rained so much that the waters were great. And the weather was dark as night.'
31 AUG.	Further payments to Leonardo's assistant, Ferrando Spagnolo, and the 'colour grinder' Tomaso di Giovanni.
31 AUG., 31 OCT.	Painting supplies for the *Anghiari* mural and the cloth covers for the scaffolding are reimbursed.

Second Milanese Period (1506–1513)

1506

| 13 FEB. | Leonardo and the heir of Evangelista da Predis |

(who had died in 1491) designate Giovan Ambrogio da Predis to represent them in the dispute with the Confraternity of the Immaculate Conception.

4 APR. Arbitrators are appointed regarding the dispute over the price of the *Virgin of the Rocks*.

27 APR. Giovan Ambrogio da Predis, on behalf of Leonardo, who is in Florence, comes to an agreement with the Confraternity regarding the *Virgin of the Rocks*, which seems to be still unfinished.

3, 12 MAY Letters between Isabella d' Este and Alessandro Amadori (brother of the first wife of Ser Piero da Vinci) mention 'those figures, which we have beseeched from Leonardo'.

30 MAY A contract between Leonardo and the *Signoria* of Florence requires that, before Leonardo can depart for Milan, he is to return to Florence within three months to finish the *Battle of Anghiari*.

18 AUG. Charles II d'Amboise, governor of Milan and who had become Marshall of France in 1504, writes to the *Signoria* in Florence requesting Leonardo's services in Milan.

19, 28 AUG. Letters between the French court in Milan and the *Signoria* of Florence record the negotiations concerning Leonardo going to Milan without penalty.

EARLY SEPT. He sets out for Milan with Salaì, Lorenzo, and 'Il Fanfoia'. Their host is Charles d'Amboise, who commissions Leonardo to design a suburban villa and garden.

9 OCT. The frustrated *gonfaloniere* of the Florentine republic, Piero Soderini, accuses Leonardo of impropriety.

16 DEC.	In a letter to the *Signoria* of Florence, Charles d'Amboise expresses his satisfaction with Leonardo's work.

1507

12, 14, 22 JAN.	In an exchange of letters between the Florentine ambassador Francesco Pandolfini, the *Signoria* of Florence, and the royal court at Blois, it is agreed that Leonardo should stay in Milan to serve the French.
MAR.	Leonardo returns with Salaì to Florence.
27 APR.	A decree restores to Leonardo his vineyard at S. Vittore near the Porta Vercellina, which had been expropriated during the Fall of Milan of December 1499.
23 JULY	Leonardo designates representatives in an unnamed legal case and seems to be living within the parish of S. Babila in Milan.
26 JULY	Florimond Robertet intervenes in Leonardo's dispute with the *Signoria* of Florence over the unfinished *Battle of Anghiari* project, and he requests on behalf of the King the presence in Milan of 'our dear and well-loved Leonardo da Vinci painter and engineer of our trust'.
3 AUG.	A member of the Dominican order is appointed as arbitrator in a dispute between Leonardo and Giovan Ambrogio da Predis.
	Leonardo produces stage designs for *Orfeo*, the play by Angelo Poliziano, with a set for a 'mountain which opens'.
15 AUG.	Charles d'Amboise demands that the *Signoria* of Florence ensure that Leonardo can return to Milan

again 'because he is obliged to make a [painted] panel' for King Louis.

20 AUG. Leonardo finds someone to represent him legally in Milan.

26 AUG. The arbitration decisions regarding the *Virgin of the Rocks* commission are summarized.

18 SEPT. Leonardo writes a letter from Florence to Cardinal Ippolito d'Este in Ferrara, soliciting support in his legal dispute with his brothers.

Leonardo meets the young nobleman Francesco Melzi (1491/3–*c*.1570) from Vaprio d'Adda, who was to be his devoted pupil, companion, and major heir.

Leonardo's uncle, Francesco, dies and leaves Leonardo as sole heir.

WINTER 1507–8 Leonardo returns to Florence at some point in the winter of 1507–8. Also this winter he dissects an old man, supposedly 100 years old (the 'centenarian'), at the Hospital of Sta Maria Nuova in Florence.

1508

22 MAR. Leonardo is staying at the house of Piero di Baccio Martelli.

23 APR. By this date Leonardo had returned to Milan to serve Louis XII.

JULY From July 1508 until April 1509 Leonardo records the salaries that he is being paid by the French king.

18 AUG. Giovan Ambrogio da Predis and Leonardo receive permission to remove the *Virgin of the Rocks*, which is newly installed in S. Francesco il Grande in Milan, so that Giovan Ambrogio can copy it, under Leonardo's supervision.

| 12 OCT. | Leonardo authorizes a release of a quittance regarding the *Virgin of the Rocks*. |
| 23 OCT. | Giovan Ambrogio da Predis receives a final payment of 100 *lire imperiali* regarding the copy of the *Virgin of the Rocks*, and Leonardo confirms the settlement of the confraternity's debt. |

1509

| 28 APR. | Leonardo notes that he has solved a problem of geometry. |

1510

| 1510 | Leonardo is paid a salary of 104 *livres* for the year by the French state, under Louis XII. |
| 21 OCT. | Leonardo is asked to advise on the design of the choir stalls of Milan Cathedral. |

1511

| 2 JAN. | Leonardo writes that a quarry 'above Saluzzo' has marble of the hardness of porphyry 'if not greater', and that his friend the *maestro* Benedetto has promised to give him a piece to use as a painter's palette for mixing colours. |
| 10, 18 DEC. | Leonardo records that the invading Swiss soldiers have set fires in the city of Milan, marking the end of the French domination of Milan. Leonardo and his household abandon the city, settling for some time at the Melzi family villa in Vaprio d'Adda. |

1513

| 25 MAR. | Leonardo may have returned to Milan, as he appears in one of the register books of the Milan cathedral masons' works. |

Roman Period (1513–1516)

1513

24 SEPT. Leonardo writes, 'I departed from Milan to go to Rome on September 24 with Giovan Francesco [Melzi], Salaì, Lorenzo and "Il Fanfoia". '

OCT. Leonardo and his four companions probably pass through Florence.

I DEC. Leonardo is in Rome as part of the household of Giuliano de' Medici (brother of Pope Leo X), who sets up the artist in a workshop in the Belvedere wing of the Vatican Palace.

1514

7 JULY Leonardo writes that a geometrical problem was 'finished on July 7 at the 23rd hour at the Belvedere, in the studio made for me by il Magnifico [Giuliano de' Medici]'.

25–27 SEPT. Leonardo writes that he is in Parma and 'on the banks of the Po'. He visits Civitavecchia to undertake studies of the harbour and archaeological ruins.

8 OCT. Leonardo is inscribed in the confraternity of S. Giovanni dei Fiorentini in Rome.

1514–1515

Leonardo writes drafts of letters to Giuliano de' Medici that mostly concern his disputes with Giovanni degli Specchi, a German mirror-maker.

1515

9 JAN. Leonardo notes that his master Giuliano de' Medici departed at dawn from Rome in order to marry in Savoy.

12 JULY	At a banquet honouring the entry of King Francis I into Lyons on his return from Italy, a mechanical lion invented by Leonardo is presented as a gift from Lorenzo di Piero de' Medici, Duke of Urbino.
20 NOV.	Pope Leo X makes his triumphal entry into Florence, and Leonardo and his employer Giuliano de' Medici travel as part of the papal entourage. Leonardo plans a new palace for Lorenzo di Piero de' Medici, opposite Michelozzo's Palazzo Medici.
7–17 DEC.	Leonardo leaves Florence, passing through Firenzuola, on his way to Bologna, where the Pope is to meet the French king. For his trip, Leonardo receives 40 *ducati* from Giuliano de' Medici.

1516

13 MAR.	Leonardo records the solution to a mathematical problem.
17 MAR.	Giuliano de' Medici dies, and Leonardo writes: 'The Medici made me, and destroyed me.'
AUGUST	Leonardo takes measurements of the large early Christian basilica of S. Paolo fuori le Mura in Rome.

French Period (1516–1519)

1516	Leonardo goes to France as *peintre du Roy* for King Francis I. He is accompanied by Melzi and Salaì.

1517

MAY	Ascension Day: the artist writes that he is in Amboise and Cloux.

I OCT.	A letter from Rinaldo Ariosto to Federico Gonzaga in Mantua describes a celebration for King Francis I in Argentan, mentioning Leonardo's mechanical 'lion that opened, and in the inside it was all blue, which signified love according to the customs here'.
10 OCT.	Leonardo receives a visit from Cardinal Luigi of Aragon and his secretary Antonio de Beatis, who records the event in his diary. De Beatis saw three paintings, a portrait of 'a certain Florentine woman done from life at the request of the said magnificent Giuliano de' Medici', a young St John the Baptist, and a Madonna, Child, and St Anne. Because Leonardo had suffered paralysis of his right side, possibly caused by a stroke, 'he can no longer paint with the sweetness of style that he used to have, and he can only make drawings and teach others'.
II OCT.	De Beatis's diary amends his record of the previous day: 'there was also a picture in which a certain lady from Lombardy is painted in oil, from life, quite beautiful, but in my opinion not as much as the lady Gualanda, the lady Isabella Gualanda'.
29 DEC.	De Beatis's diary records his visit to Leonardo's *Last Supper* at the refectory of Sta Maria delle Grazie in Milan: 'although most excellent, it is beginning to deteriorate.'
END YEAR	Leonardo is recorded at work in Romorantin in connection with a project to build a palace for King Francis I.
1517–1518	The pension from the king for the 'master Leonardo da Vinci, Italian painter', amounts to 2,000 *ecus soleil* for two years. 'Francesco Melzi, Italian nobleman', receives 800 *ecus* for two years,

Leonardo's Life in Outline

and 'Salaì, servant of master Leonardo da Vinci',
100 *ecus*.

1518

UNTIL
16 JAN.
Leonardo remains in Romorantin working on the
plans for the palace and related canals.

19 JUNE
In celebration of the wedding of Lorenzo de'
Medici and Maddalena de la Tour d'Auvergne,
niece of King Francis I, *The Feast of Paradise*,
originally staged by Leonardo in 1490, is
performed in Cloux with mechanical scenery.

24 JUNE
Leonardo writes that he has left Romorantin to go
to the castle of Cloux at Amboise.

1519

23 APR.
Leonardo, 67 years old and ailing, goes before the
royal court at Amboise to acknowledge his will.

2 MAY
Leonardo dies in the castle of Cloux. Following
his wish, he is buried in the cloister of the church
Saint-Florentin at Amboise (destroyed).

1 JUNE
His beloved companion and artistic heir, Francesco
Melzi, writes to Leonardo's half-brother Ser
Giuliano da Vinci to notify the family of
Leonardo's death.

Further Reading

A full or even representative bibliography would run to inordinate length. The following selection is designed to guide the reader towards some of the more accessible recent and authoritative sources, and to open a door into the primary documentation for Leonardo's life and works. Books in English are cited where possible, but some Italian and French writings are included where no suitable English option is available.

1. General monographs etc.

K. Clark, *Leonardo da Vinci*, ed. M. Kemp, London, 1993, remains the most eloquent introduction to Leonardo as an artist

A series of perceptive studies have been produced by A. Chastel, a useful collection of which is available in *Leonardo da Vinci: studi e richerche, 1952–1990*, Torino, 1995

M. Kemp, *Leonardo da Vinci. The Marvellous Works of Nature and Man*, London, 1989, covers the full range of Leonardo's work and thought

P. Marani has published a series of notable monographs and catalogues, most recently *Leonardo da Vinci*, New York, 2003, including a useful apparatus in collaboration with E. Villata

The most comprehensive and fully illustrated recent catalogue is by F. Zöllner, with J. Nathan, *Leonardo da Vinci*, Cologne, 2003

A perceptive account of Leonardo's artistic origins is given by D. A. Brown, *Leonardo Da Vinci: Origins of a Genius*, New Haven, 1998

A valuable collection of writings on Leonardo from early accounts to modern scholarship has been edited by C. Farrago, 5 vols, *Leonardo's Writings and Theory of Art*, London, 1999

The regular journal, the *Raccolta Vinciana*, ed. P. Marani in Milan, publishes bibliographical updates and new research, as did *Achademia Leonardi Vinci*, ed. C. Pedretti

Leonardo's posthumous reputation is discussed by A. R. Turner, *Inventing Leonardo*, New York, 1993

The strange history of the *Mona Lisa* is outlined by A. Chastel, *L'illustre incomprise—Mona Lisa*, Paris, 1988

2. Sources, facsimiles etc.

The documentation of Leonardo's life is edited by E. Villata, *I Documenti e le testimonianze contemporanee*, Ente Raccolta Vinciana, Milan, 1999

Facsimiles of Leonardo's Manuscripts were earlier published under the auspices of the Reale Commissione Vinciana, and new facsimiles are being published by Giunti as the *Edizione Nazionale dei Manoscritti e dei Disegni di Leonardo da Vinci*, from 1964 onwards

A compact, 3-volume version of the huge *Codice atlantico* was published by Giunti in 2000, ed. C. Pedretti, with transcriptions by A. Marinoni

Recent transcriptions, generally accompanying the Giunti facsimiles, are by the major scholars of Leonardo's manuscript legacy, C. Pedretti and A. Marinoni

A series of translations by John Venerella of the Manuscripts held by the Institut de France are being published by the Raccolta Vinciana in Milan, from 1999 onwards

The standard anthologies of excerpts from the manuscripts in translation are J. P. Richter, *The Literary Works of Leonardo da Vinci*, 2 vols., Oxford, 1970, with *Commentary* by C. Pedretti, 2 vols., Oxford, 1977; and J. McCurdy, *The Notebooks of Leonardo da Vinci*, 2 vols., London, 1938

The standard edition of the *Treatise on Painting* is by C. Pedretti, *Leonardo da Vinci: Libro de pittura*, Florence, 1995

For the *Paragone* (comparison of the arts), which opens the *Treatise*, see C. Farago, *Leonardo da Vinci's Paragone: a critical interpretation*, New York, 1991

An accessible anthology of Leonardo's writings on art is provided by *Leonardo on Painting*, ed. M. Kemp, trs. Kemp and M. Walker, New Haven and London, 1989

3. Drawings

The best compact collection remains A. E. Popham, *The Drawings of Leonardo*, London, 1947, and intro. M. Kemp, London, 1994

The important collection of drawings at Windsor is catalogued by K. Clark and C. Pedretti, *The Drawings of Leonardo da Vinci*, London, 1968

A rewarding series of exhibitions of the Windsor drawings have been accompanied with catalogues by Lady J. Roberts and M. Clayton

C. Bambach's catalogue of the exhibition at the Metropolitan Museum, *Leonardo da Vinci Master Draftsman*, New York, 2003, contains important scholarship and essays by various authors, as does Françoise Viatte's Louvre exhibition catalogue, *Léonard de Vinci. Dessins et Manuscrits*, Paris, 2003

4. Architecture and Engineering

The most complete review of Leonardo as an architect is C. Pedretti, *Leonardo Architect*, London, 1986

P. Galluzzi, *Leonardo da Vinci: Engineer and Architect*, Montreal, 1987, and *The Renaissance Engineers from Brunelleschi to Leonardo da Vinci*, Florence, 1996, contain valuable interpretations of Leonardo and set the context for his activities

For military architecture, see P. Marani, *L'Architettura Fortificata Negli Studi di Leonardo da Vinci*, Florence, 1984

5. Aspects of Science etc.

K. Keele, *Leonardo da Vinci. Elements of the Science of Man*, London, 1983, sets Leonardo's anatomical researches into the context of his thought

A comprehensive treatment of Leonardo's optics is provided by K. Veltman, *Linear Perspective and the Visual Dimensions of Science and Art*, Munich, 1986

The best review of Leonardo's mathematics is A. Marinoni, *La Matematica di Leonardo da Vinci*, Milan, 1982

Comprehensive analysis of the water drawings and notes is provided by the series of monographs by E. Macagno, *Leonardian Fluid Mechanics*, Iowa, 1986 and subsequently

C. Starnazzi, *Leonardo Cartografo*, Florence, 2003, has explored Leonardo's geological interests

A good introduction to Leonardo's thought is provided by R. Zwijnenberg, *The Writings and Drawings of Leonardo da Vinci: Order and Chaos in Early Modern Thought*, New York, 1999

For the physiognomics, see M. Kwakkelstein, *Leonardo as a Physiognomist*, Leiden, 1994

Index